skyscrapers

skyscrapers

ANDRES LEPIK

PRESTEL
Munich · Berlin · London · New York

CONTENTS

skyscrapers

A Design for the 20th Century

Ever since the late nineteenth century when skyscrapers first appeared in the United States, they have shaped the public's perception of architecture. With their increasing proliferation since the Second World War, they have changed the face of most major cities worldwide. Skyscrapers have replaced church spires as peaks on the skyline and have become new topographical reference points. Economic interests and town-planning issues are usually the main factors behind proposals for their construction. But above and beyond rational economic considerations, skyscrapers have also long been associated with dreams, hopes and utopias that have lead them to aspire to new heights. From the Woolworth Building to the Empire State Building and the World Trade Center, skyscrapers have become a symbol for the seemingly limitless possibilities of architecture, a constantly renewable promise for the future. The numerous record projects that were announced before the dawn of the new millennium point to our enduring faith in the capacity of this design typology to continue to develop. On the other hand, skyscrapers are also associated with all kinds of anxieties, resistance and risks. In the negative mythology of the urban Moloch, the skyscraper became the most important symbol for the loss of individuality and of life on a human scale. In popular culture—from *Metropolis* to Gotham City in *Batman* to *Blade Runner*—skyscrapers always provide the backdrop to the developments threatening our future.

Like the progress in air travel and space exploration in the twentieth century, the evolution of the skyscraper has led to huge advances in technology and engineering, but has also opened up new hitherto unforeseen risks. As in the case of all man-made structures, the greatest danger is, and always has been, the possibility of collapse due to structural defects or natural causes, particularly earthquakes. Our fear of such events goes back a long way. In the Old Testament, the story of the failed Tower of Babel warned against the human hubris of building high into the sky and ignoring the heavenly boundary. For many years, as construction methods and calculations grew ever more precise, the danger of an actual collapse seemed to be an irrational, purely theoretical premise. Yet on September 11th, 2001, with the attacks planned and executed by terrorists, this danger became a harsh reality. The attack on the World Trade Center in New York was also an assault on a built symbol and on the thousands of people from all over the world who were in it at the time. It also naturally raised the question as to whether such tall skyscrapers should ever be built again in the future. For these structures can never guarantee the occupants absolute security in the face of attacks of this kind. Yet, in just the same way that a single plane crash does not hold back the continuation and expansion of global air traffic, the attack on the World Trade Center has not fundamentally called into question this particular building design. In an age when more than half of the world's population is already living in large towns and cities, the increasing density of the way we work and live in urban centers makes the continued construction of

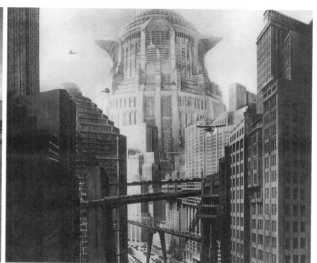

Pieter Bruegel the Elder, *The Building of the Tower of Babel*, 1563, Kunsthistorisches Museum, Vienna

Erich Kettelhut, scenery for the film *Metropolis* by Fritz Lang, 1927

skyscrapers inevitable. In fact, the nature and location of most of the plans for new skyscrapers since September 2001—new and existing projects throughout the world—rob any possible future attacks of the supposed ideological justification of 9/11.

The extent to which the skyscraper is not purely functional, beholden to the demands of the economy, but is also a symbolic structure, was widely known long before 9/11. Yet, it was only this catastrophe that showed just how much it was the repository of the central tenets and values of a culture that was viewed as a threat by those who either did not or did not want to share the same values. Even so, it was already becoming clear before 2001 that the hitherto virtually unlimited hegemony of the American skyscraper was rapidly being ousted by new record-breaking projects in the countries of Asia. Of the twenty tallest buildings in the world, there are now only six in the United States; the majority are currently in Asia and were constructed within the last ten years.

History

The development of the skyscraper was crucially influenced by two seemingly independent factors. The indispensable given was the free-standing, load-bearing iron skeleton, which was later replaced by an even stronger steel frame. The self-supporting iron frame, already developed in England in the first half of the nineteenth century, was further advanced in France after 1850, by the French engineer Gustave Eiffel, amongst others. His ground-breaking invention of a riveted iron construction reached the United States in 1885 with his design for the internal support structure for the Statue of Liberty. And news of his plans for a 984-foot (300-meter) tower for the 1889 World Exhibition in Paris was seen as a direct challenge by American engineers. By 1888 the architect Leroy S. Buffington from Minneapolis had patented a skeleton construction—called the "Cloudscraper"—which could accommodate up to twenty-eight floors.

Since it was practically impossible to find tenants for offices and apartments above the fourth or the fifth floor because of the tedious climb up the stairs to the higher floors, the invention of the elevator was the second factor underpinning the establishment of the skyscraper. Mechanical elevators as such had been known long before the nineteenth century, but it was only in 1853 when Elisha Graves Otis presented a passenger elevator guaranteed not to plunge suddenly downwards, that it became possible for people to travel upwards in

safety and comfort. In 1857 the first passenger elevator was built into a five-story New York office building. However, the hydraulic system used to power these elevators—still being used in the Flatiron Building as late as 1903—could only achieve very slow speeds. In 1880 Werner von Siemens in Germany demonstrated the first electrically powered elevator. In 1889 the first electric elevator system was installed in an office block in New York. Improvements in the technology soon opened the way to the ever faster vertical conquest.

However, besides these important technical and structural factors, there was a third (economic) catalyst. After the devastating fire of 1871 in the center of Chicago, there was a surge in the demand for office space. Sites in the city center were expensive, and investors expected maximum usage. Increasing the number of floors meant a higher return on investments. It was only the building boom in Chicago in the 1880 combined with the intense financial pressures and the exploitation of the new construction methods that made it possible for the skyscraper to evolve so quickly.

The Home Insurance Building in Chicago (1885), designed by the architect William Le Baron Jenney, is generally regarded as the first tall building of this kind. Its crucial difference lies in its construction. Iron constructions had already been used in walls to reinforce the load-bearing brick walls. Jenney went a step further and now used the steel frame to support the masonry walls, although this decisive step in construction methods was not yet visible from the outside. The building looked like a Renaissance palace that had been extended in all directions. But from now on, buildings could rise ever higher without increasing the thickness of the walls. The ten-story Home Insurance Building was soon overtaken in 1889 by the fourteen-story Tacoma Building, also in Chicago. Freed of its load-bearing function, the facade—with its dynamic design and tall windows breaking up the wall surface—points very clearly to the new possibilities. By 1892 the Masonic Temple in Chicago, with its twenty-two floors and 302 feet (92 meters) height, was the tallest building of its time and the first to be publicly known as such. In 1895 the Reliance Building (p. 30) went even further in this same direction.

Passenger elevator by Otis Brothers & Co., New York, around 1900

William Le Baron Jenney, Home Insurance Building, Chicago, 1885, demolished 1931

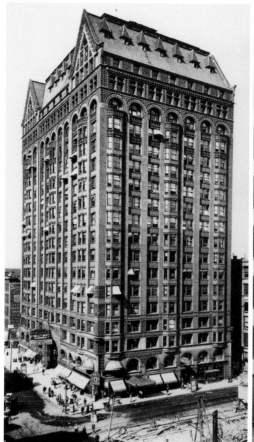

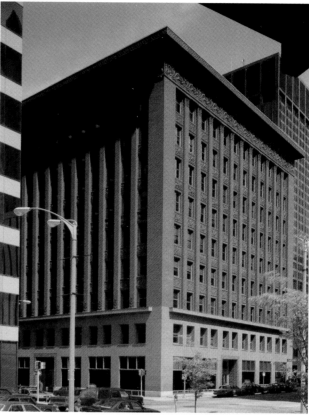

Burnham and Root, Masonic Temple, Chicago, 1891–92, demolished 1939

Louis Sullivan, Dankmar Adler, Wainwright Building, St. Louis, 1890–91

While the unstoppable structural and technical advances saw tall buildings reaching ever greater heights, the teaching and theory of architecture were not prepared for the arrival of this new structural design. Initially, the designs conformed to the conventional patterns of palace architecture. In other words, skyscrapers were already quite tall, but without their height becoming a feature of the design. Similarly, in the early days the new possibilities of construction—above all the liberation of the facade from its load-bearing requirement—had virtually no influence on the overall appearance. When it first started to evolve, there were as yet no theories relating to this new structural design. Accordingly, Louis Sullivan started to formulate a theory to match the architectural potential of the skyscraper. He wrote: "It must be tall, every inch of it tall. The force and power of altitude must be in it, the glory and pride of exaltation must be in it. It must be every inch a proud and soaring thing, rising in sheer exultation that from bottom to top is a unit without a single dissenting line."[1] To this day Sullivan's exhortations are still relevant in terms of the intended effect of a sky-scraper. And it was Sullivan who recognized—as early as 1891—the need for tall buildings to narrow (by means of set-backs) as they rise, in order to allow enough light into the street and into the buildings themselves, which were growing ever taller and more tightly packed.

Together with his partner Dankmar Adler, Sullivan created two important tall buildings: the Wainwright Building in St. Louis (1891) and the Guaranty Building in Buffalo (1895). He simplified the overall shape and accentuated the verticals by virtue of continuous columns running between the windows for ten stories. Despite their much more successful total de-sign, making a special point of their height, these buildings still seem solid and closed, and fail to take advantage of the possibilities of the curtain wall. In his thinking on skyscrapers, Sullivan also suggested that a tall building should be divided into three sections like a column, with a base, a shaft and a capital. For some time this view held sway. With the onset of modernism this principle gave way temporarily to the uniform box-shape, before making a comeback in postmodernist designs.

Tallest Buildings

At the time of the construction of the first skyscraper in Chicago, the question as to which was the tallest building in the world soon began to play an increasingly prominent part in public discussions. This accolade became a sought-after, prestigious trophy, which every building, client or city wanted to earn. Gustave Eiffel's tower for the World Exhibition in Paris set a breath-taking record in 1889 with its height of 984 feet (300 meters). Worldwide, it was the tallest man-made structure and even if it could not count as a building because it contained no usable surfaces, it could not have done more to excite fantasies of the coming architectural conquest of the skies. With the construction of the American Surety Building in 1896, designed by Bruce Price, New York claimed the title for tallest building and took the lead in the construction of skyscrapers. In contrast to generally closed, block-like structures, in New York there was initially a preference for "towers" such as the Singer Tower completed in 1908 (p. 36) or the Metropolitan Life Insurance Tower (1909). For the external look of a building, the architects—many of them having studied at the École des Beaux-Arts in Paris—drew heavily on European models. Thus, the tip of the Singer Tower echoes the corner turrets of the Louvre, the Metropolitan Life Insurance Tower follows the example of the Campanile of San Marco in Venice and the top of the tower of the Bankers Trust Company Building is a reference to the Mausoleum of Halikarnass. This historicizing stylistic pluralism in the design of skyscrapers continued with the Woolworth Building (p. 38) of 1913 through to the Chicago Tribune Tower (p. 40) of 1925, the exterior of which is influenced by examples of Gothic architecture in Europe.

With the rapidly growing number of skyscrapers, particularly in Manhattan, questions soon arose concerning their relationship to each other as part of a cityscape. Initially driven purely by commercial considerations, the advent of skyscrapers soon began to change the look of the modern city by leaps and bounds. The idea of the skyline as a composition incorporating a series of skyscrapers took hold, but this continued drive upwards brought about problems. If a new building outstripped its neighbors, the latter would now be in shadow

Gustave Eiffel, Eiffel Tower, Paris, 1887–89

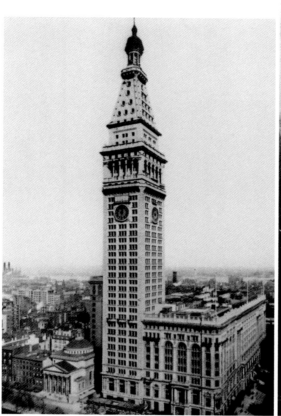

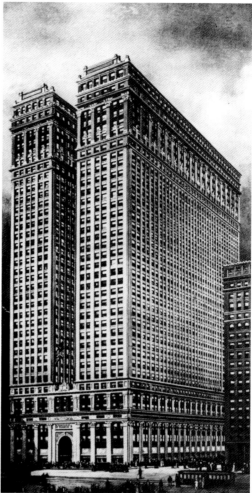

Napoleon LeBrun & Sons, Metropolitan Life Insurance Tower, New York, 1907–09

Ernest Graham, Equitable Building, New York, 1912–15

and its offices would by definition receive less light. This led to a decline in property values, rental rates and ultimately a decrease in tax revenues.

In 1908 Ernest Flagg, the architect of the Singer Tower, pointed to the urban problems that come with a rising number of tall buildings. In addition to the matter of one building overshadowing another, he already foresaw the ensuing increased volume of car traffic and problems that any fire would pose. But it was not until the construction of the Equitable Building in New York (1915) that changes were made in building regulations. With the construction of this building—the largest structure in the world in terms of its floor space—the limits to what could be tolerated were finally reached, since it overshadowed all its neighbors. As a result, in 1916 the City of New York passed its Zoning Law, which linked the heights of buildings to precisely prescribed set-backs. This law stated that the more a building receded towards the top, the higher that building could be. And if, after a certain height, its dimensions are no more than a quarter of the ground level floor plan, then its height is entirely unrestricted. This law crucially altered the aesthetics of subsequent new skyscraper projects and hence the shaping of the skyline too. Taking the terms of the Zoning Law as his guide, Hugh Ferriss (known for his visionary drawing of buildings and architecture) created his own influential visions of the next generation of skyscrapers.

One advantage not to be underestimated for the subsequent record-breaking projects in New York was the city's geological situation. Since the bedrock in Manhattan is not far beneath surface, foundations were easier to anchor than in the sandy earth of Chicago. Thus the next record heights could soon be set, quickly passing from one building to the next but remaining in New York for over sixty years. In 1908 the Singer Building held the record, only to be deposed the following year by the Metropolitan Life Insurance Tower. In 1913 the record was broken yet again with the completion of the Woolworth Building.

Hugh Ferriss, studies for the maximum mass permitted by the 1916 New York zoning law, 1922

With viewing platforms now available in various buildings, the public could participate directly in the breakneck upwards thrust, and cast their astonished gaze downwards on the skyline that was now rising faster and faster. On the 40th floor of the Singer Tower there was a viewing terrace, open to paying visitors. Similar arrangements also existed on the 46th floor of the Metropolitan Life Insurance Building and on the 55th floor of the Woolworth Building. While human beings used to look down from mountains—and then church towers—on the town below them, at these viewing points an increasing number of equally high or even higher structures would loom into view. From this elevated vantage point one could experience the skyline in a different way. The Woolworth Building not only claimed a new record height, it also set a completely new agenda with its fastest elevators of that time and its nocturnal illumination by floodlights. Exactly as the client had wished, it became a symbol of the commercial success of the company, and by association, a symbol of the city itself. The mythical character traits that the twentieth century skyscraper soon acquired have their roots in this building.

Visions in Europe

The first flowering of the skyscraper in Chicago and New York preceded the First World War and was watched with interest in Europe. It kindled the imaginations of architects dreaming of ever taller buildings. As early as 1908, Antoni Gaudí was already sketching a 1,181-foot (360-meter) hotel for New York. Although there were intense discussions on the construction of tall buildings in Europe around 1920, developments on the scale of what was happening in the United States were above all stalled by the conservative attitudes of European building regulators. Their intention was to prevent the traditional townscapes of historic inner cities from being destroyed. In the absence of tall buildings as a practical possibility, all over Europe—especially after the First World War—theoretical design solutions started to emerge. Auguste Perret, for instance, designed a visionary city with towers, and in Italy the futurists Antonio Sant'Elia and Marco Chiattone were dreaming of tall, machine-like structures. In Russia Constructivist architects designed skyscrapers as symbols of revolutionary progress. El Lissitzky's Cloud-Iron (1924–25)—a horizontal skyscraper—was amongst the most audacious fantasy structures.

A rendition of Antoni Gaudí's original drawing of Hotel Attraction, New York, project, 1908

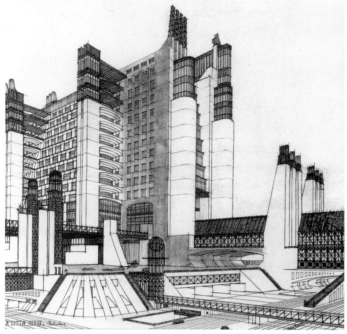

Antonio Sant'Elia, La Città nuova, project, 1914

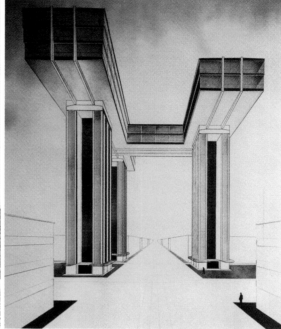

El Lissitzky, Cloud-Iron, Moscow, project, 1924–25

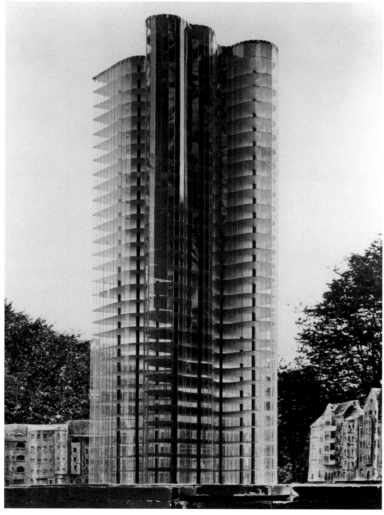

Ludwig Mies van der Rohe, model of glass skyscraper, project, 1922

One of the most influential contributions to the European debate on tall buildings came from Ludwig Mies van der Rohe. In the competition for a tower block at the Friedrichstrasse station in Berlin, he submitted a design for a glass-skinned, crystalline skyscraper. With glass as the emphatically dominant design feature, Mies was echoing the utopian ideas of the German architects and artists' group *Gläserne Kette* (Glass Chain). Mies's approach was far ahead of his time and still a long way from being technically possible. Nevertheless, Mies continued to work on his concept of a glass skyscraper, on paper and with a model. The publication and exhibition of his designs aroused a high degree of interest in his architectural visions. Beyond this, Mies also drew his colleagues' attention to the sheer beauty of the steel frame construction: "Only skyscrapers under construction manifest their bold structural thinking and one is overwhelmed by the impression of this towering steel skeleton. The cladding of the facades completely destroys this impression."[2]

The USA and Modernism

The triumphal arrival of modernism in Europe began in the 1920s, yet still no skyscrapers were being built there. European architects would travel to the United States to study the rationalization of construction methods and the latest technological advances. Yet, until well into the 1930s, the United States remained largely untouched by modernism, above all in the ongoing construction of skyscrapers. Although clients enthusiastically embraced technological innovation in the construction methods, in the provision of elevators and lighting, when it came to the outward appearance of their buildings they still clung to traditional design formulas. Ayn Rand's 1943 novel *The Fountainhead* revolves around exactly this conflict. And after traveling through the United States for two months in 1928, Walter Gropius remarked that, "There is no true American architecture yet."[3]

The first real contact with developments in Europe came with the competition for the Chicago Tribune Tower in 1922. Of the 204 proposals, over a third were from European entrants. Above all, the designs submitted by Adolf Loos and Walter Gropius seem to have been pointing to future developments. On one hand there was the clearly constructed, well proportioned modernist "box," and on the other hand their designs already used the expressive forms that postmodernism was later to rediscover in tall buildings. With the touring exhibition of competition entries, modernist European architects became known across the United States, far beyond Chicago. The first clearly identifiable reaction to the European submissions in this famous competition can be seen in the American Radiator Building in New York (p. 44). Although Raymond Hood, the winner of the competition, went on to realize his neo-Gothic tower in Chicago, at the same time in New York he was clearly inspired by the much more modern design proposed by the winner of the second prize, Eliel Saarinen. Hood learned from Saarinen how to give a building a coherent form and simultaneously to accentuate its height by carefully composed set-backs. With his Radiator Building, Hood set in motion a wave of Art Deco buildings in the 1920s which were to form a high point in the evolution of the skyscraper. The Barclay-Vesey Building (1926), the Fuller Building (1929) and the Daily News Building (1930) subsequently became the most important skyscrapers of that time, until Raymond Hood's McGraw-Hill Building set a new course leading away from Art Deco towards modernism.

The Chrysler Building (p. 46) and the Empire State Building (p. 50) mark the second flowering of the skyscraper. Both entered the race to become the tallest building, which was now a publicly celebrated event. The Chrysler Building became the first building to outstrip the Eiffel Tower, but was soon overtaken by the Empire State Building with its docking mast for zeppelins—although this never fulfilled that function. Nevertheless, it was the first time that

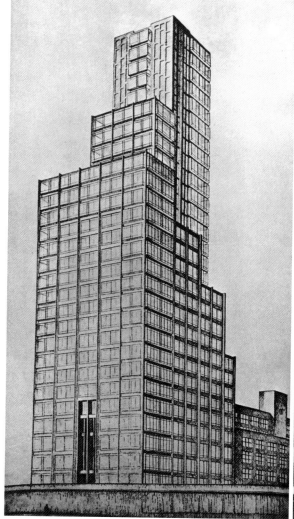

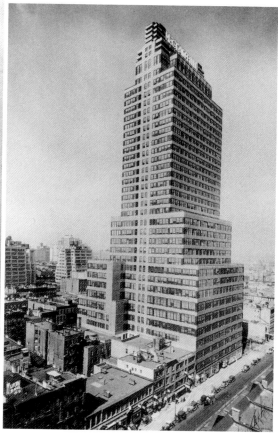

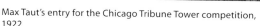
Max Taut's entry for the Chicago Tribune Tower competition, 1922

Raymond Hood, Godley & Fouilhoux, McGraw-Hill Building, New York, 1930–31

the futurist notion of accessing skyscrapers from the air at least became a concrete intention. Both of these buildings still basically adhered to Sullivan's concept of a three-part structure and to the typology of tall buildings specific to New York. Both the Chrysler Building and the Empire State Building had public viewing terraces. In the case of the Empire State Building, which was completed during the Depression, the admission fees charged to the many visitors at least provided a small income while the offices remained largely vacant. In terms of skyscraper design, the Empire State Building marked the end of the traditional steel frame construction, and it remained unchallenged until the 1970s because this type of construction was simply too expensive upwards of a certain height.

The record height of the Empire State Building was and still is, very special for a variety of reasons. It stood unchallenged for over forty years, the longest reign of any skyscraper. Yet it also marked the stylistic finale of the Art Deco skyscraper. The Rockefeller Center (p. 56) soon signaled the arrival of a new concept: the idea of a comprehensively composed group of skyscrapers as a "city within a city." With its newly created open areas and roof gardens, with its plaza and concert halls, the Rockefeller Center really did become a skyscraper city. It showed how a clever mix of functions and the planned integration of skyscrapers into their setting could create completely new urban spaces. Not long afterwards, William Lescaze's PSFS Building in Philadelphia (p. 54)—with its flat roof, powerfully defined verticals and asymmetric sub-sections—marked a crucial stage in the stylistic progress of the skyscraper towards modernism. This and Hood's McGraw-Hill Building were the only tall buildings to be included in the 1932 exhibition *Modern Architecture: International Exhibition* at the Museum of Modern Art, New York, organized by Philip Johnson and Henry-Russell Hitchcock. The accompanying

Frank Lloyd Wright, One-Mile-High
Skyscraper, project, 1956

publication, *The International Style: Architecture since 1922*, constitutes the first triumph of the skyscraper in the literature and in the reception history of architectural styles.

Particularly after 1933, political developments in Europe drove an increasing number of modernist architects to seek refuge in the United States. In 1937 Walter Gropius accepted a chair at Harvard; in 1938 Ludwig Mies van der Rohe became director of the Illinois Institute of Technology in Chicago. Soon after the Second World War, Mies was able to realize his long-nurtured ideas on the construction of skyscrapers. His Promontory Apartment Building (1949), using concrete-frame construction, was soon followed by the Lake Shore Drive Apartments (p. 62). These represent the first modern apartment block and the earliest example of a double tower. By positioning the two towers neither symmetrically nor parallel to one another, but slightly apart, Mies created a dynamic design which still exerts a palpable influence today. This same idea was used for the World Trade Center and most recently a similar design was devised by Massimiliano Fuksas for his Vienna Twin Tower (Vienna, 2001).

By 1969 Mies had planned and realized a total of fourteen tall buildings. Early on, however, the design of the Seagram Building (p. 66) already achieved an architectural quality that could never be surpassed. Together with the Lever House (p. 64)—facing the Seagram Building and completed just a few years earlier—they became the two main archetypes for future developments in skyscraper construction. These two alternatives comprised a dark, glazed box with bronze braces, creating the impression of an elegant sculpture, or the bright, glazed transparent box, which revealed its internal structures. In both cases, the connection with the urban setting at street level is of particular importance. Lever House created a public open space underneath itself by being raised up on stilts, while the Seagram Building was set well back from the edge of the street, opening up a public space in the front. In fact, this marked the introduction of the public plaza which is still repeated the world over as the skyscraper's tribute to the city. This design solution was subsequently incorporated into the new building regulations passed in New York.

Both the Seagram Building and Lever House continued to use the tried and trusted steel frame, which long remained the standard construction method for

tall buildings. Meanwhile Frank Lloyd Wright was developing a different method. His Johnson Wax Research Tower (p. 60) was constructed in the shape of a tree, with the floors extending outwards from the central trunk like branches. This idea was only taken up by others much later, for instance by Bertrand Goldberg in his Marina City in 1964. Wright himself furthered this concept in the Price Tower in Bartlesville (1956). It would also have formed the structural basis of his visionary project for a One-Mile-High Skyscraper (1956). This super-skyscraper formed the center of his utopian vision of Broadacre City and was designed as a multi-functional structure. No doubt the presentation of this project was an attempt to give visual form to the dreams of the unlimited potential of the skyscraper of the future. But the idea of realizing a structure whose foundations would have to go as deep as the Empire State Building was tall, went far beyond was what conceivably possible. Yet the effect of this utopian project on the imaginations of many architects should not be underestimated.

In the years after the Second World War, in many places in Europe there was a shift in public attitudes to the construction of skyscrapers. With the Torre Pirelli in Milan (p. 70) and the Thyssenhaus design in Düsseldorf (p. 76) an early form of European skyscraper appeared on the scene. In the case of the Torre Pirelli, it was Pier Luigi Nervi's concrete construction that gave the building its elegant, yet highly dynamic look. The Thyssenhaus owed both its construction and its facade to existing American buildings. But the ground plan and the composition of the volumes have an elegance that also attracted attention in the United States. From the start, the formal design of skyscrapers in Europe was shaped by very different building regulations to those that applied in the United States. These included the stipulation that no workstation should be more than 23 feet (7 meters) from a window. Consequently, the ground plans for the floors could not be as generously laid out as in the United States, where a distance of up to 65 feet (20 meters) was allowed. European tower blocks therefore remained very narrow. The SAS Royal Hotel, built in Copenhagen in 1960 (p. 72), is relatively modest in terms of its height, but nevertheless stands as an important European design solution bearing some of the hallmarks of its American precursors. From its subtle connection to the city to its elegant resolution of the check-in area, to the restaurant and lamps on the bedside tables all of this contributed to the making of a hightly respected architectural *Gesamtkunstwerk*.

Initially, the 1960s saw no major innovations in the evolution of the skyscraper. Even the race to be tallest building seemed to have been forgotten. Now the modern skyscraper set the standard almost all over the world with between fifty and sixty floors on average. Mies's students disseminated his teachings without adding new perspectives that would have moved his ideas on. The Richard J. Daley Center in Chicago (1965) is one of a number of skyscrapers directly influenced by Mies, as is the Lake Point Tower (p. 84) of 1968. The only student to offer an interesting new impulse was Bertrand Goldberg with his Marina City (p. 78). His urban concept of reclaiming living space in the city by radically combining it with cultural provision even to the extent of including a private jetty was exemplary. However, his ideas fell largely on fallow ground. The rounded ground plan—with considerable advantages in terms of structural stability in the face of winds blowing against the facade—formed the basis of the first important skyscraper in Australia, Harry Seidler's Australia Square in Sydney (p. 82). A student of Gropius and Breuer, Seidler—with the help of Pier Luigi Nervi—created a structure that was both dynamic and elegant and graced by a lively public plaza. This paved the way for the development of a skyline in Sydney which has since become one of the most memorable worldwide.

New Records

The construction of the John Hancock Center in Chicago (p. 88) in 1969 marked a new phase in the evolution of the skyscraper. In the same year that a space mission landed on the moon, architecture was also striving to reach new heights. At that time belief in technological progress was almost limitless and the simultaneous development of the jumbo jet (Boeing 747) and of the supersonic passenger aircraft Concorde further testified to this. The new departure in skyscraper design was based on a new structural concept developed by the engineer Fazlur Khan. His braced frame tube system meant that the John Hancock Center came dangerously close to the record height of the Empire State Building while at the same time requiring significantly less steel. Meanwhile Minoru Yamasaki was using a rigid frame tube for the World Trade Center (p. 94). So in the early 1970s, the race for the world record was on again, and in 1972 the World Trade Center won it for New York for a short period of time. However, with the construction of the Sears Tower (p. 96) the title returned to Chicago for the next twenty-three years. The Sears Tower used another system devised by Fazlur Khan, namely the bundled tube; the architectural design was by Bruce Graham of Skidmore, Owings and Merrill.

Although the new super-tall skyscrapers used revolutionary features in their construction methods and attracted worldwide attention with the records they set, nevertheless in terms of their aesthetics they provided little that the public could identify with. Moreover their connection with their urban surroundings was generally not carefully conceived. The Twin Towers of the World Trade Center stunned observers by their immense height combined with a minimalist design. Although they were sharply criticized on all sides for their monumentality, nevertheless with the viewing terrace on the South Tower and the "Windows of the World" restaurant they established themselves as one of the main sights of Manhattan. By contrast, the Sears Tower at least attempted to make design sense of its unimaginable height by the set-backs of its tower tubes. But it too—a dark sculptural form—proved to be an architectural monument that few could identify with.

However, the concurrent construction of the Transamerica Pyramid in San Francisco (p. 92) was the first expression of a newly awakened interest in eloquent forms, a legible vocabulary and references to architectural history. At first the 1970s were dominated by cuboid structures—usually with a flat glass skin and often reflective like mirrors—such as the United Nations Plaza in New York (1976), the John Hancock Center in Boston (1976) by Pei Cobb Freed & Partners or the Westin Peachtree Plaza Hotel in Atlanta (1976). While these crystalline sculptures often provided large internal public spaces in glazed atriums, as in the IDS Center in Minneapolis designed by Johnson/Burgee Architects in 1973, externally they looked at best like well-designed or not so well-designed boxes with no real connection to their urban setting. Only the Citicorp Center in New York (p. 98), with its sunken Plaza, departed from the usual schema because the neighboring parish expressly demanded that they should. With its slanting roof, in fact intended for solar panels, the building acquired almost by chance a profile that was readily identifiable on the skyline.

Proliferation

Since the 1970s, skyscrapers have increasingly appeared in other North American cities and in other countries. Thus, a major architectural practice like SOM Skidmore, Owings and Merrill could find a worldwide market for its specialist experience in the construction of tall buildings. Like other cutting-edge technological products, skyscrapers were increasingly regarded as symbols of a nation's economic prowess. The building of the National Commercial Bank in Jeddah (p. 100), designed by Gordon Bunshaft, who also created Lever House, is one of the

legendary status above all by overtly connecting with its utopian potential, which in turn made it into a global measure of success. Modernist skyscrapers—both in their form and concept—owe much to the critical input from Europe. But with its proliferation and commercialization it has progressively lost its mythology. The striving to set new records, which was intrinsic to the skyscraper from the outset, is embodied an enduring drive to constantly advance its design. Each record paved the way for the next, but in so doing also degraded all its forerunners. Even if the skyscraper, in terms of its concept, is by far the most forward-looking architectural structure of all, it is still important that historically significant examples should be protected and restored like any other historic monument. In the case of both Lever House and the Thyssenhaus, for instance, the renovations could even still be directed by the architectural firms that originally created these buildings.

With the successful spread of capitalist economic systems, by the end of the twentieth century, a growing number of countries were able to participate in the symbolic race for the tallest building. And it became evident that, despite the skyscraper having originated in the United States, it has the capacity in very different countries and places to fulfill its role as a structure representing a particular region or nation, as a "signature building." There is still a great deal of mileage in the mixed-function skyscraper. Consequently its potential for development is still a long way from reaching its limits. And in the future, too, skyscraper designs will still be about the fascinating appeal of the record for the tallest building in the world. But at the same time, new typologies will make their mark, no longer relying on the overwhelming symbolic effect of a single, isolated structure.

Most scientific or technological records—such as the moon landing or Martian exploration—are only ever a mediated experience for most people. On the other hand architectural records set by skyscrapers, bridges and cathedrals open up the possibility of a direct physical experience and of individual participation. This is also the reason why so many skyscrapers, ever since the early days, have public viewing platforms. For since time immemorial

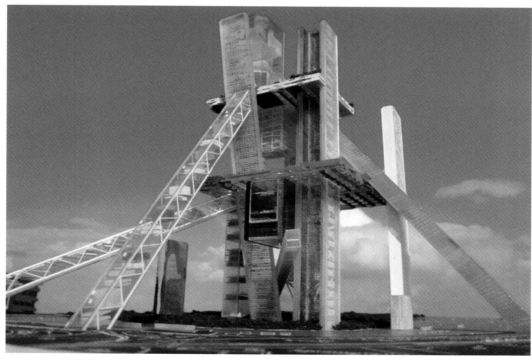

OMA Office for Metropolitan Architecture, Hyperbuilding, Bangkok, study, 1996

Race to the sky
On the last day of August 2003 for the first time since the website skyscrapers.com was launched, the number of Asian high-rise buildings in its database passed the number in North America. This website is the largest database on high-rise buildings (35 meters and higher) with a list of 76,648 skyscrapers. The change at the top is accelerating. On October 17th 2003 the final structural beam on the Taipei 101 building was raised into place, making it the world's tallest building. More than 50 meters taller than the world's former highest office building, the Petronas Towers in Kuala Lumpur, Malaysia and drawers are full of plans for even higher structures. The most famous latest announcement came from New York where at the place of Ground Zero a 541meter high building should be erected.
Ironically, the highest building under demolition in the database of skyscraper.com is the "Tour Lotto" in Brussels with 23 floors, which will be replaced by the "Central Plaza" building (14 floors).

Urbanization Rate
< 20 %
20 - 40 %
40 - 60 %
60 - 80 %
> 80 %

Map showing the distribution of skyscrapers around the world (from *Content* by OMA/AMO, 2004)

humans have felt a deep desire to look down on their everyday surroundings from above, longing for the ever liberating, elevating self-awareness that comes from seeing the bigger picture. As far back as 1336 Francesco Petrarca climbed up Mont Ventoux and reported afterwards on the taxing ascent and his subsequent amazement. Skyscrapers are not only a source of amazement at street level, they also often offer humans a chance to effortlessly scale a certain height by means of a breath-takingly fast elevator. Skyscrapers are symbols of major economic, structural and architectural achievement. And they give large numbers of people the chance not only to enjoy dizzying heights for the short duration of a unique view, but also to live, to work and to eat together in man-made chains of architectural peaks. They are an endlessly progressing, self-fulfilling utopia.

1 Louis Sullivan, "The Tall Office Building Artistically Considered," in *Lippincott's Magazine*, March 1896.

2 Ludwig Mies van der Rohe, "Hochhausprojekt für Bahnhof Friedrichstraße in Berlin," in *Frühlicht*, 1 / 1922,

 as cited in Fritz Neumeyer, *Mies van der Rohe, das kunstlose Wort*, Berlin 1986, p. 298.

3 Winfried Nerdinger (ed.), *Der Architekt Walter Gropius*, Berlin 1985, p. 20.

4 Rem Koolhaas, *Content*, Cologne 2004, p. 474.

On the New Edition

Since this book first appeared, a number of new high-rise projects have been announced worldwide. Many of these, as so often happens, will merely remain studies for projects and disappear into the investors' desk drawers; high-rise projects are often only used for self-promotion and image-building. Some of the announced projects are formal *jeux d'esprit*, crooked or even twisted "gherkins" that demonstrate only the technical possibilities of our times and at the same time attempt sensationally to draw attention to themselves. But the tendency, already recognizable since the turn of the millennium, for more and more countries outside the USA to take over the lead in the area of record buildings continues. The title of tallest skyscraper seems forever lost for the USA. Meanwhile the Asian and Arab countries compete with enormous financial and political energy in the race for new records. Sometimes the political arguments for these buildings even seem to shut out all others. For example, the continuing discussion on the planned Gazprom Tower in St. Petersburg, with architects such as Jean Nouvel, Massimiliano Fuksas, Herzog & de Meuron, Rem Koolhaas and Daniel Libeskind taking part in the competition, make it clear that Russia too is now decisively seeking a way to enhance its international profile by means of spectacular high-rise projects. In the case of St. Petersburg this is linked with the reckless endangerment of the world cultural heritage of its old city. Even the architects taking part in the competition seem to ignore any moral consciousness of architectural history. The Federazija Tower by the architects Sergei Tchoban and Peter Schweger in Moscow is currently under construction and at about 360 meters in height will become the tallest building in Europe.

With the almost countless numbers of newly announced projects it becomes clear that architects such as Norman Foster are continuing to build up their global presence but, at the same time, no longer find any conceptually new solutions for high-rise building. And even Rem Koolhaas, who after all had only recently announced the "death of the high-rise," has announced at least four new international high-rise projects. His change of heart however has not resulted in any new architectural approaches. And New York? As much as seven years after the attack of September 11, nothing decisive has happened on the site of the World Trade Center. In the meantime the World Trade Center 7 has appeared at its edge and is considered, like the Hearst Tower in New York, to be an example of "green" architecture and has managed to score well with the Leadership in Energy and Environmental Design (LEED), a green building rating system developed by the US Green Building Council. The Bank of America Tower (p. 154) will further underline this tendency toward ecological high-rises and set even higher standards. This was a further decisive reason for resuming work on this building. If in the 21st century there are no more height records with which New York could take up a leading position in high-rise building, it could now at least provide a model of sustainability. In view of the prognoses for the future of the world climate, this would certainly be an important stimulus for the uninterrupted further development of skyscrapers.

500

1,500

400

1,000

300

200

500 feet

100 meters

Reliance Building

Chicago, Illinois, USA

Burnham and Company

1890–1895
202 feet / 61 meters

Detail of the facade with so-called Chicago windows

The devastating fire of 1871 in Chicago was followed by a major building boom, both to replace lost office space and to meet growing demand. Investors demanded high-rise buildings which could be constructed speedily and whose interiors could be divided up as flexibly as possible, which would make the expensive sites profitable. Thus, within a short period of time in the 1880s, the high-rise building type was developed, with a steel frame construction as a load-bearing framework and continually improving elevators for interior access. The structural advantages of the interiors were, however, at the outset employed in a manner that was hardly creative. After Holabird and Roches's Tacoma Building (1889, demolished 1929), the Reliance Building was one of the first that made the new technological possibilities clearly evident from the street-level viewpoint.

The building was erected in two phases. The ground floor, with its large storefront windows, and the second floor were designed by John Root. The floors above these were executed by Charles B. Atwood, who succeeded Root as chief designer in the Burnham office after the latter's death in 1891. The resulting change in architectural language is still noticeable today. The ground floor is clad in a dark color and is totally without ornamentation, while the facade of the thirteen office floors is designed in an unusually open and transparent

manner. Here, Atwood makes creative use of the bay window-like "Chicago window" developed by Burnham and Root. A large, unopenable glass panel is centrally placed in front of the level of the facade, while two narrow, slanting windowpanes placed at the sides can be opened. The remaining facade surface between the large window areas is covered with light-colored terracotta panels decorated in the neo-Gothic style.

The facade is placed as far as possible in front of the steel frame construction and can be seen as an early example of the curtain wall. At the corners, where the load-bearing construction could not quite be hidden, two linked pillars are placed diagonally and by using stylistic techniques borrowed from the Gothic, give a lighter appearance to the otherwise weighty-looking edge of the building. The facade, with its almost exclusive emphasis on the horizontal, curving slightly back and forth, together with the wide window apertures, gives the building a decidedly modernist appearance. This becomes abundantly clear in relation to contemporary high-rise buildings such as the Wainwright Building in St. Louis, Missouri (1891) and the Guaranty Building in Buffalo, New York (1895) by Adler & Sullivan. These still emphasized the vertical in their facades as a means to make the division of forces more comprehensible. The Reliance Building can be described as the first of Chicago's skyscrapers still in existence that reveals externally the advantages of steel frame construction developed by its predecessors. It clearly anticipates the "dematerialization" of the facade as load-bearing wall, a development that would not take hold for about another thirty years.

Historical postcard

The facade of the Reliance Building already utilises the advantages of steel construction for greater transparency

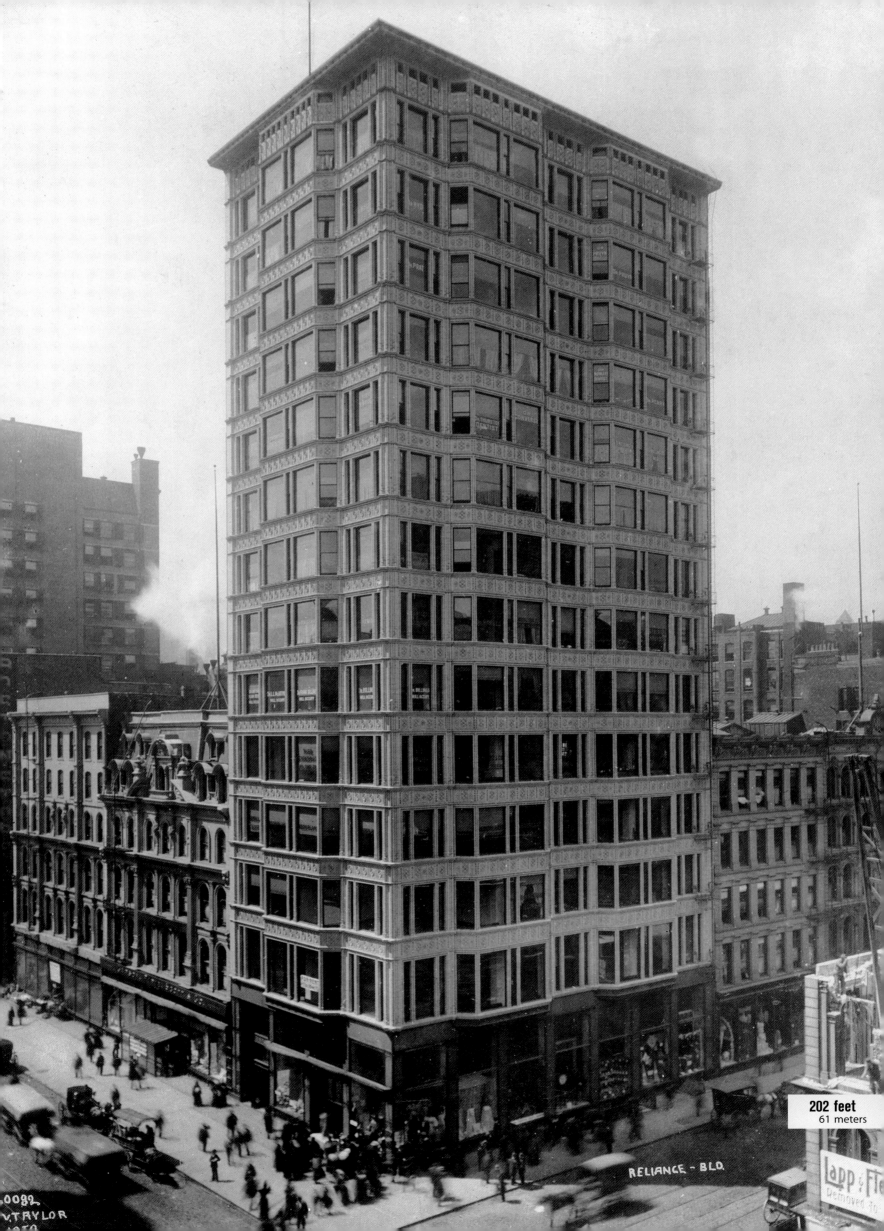

202 feet
61 meters

RELIANCE - BLD.

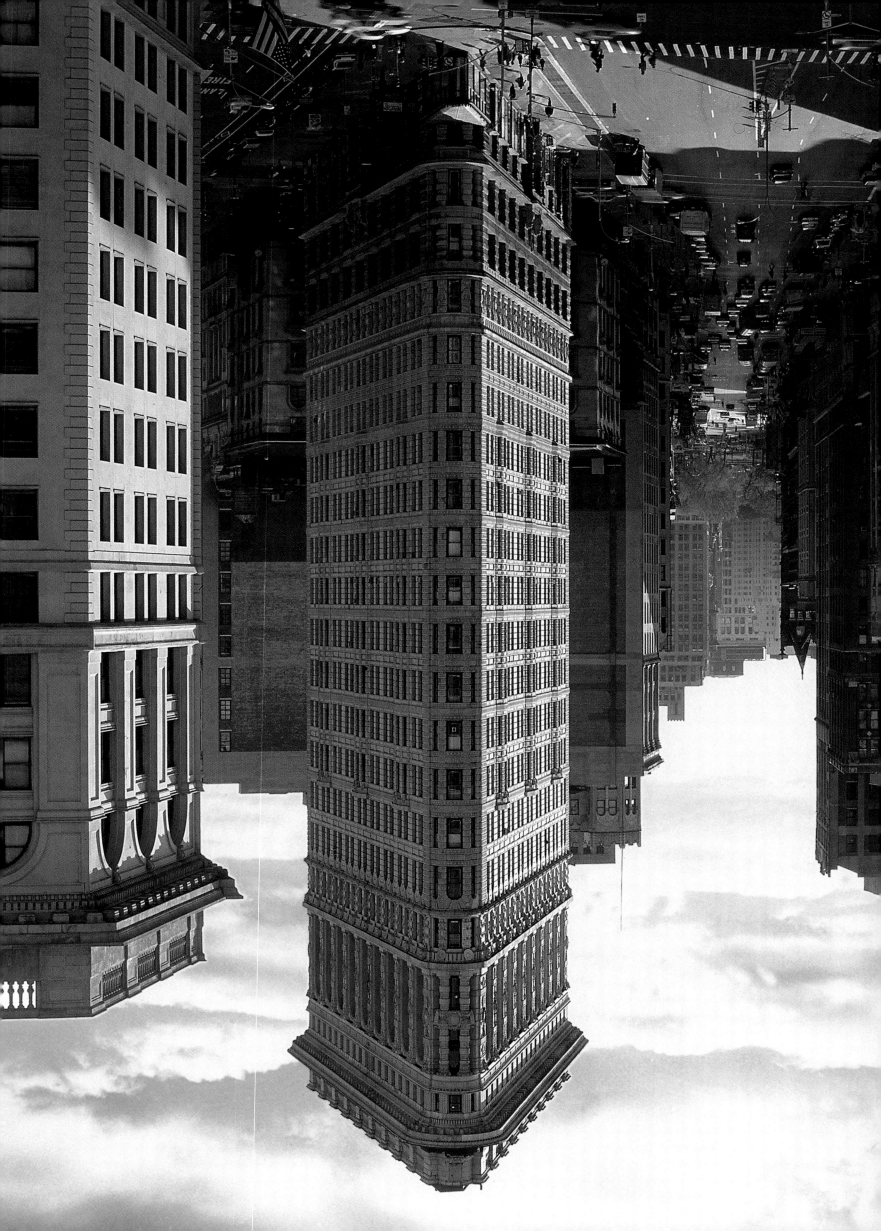

Flatiron Building New York, USA

Daniel H. Burnham & Co.

1901–1903
285 feet / 87 meters

In the chessboard-like street plan of New York City, the diagonal of Broadway produces several extremely acute-angled sites, such as that of Times Square. South of Madison Square Park there is such a space between 22nd and 23rd Streets at the junction with Fifth Avenue. Here, between 1901 and 1923, the steel construction company George A. Fuller Co., which moved from Chicago to New York, together with the architect Daniel H. Burnham, also from Chicago, built one of the most striking office buildings in New York. It was given the name of the Fuller Building, but because of its shape, sharply tapering northwards, it acquired the nickname Flatiron Building. This soon became established as its official name, which it bears up to the present day. The Fuller Company sold the Flatiron Building only a year after its completion, but nevertheless moved into it themselves. They remained active in real estate up to 1994 and built many more large buildings in New York, such as Lever House (p. 64).

From the city-planning point of view, the Flatiron Building site was as problematic as it was favorable. The site, which is very pointed, hindered optimum use of the space. On the other hand, it had the great advantage that between Broadway and Madison Square Park it was almost isolated as a single building in the structure of the city. Its architect, Daniel H. Burnham, who with his office was responsible for the design of the World Columbian Exposition of 1893 in Chicago, once again followed in the exterior design the tradition of the revival of historical forms of architecture in the Beaux Arts style. The Flatiron Building is accordingly in the tra-

dition of the early skyscrapers, with the usual structuring in three parts: a five-story base (in this case clad entirely in limestone), a twelve-story central section, and a four-story top section. The very flat, eight-story bay windows are a striking feature—a type more common in Chicago than in New York. The rich ornamentation and the many architectural decorations lend the facade the surface of a decorated jewel-box.

The Flatiron Building was built on a fully load-bearing steel skeleton, but was by no means, as is sometimes claimed, one of the first buildings constructed in this way in New York. Since the 1890s there had been many office buildings with a steel-skeleton structure in the city, including the Park Row Building, which at 581 feet (177 meters) was

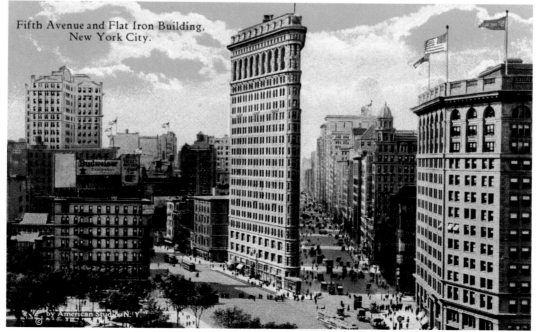

Fifth Avenue and Flat Iron Building, New York City.

Historical postcard

285 feet
87 meters

Detail of the facade, decorated in the Beaux Arts style

the tallest building in the world between 1899 and 1908. The narrow and isolated site necessitated a particularly strong reinforcement of the steel skeleton, in order for it to withstand the high winds encountered at that location.

Because of its unusual shape, its freestanding position and its rich decoration, the Flatiron Building soon rose to become one of the landmarks of New York. For a long time it was the tallest building north of the Financial District. The photographer Alfred Stieglitz contributed to its almost legendary charisma. He photographed it a number of times, and said: "The Flat Iron is to the United States what the Parthenon was to Greece." (Dorothy Norman, Alfred Stieglitz, *An American Seer*, New York, 1973, p. 45)

Ground plan

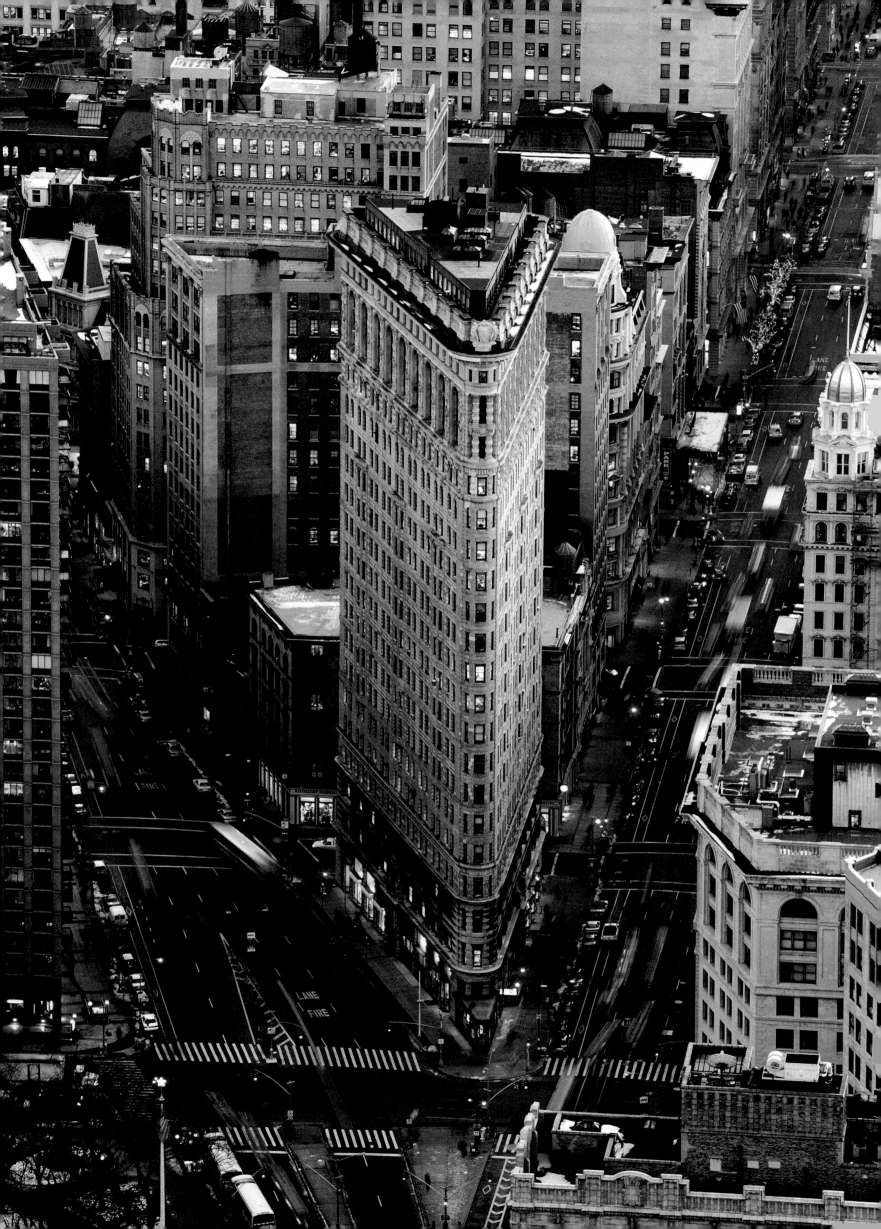

Singer Tower New York, USA

Ernest Flagg

1906–1908, demolished 1968
614 feet / 187 meters

The Singer Tower established a new height record for skyscrapers in New York. As early as 1906 the Singer Sewing Machine Company had announced its intention to outdo all previous high-rise buildings in the Financial District of Manhattan with its planned administration and office building on the corner of Broadway and Liberty Street. On its completion in 1908 it succeeded in doing so, but only for a short time, for a mere year later the record would be broken by the Metropolitan Life Insurance Tower.

The Singer Tower can be considered a typical example of the tower high-rise in the Beaux Arts style. However, the slender tower with its lightly corbelled, lavishly decorated spire was more reminiscent of a lighthouse. Structured with light-colored bands, it strongly stressed the vertical; only three horizontal bands were inserted, every five stories. The four corners, each with only one window, appeared particularly strengthened with respect to what the structural stability suggests on the exterior. The tower structure itself does not rise freely from street level, but only above the 15th story from the center of a complex of two lower structures, which had been built earlier, also by Flagg. Before the tower was built, he had to bring these buildings to an equal height. The static construction and anchoring presented a major challenge on account of the building's slenderness in relation to its height. At this location the basic bedrock is 91 feet (28 meters) below street level, and in between there were clay, sand and other non-load-bearing strata. The tower also had to be protected in particular from high winds, and indeed it did stand firm against the powerful winds of 1912 with gusts as high as 87 miles per hour (140 kmh).

Ground plan

In spite of its complex planning, the building of the Singer Tower, from the excavation of the foundations to the opening, took just twenty months. The Singer firm reserved the right to use the top stories of the tower itself—including the six floors in the lantern of the tower—and to rent out only the stories below the 31st. Nevertheless, some attention was given to the public's need for a "view from above." A viewing platform for visitors was constructed on the 40th floor, with an admission price of 50 cents. The Singer Tower became the standard for the zoning law of 1916, because the tower took up only twenty-five percent of the surface of the site. This was established as the basic requirement in the future for all building projects of unlimited height.

The Singer Tower only briefly retained the height record, but on account of its rich decoration it remained one of the sights of the city for some time. In 1968 it achieved one more record, as the tallest building in the world ever to have been demolished.

Opulent initials of the Singer Company in the interior of the building

Richly decorated cornice of the twelfth floor

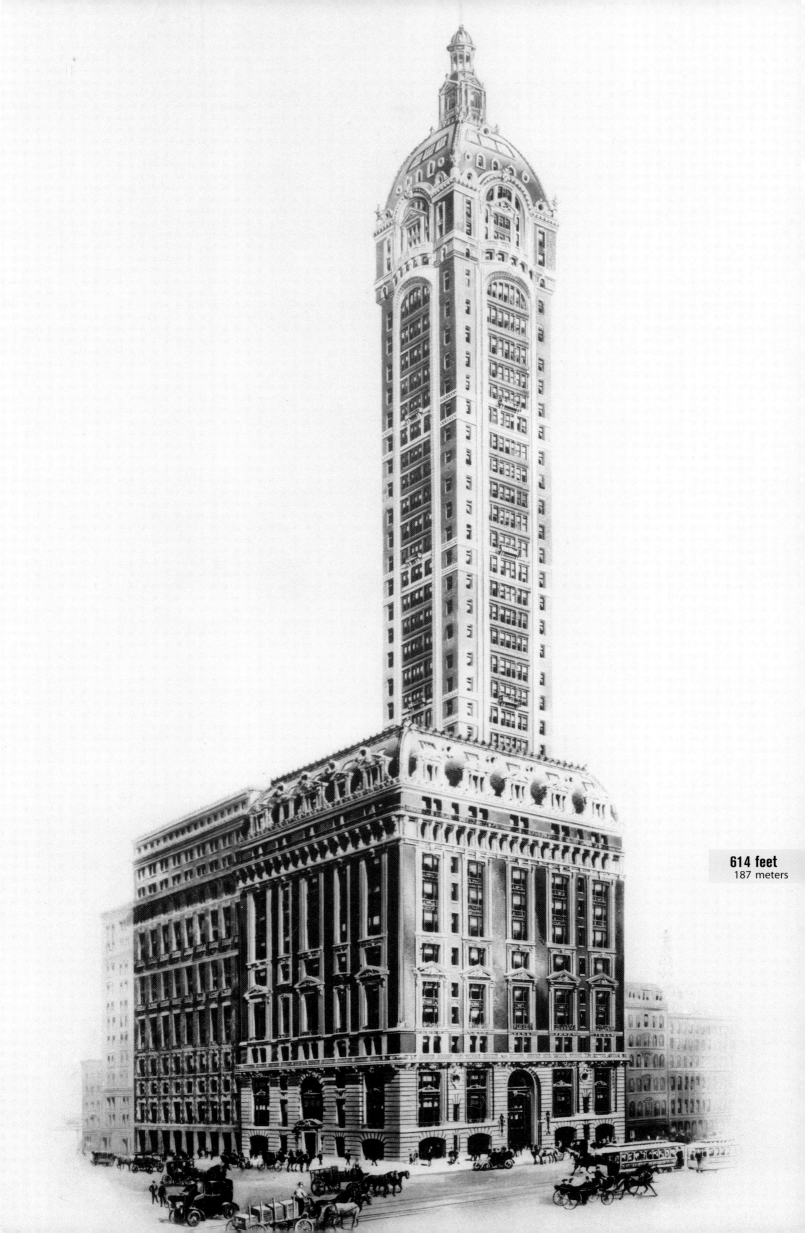

614 feet
187 meters

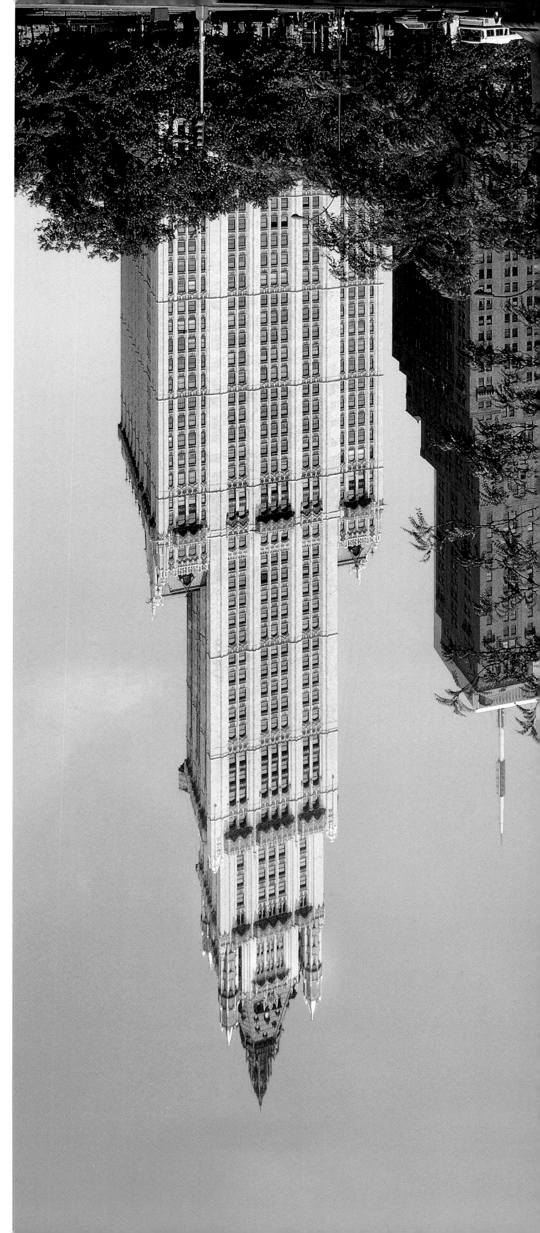

Total view of the building

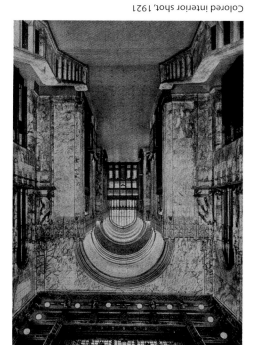

Colored interior shot, 1921

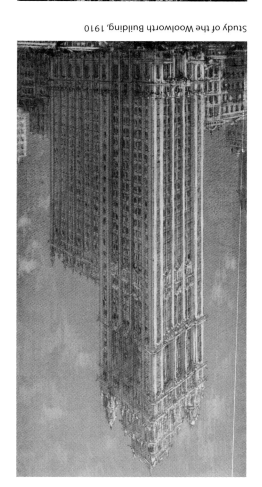

Study of the Woolworth Building, 1910

Woolworth Building New York, USA

Cass Gilbert

1910–1913
792 feet / 241 meters

Frank Winfield Woolworth founded his company in 1879 with the intention of selling a wide range of goods in his retail stores at low prices, for five or ten cents. But the unique success story of his enterprise also rested on a number of new social developments, such as paid vacations and Christmas bonuses, which served to motivate his staff in exemplary fashion. About 1910, when his empire encompassed more than 600 stores, Woolworth made plans for a new administrative office building. His openly declared vision was that his building should outdo the Metropolitan Life Insurance Tower in height by 50 feet (15 meters) and at the same time provide the city with a new landmark.

The site on Broadway, opposite City Hall Park and diagonally across from the Park Row Building, gave him the opportunity to develop a building with a showpiece facade that was effective in city-planning terms. In Cass Gilbert, Woolworth chose an architect who had a few years earlier built another notable high-rise building, the West Street Building (1907). Together with his client, Gilbert developed a building program that aimed at the optimal use of space, making use of the latest technological advances of the day.

The laying of the foundations was very problematic because at this location the load-bearing bedrock lies on average 115 feet (35 meters) deep. The structure above was created as an extremely stable steel skeleton. The structural volume was from the start arranged to achieve to the best possible effect with regard to height and distance of the tower, which was positioned to the east. On a base of 30 stories, open at the rear in a U-shape to allow light to enter the office space, the tower rises in the center of the street facade to a height of a further twenty-three stories. For the outer facing of the steel skeleton, Gilbert reverted to the language of forms of the late Gothic period. For him, the so-called "Flamboyant" style was the most appropriate model for expressing the aspiration toward height in architecture. Through the set-backs from the 30th story upward, the tower remains recognizable at street level as a uniform structure. From the 45th story on, a set-back begins whereby the tapering, rectangular tower becomes an octagon with four finials at the corners and is crowned by a pyramidal, copper-covered roof with lantern top.

The legendary effect that the Woolworth Building was able to exert for such a long time is attributable not only to its exterior form but also to the interior decoration of the lobby, as well as the unusual concept of its extravagant nocturnal lighting. The cruciform floor plan of the entrance lobby cer-

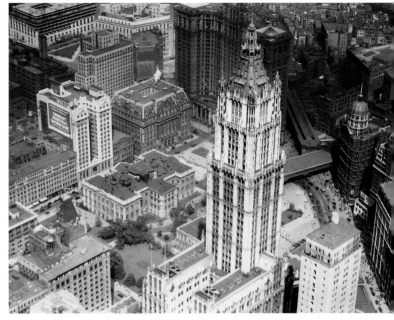

Historical view from above

tainly resembles that of a cathedral, and, in contrast to the Gothic language of forms of the exterior, it is decorated in the Romanesque style. While the walls are clad with veined marble from the Greek island of Skyros, the barrel-vaulted ceilings are adorned with mosaics in the style of early Christian examples. The architect, Cass Gilbert, immortalized himself and his client as well as other individuals involved in the building, in the form of allegorical stone caricatures.

In the Woolworth Building, built shortly before the First World War and the zoning law of 1916, the initial heyday of high-rise building in New York came to a brilliant conclusion. Gilbert succeeded in following his client's ambitious guidelines and developing exactly the type of high-rise building that was to be influential over the years that followed. Architecture became the widely visible symbol of the striving for industrial success. But in the end it was not the record height of this building that was the decisive argument for its lasting success. Rather, it was the combination of perfect proportion and the most advanced technology, traditional decoration and contemporary comfort upon which the legend of this building was based. And after the Woolworth Building, the self-confident positioning of a building in the urban planning context became increasingly a leitmotif for the high-rise projects that followed. Only the economic situation could, for a time, hold up the further triumphal progress of the skyscraper—its singular and symbolic significance as a new building type in the twentieth century was inscribed in exemplary fashion in the American sense of national identity by the Woolworth Building.

792 feet
241 meters

Chicago Tribune Tower
Chicago, Illinois, USA

Raymond Hood and John M. Howells

1922–1925
463 feet / 141 meters

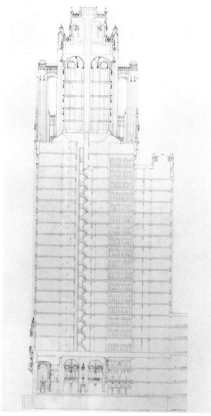

Cross section of the building

"There never has been such a contest and it is very doubtful that there ever will be another." (Editorial page of the *Chicago Tribune*, December 3, 1922.)

The office tower of the Chicago Tribune newspaper became world-famous primarily as a result of its planning. For the building, completed in 1925 and designed by Raymond Hood and John M. Howells, represents neither a record height nor a particular stylistic innovation.

On June 10, 1922, the Chicago Tribune, on the occasion of its 75th anniversary, announced an international architectural competition for its new administrative building. The site, directly opposite the Wrigley Building completed in 1924, had a surface area of only about 98 x 131 feet (30 x 40 meters). In order to provide for the required floor area, the only solution was a tower structure. The competition requirements followed the strict local building code. The site could be fully built upon up to a height of 180 feet (55 meters), above which the building had to be set back, with a maximum permissible height of 393 feet (120 meters). The closing date for submitting designs was November 1, extended by one month for submissions from abroad. The prize money amounted to a hefty $100,000, of which $50,000 was set aside for the first prize alone—an enormous sum in those days.

Ten American architectural offices had been directly invited to compete by the Chicago Tribune, particularly those which already had experience in building offices. The competition entries had to be submitted anonymously.

By the deadline of December 1 a total of 204 designs had been submitted; a further 95 followed and were disqualified. The jury, however, did not wait for the deadline to arrive, but reached a preliminary decision on November 13 in favor of submission number 69, the design by the New York office of Hood and Howells. While the submissions from Europe were delayed because of the long postal route, the jury continued to sit, and confirmed the decision that had already been made. Only the arrival of a submission from Finland on November 29 persuaded them to award the second prize to Eliel Saarinen. In the end, after further discussion, the first prize was indeed awarded to Hood and Howell, and they received the commission to execute the design. While the jury was convinced that it had commissioned "the most beautiful and distinguished office building in the world," in 1923 the architect Louis H. Sullivan criticized what he considered to be a glaringly mistaken decision. He considered the submission by the second-prize winner, Saarinen, to be the more important design. The chief prizewinners were not unaffected by this dispute. A few years later, their design for the Daily News Building in New York was modeled on Saarinen's design for Chicago.

The competition for the Chicago Tribune Tower became famous above all for the many contributions from Europe. Among others, there were five from Austria, seven from France, nine from Italy and as many as thirty-seven from Germany. The comparison of many of these designs makes it clear to what extent architectural practice in America around 1925 was still limping behind contemporary developments in architectural modernism in Europe. The Bauhaus and its consequences had not yet reached the USA. Most American competition entries relied for inspiration on the familiar stock of historical stylistic quotations from the Romanesque, Gothic or Renaissance. The designs of Walter Gropius and Adolf Meyer on one hand, and the contributions of Thilo Schoder and Max Taut on the other contained elements that already fundamentally anticipated further advances in high-rise buildings. The Chicago Tribune organized a traveling exhibition of all the designs submitted to the competition which, in the end, enabled these designs to become known to a wider public.

463 feet
141 meters

View of the winning entry in the design competition

The runner-up entry in the design competition
for the Chicago Tribune Tower, Eliel Saarinen, Finland

The third-place entry in the design competition,
Holabird & Roche, USA

Murphy & Olmstedt entry, USA

Daniel H. Burnham & Co. entry, USA

Alfred Fellheimer and Steward Wagner entry, USA

Jarvis Hunt entry, USA

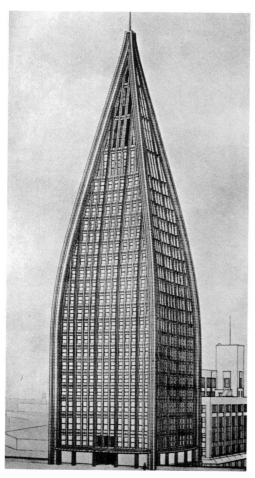

Bruno Taut, Walter Gunther and Kurz Schutz entry, Germany

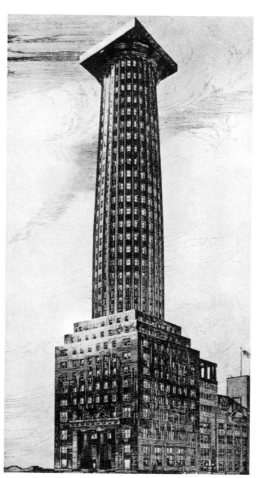

Adolf Loos entry, France

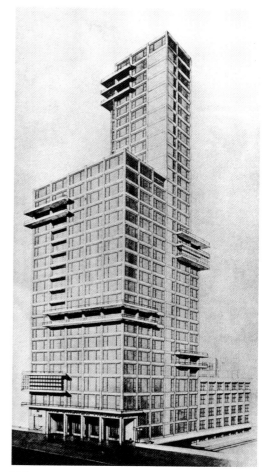

Walter Gropius and Adolf Meyer entry, Germany

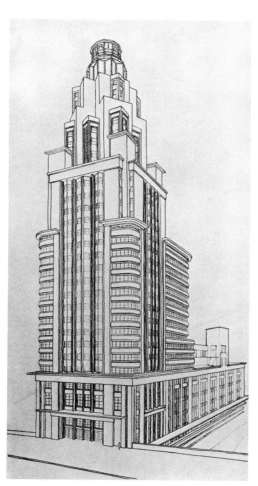

Thilo Schoder entry, Germany

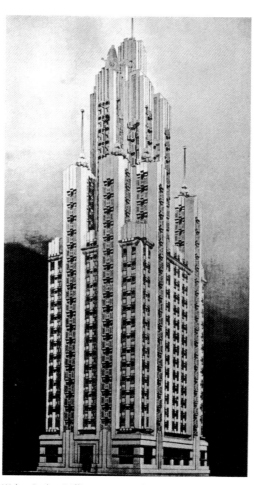

Walter Burley Griffin entry, Australia

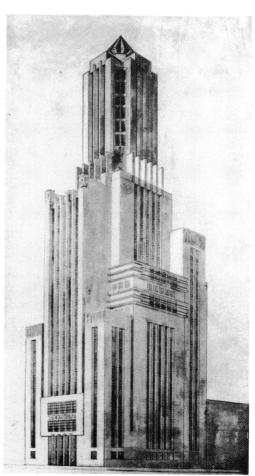

J. Batteux entry, France

43

American Radiator Building New York, USA

Raymond Hood with J. André Fouilhoux

1923–1924
338 feet / 103 meters

Raymond Hood studied architecture at the Massachusetts Institute of Technology in Boston and between 1906 and 1911 at the École des Beaux Arts in Paris. He received his first commissions in Pittsburgh and in 1914 moved to New York, where he became one of the most influential architects designing high-rise buildings. In 1924, after his success in the competition for the Chicago Tribune Tower of 1922 (p. 40), he and his partner J. André Fouilhoux executed the American Radiator Building (today the American Standard Building), and in 1931 the McGraw-Hill Building. From 1932 he took on a central role in the design of Rockefeller Center (p. 56).

The American Radiator Company Building on 40th Street was Hood's first high-rise building in New York, and after its completion he moved into the 14th floor with his architectural office. The site was small, but had the great advantage of being close to Bryant Park, so that the whole of it could be seen from the park side. The Radiator Building is one of the first of New York's high-rises to conform to the regulations of the new zoning law. Hood designed the necessary set-backs in the structure in a varied and dynamic manner. At street level, the building was linked to the adjacent shopping street by means of two-story shops.

In order to achieve the impression of a massive building structure closed in on itself, Hood, in a departure from his design for the Chicago Tribune

Total view

Tower, used a dark, almost black, brick as cladding for the facade. He wanted to prevent the windows, which are cut into the facades, from looking like black holes in daytime. This effect is reversed in the evening, when the windows, lit from the inside, turn the building into a lantern. For the American Radiator Company, which manufactured radiators and heaters, the building was a good form of advertising, appearing by night like a glowing torch. The crown-like, craggy top of the building was designed to achieve a striking effect from a distance in the silhouette of the city. Together with the neo-Gothic entrance portal, the top of the tower is still primarily reminiscent of Hood's earlier design for the Chicago Tribune Tower. Particularly noticeable are the gilded terracotta details, whose gleam can be seen from afar by day, and which are illuminated by night by gold-colored floodlights.

Although designed only a year after the Chicago Tribune Tower, the American Radiator Building represents a decisive new turn in Hood's work. He had recognized a sign of the times in the outstanding design by Eliel Saarinen, the second prize winner in the competition for the Chicago Tribune Tower, and oriented himself toward its mass distribution. The American Radiator Building owes its powerful effect not only to its massiveness, but also to its very evident theme, the striving for height. With its eccentric materiality and its reduced but effectively employed decoration, it marks the beginning of the wave of Art Deco high-rises that was to follow in New York.

Radiator Building—Night, New York by Georgia O'Keeffe, 1927

The gilded top of the building

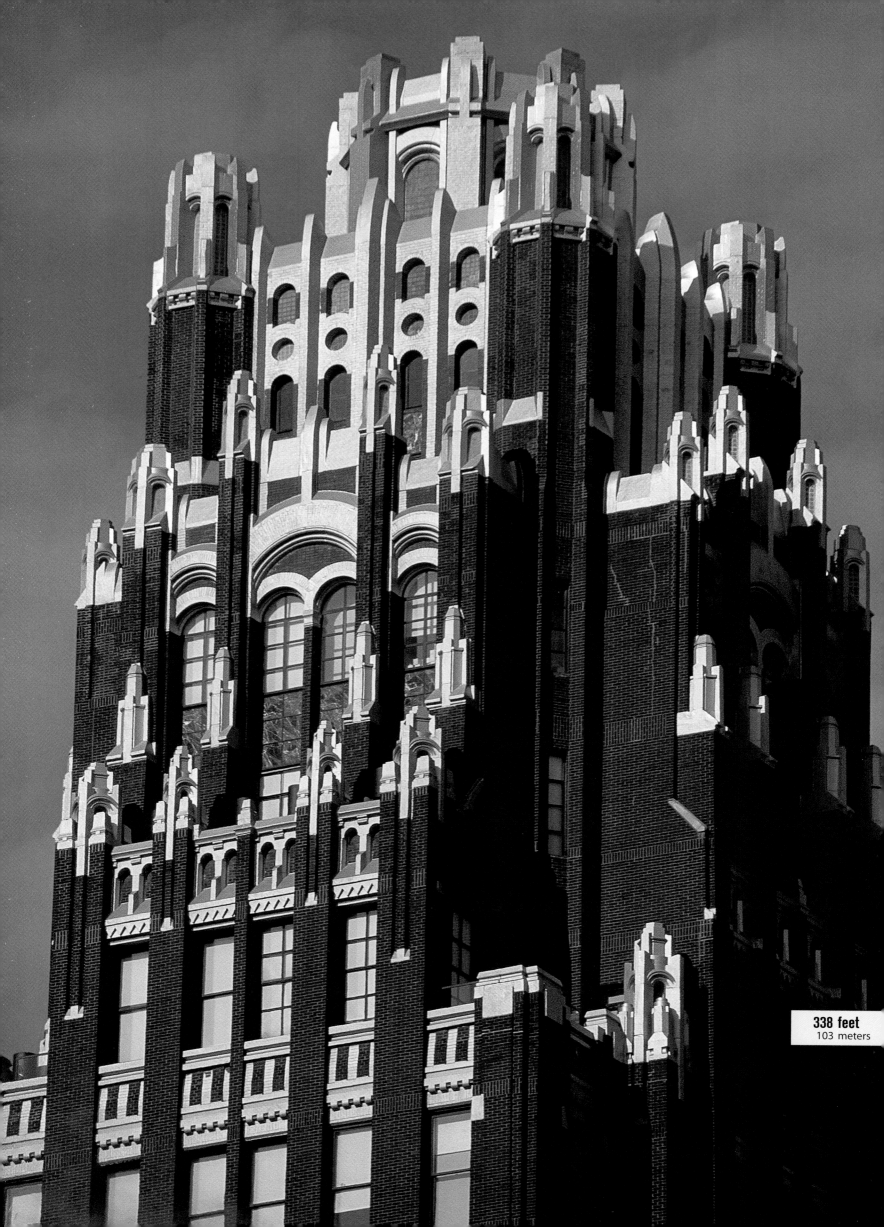

338 feet
103 meters

Chrysler Building New York, USA

William van Alen

1928–1930
1,046 feet / 319 meters

During the brief period of a single year, from 1930 to 1931, the Chrysler Building claimed the title of the tallest building in the world. And even though it soon had to cede the title to the Empire State Building, it has retained one of the foremost places on the popularity scale of the most beautiful sky-scrapers, even up to the present day. The Chrysler Building, with its needle-sharp spire, has not only become a symbol of American Art Deco architecture, but since the advent of postmodernism has also acquired an almost legendary aura; it stands among the shining stars in the Manhattan skyline.

The architect of the Chrysler Building, William van Alen, was born in Brooklyn in 1882. In 1908 he received a travel grant which enabled him to go to Paris for three years and study at the École des Beaux Arts. On his return in 1911 he made his mark with unusual designs for stores and restaurants, in conscious contrast to "European" traditions. In 1927 the former Senator William H. Reynolds commissioned a project from van Alen whose first version, still crowned with a cupola, was published in August 1928. It already included the false corner

windows and the basic division into base, shaft and top, which became the distinguishing design features of the completed structure.

In October 1928 the automobile magnate Walter P. Chrysler took control of the site, the design, and the architect and quickly pushed ahead with the completion of the building. At this point, a competition ensued which was unique in architectural history. As early as July 1929 the Bank of Manhattan Company announced its intention to construct on Wall Street the tallest building in the world at 807 feet (246 meters)—39 feet (12 meters) taller than the planned height of the Chrysler Building. And soon thereafter, on August 30, the plan for the Empire State Building was published—it was to be 1,000 feet (305 meters) high. Now, the most dynamic phase in the construction of the Chrysler

1,046 feet
319 meters

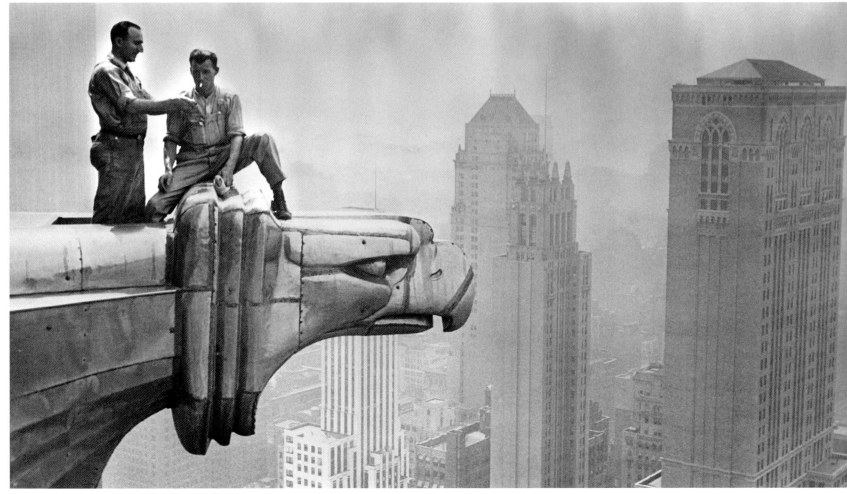

Workmen smoking during the construction of the Chrysler Building

Ornamentation on the facade in the style of Chrysler hood ornaments

The Art Deco elevator doors designed by William van Alen

Building began, in which van Alen—clearly spurred on by Chrysler—developed his plan for a tower at the top with which he would at least defeat the Bank of Manhattan.

When the extension, which was secretly constructed in five parts, was lifted to the top of the spire, the Chrysler Building reached a height of 1,046 feet (319 meters). Chrysler and van Alen had even surpassed the Eiffel Tower, which until then had been the tallest structure in the world at 984 feet (300 meters). But the race was not yet over. Only a few weeks later, the architects Raskob and Smith changed their design for the Empire State Building to a height of 1,050 feet (320 meters).

This race would, in the long run, cost dearly. In particular, the stories above the 66th (officially the Chrysler Building reaches seventy-seven floors) could in practice no longer be rented out because of the way in which the space was divided. On the other hand, the top of the Chrysler Building with its bizarre design and reflective cladding of stainless steel attracted attention, and gave the building the memorable identity that no high-rise building had previously achieved with such long-lasting effect. The symbolic nature of the building was immediately recognized by contemporary architectural criticism and was branded by Lewis Mumford, for example, as "advertising architecture."

The most luxurious aspect of this building is the opulent entrance lobby with its red Moroccan marble walls, yellow Sienese marble floors and onyx trim. The elevator doors with their intarsia are a masterpiece of New York Art Deco. The offices situated above the lobby, however, were designed in an unpretentious, standardized style; only the doorknobs and heating lattice had been specially designed by van Alen. It was only below the spire, in the so-called Cloud Club, that more exclusive and elegantly designed rooms were created.

After designing the Chrysler Building, van Alen, who died in 1954, was increasingly forgotten. There is no biography, no archive and practically no research relating to this architect who marked the face of Manhattan with a building that has so fascinated visitors to New York up to the present day. After its completion, the building entered a phase marked by variability. It was not until 1978 that it was placed under a preservation order. In 1997 the real estate firm Tishman Speyer took over the building and conducted renovation and repair work. The legendary interior decoration of the Cloud Club, however, was removed—opposition from the Art Deco Society came too late.

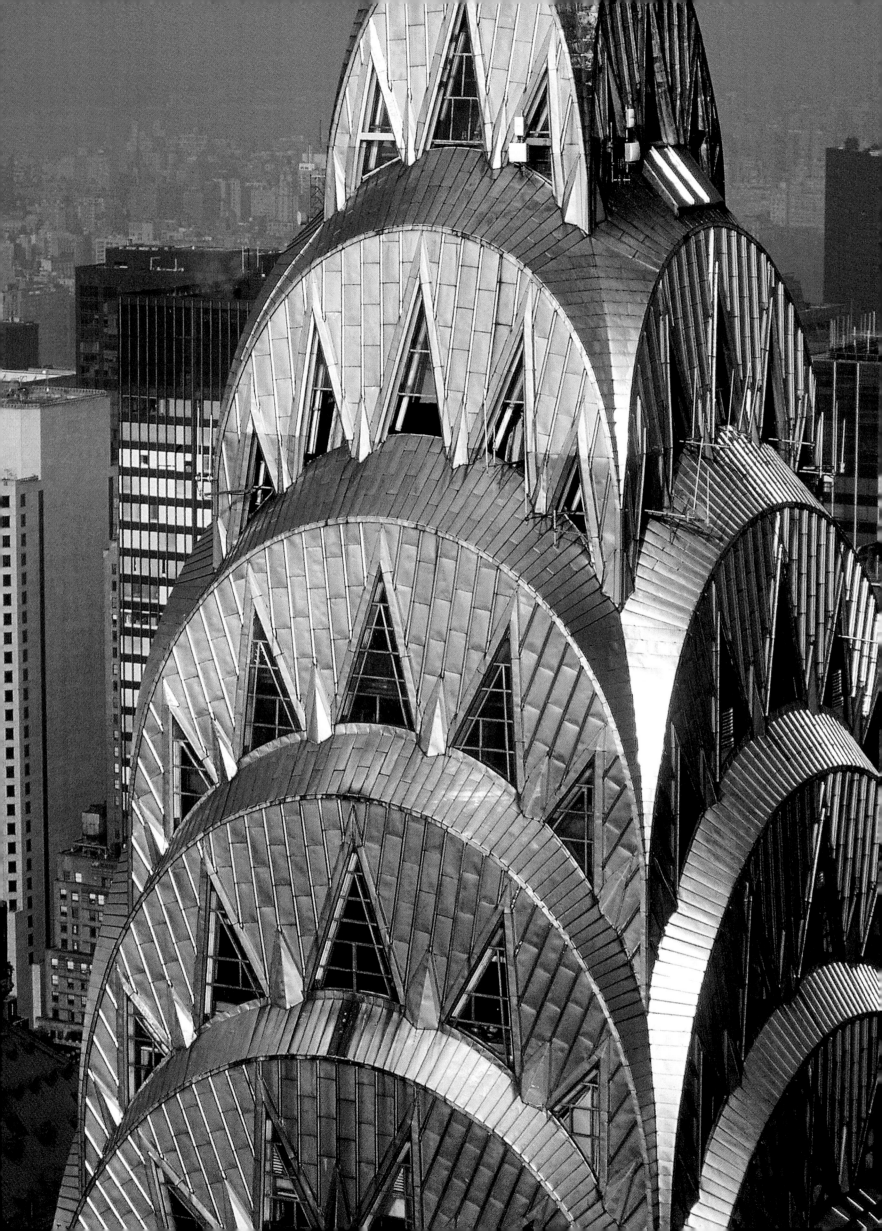

Empire State Building New York, USA

Shreve, Lamb and Harmon

1930–1931
1,250 feet / 381 meters

Countless feature films have contributed to the legend of the Empire State Building. One of the best-known is undoubtedly *King Kong* (1933)

On August 29, 1929, John Jakob Raskob, the former financial director of General Motors, and Alfred E. Smith, former governor of New York, publicly announced a project to build the tallest skyscraper in the world. They presented a preliminary design for a building of some 1,000 feet (305 meters) in height. This intensified the competition for the title, which was at the time already being contested by the Chrysler Building (p. 46) and the Bank of Manhattan Building (later 40 Wall Street). At the beginning of September, the architectural partnership of Richard H. Shreve, William Lamb and Arthur Loomis Harmon received the commission. None of the three architects had ever carried out a project even remotely comparable to this. And the deadline for the opening of the building was set for May 1, 1931—a mere twenty months away!

When Walter Chrysler and William van Alen surprisingly added the spire to the Chrysler Building in November 1930, this was an early reaction to the initial plans for the Empire State Building. It seemed the Chrysler Building had won the title with a height of 1,047 feet (319 meters). But as early as December 11, 1929, Smith played his final trump card by announcing that the Empire State Building would, according to the final plans, reach a height of 1,250 feet (381 meters). The new record height was the result of a newly devised mast on which dirigibles could dock, that was to be added to the top of the already designed structure.

Before construction could begin, the legendary (original) Waldorf-Astoria hotel, which stood on the site between 33rd and 34th Streets on Fifth Avenue, had to be demolished. In January 1930 the foundations were laid, and in March actual construction began. The employment of more than 3,000 construction workers ensured a dizzying rate of progress—the steel frame grew upwards by some four and a half stories a week. In the brief period from June to September, sixty stories were completed and in November the steel frame was complete. This unique achievement was made possible only by numerous innovations in planning, logistics and construction—including the workers' cafeterias, which made their way upward with the growing height of the structure.

Impressions by the photographer Lewis W. Hine of the construction of the Empire State Building. In the background, the Chrysler Building and Rockefeller Center

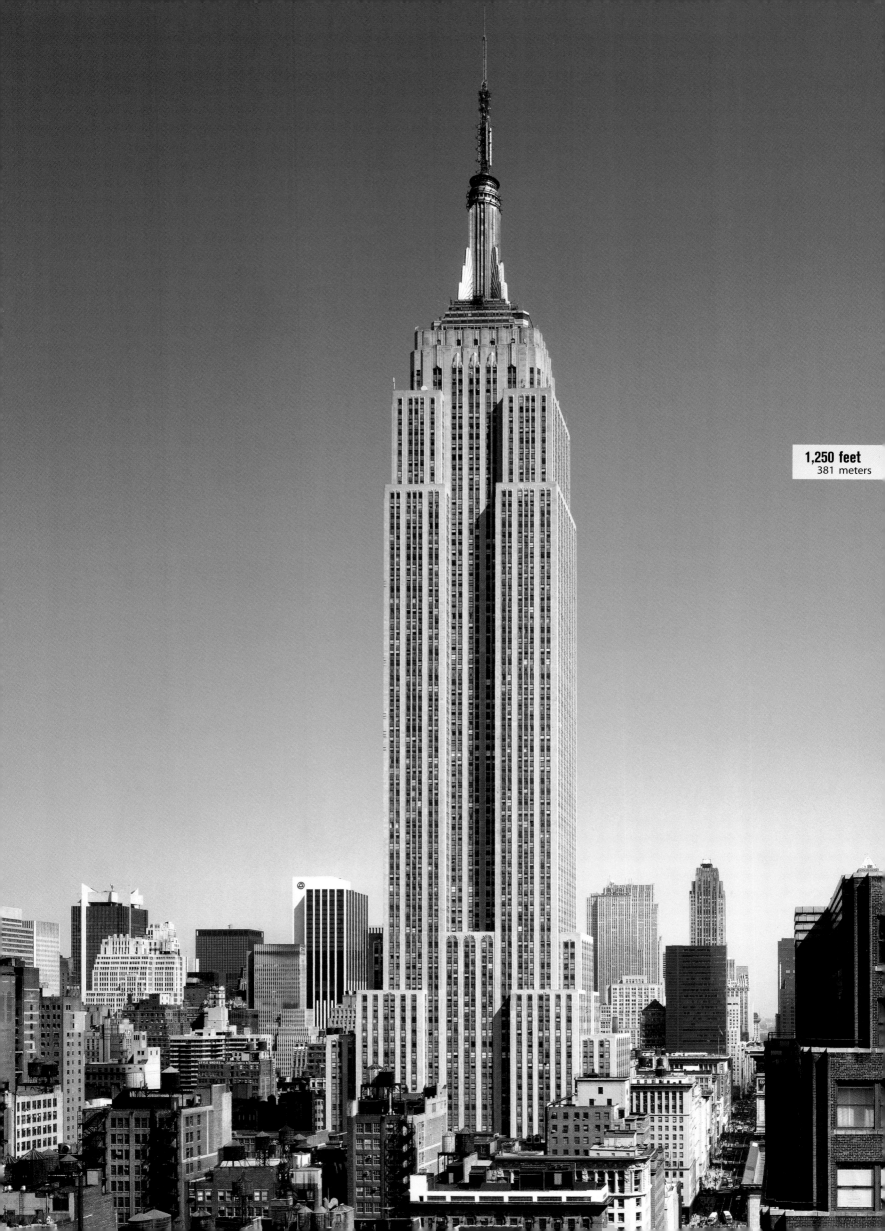

1,250 feet
381 meters

The top of the skyscraper, since 1976, is bathed in colored light on special occasions

In its outward appearance, the Empire State Building is very restrained, its proportions strictly following the regulations of the zoning law. Cost-saving, prefabricated elements were incorporated into the facade, in order to increase the building speed even further. Essentially, the total design follows Sullivan's threefold division into base, shaft and peak. At the same time, the facade, clad with smooth gray limestone, in its extreme reduction of ornamentation and emphasis on vertical structure, exhibits a reaction against modernism.

The Empire State Building was completed in the midst of the Depression. For this reason, it was at first difficult to find tenants for the better part of the office space, and the building was nicknamed the "Empty State Building." Only twenty years later would the building be fully occupied and begin to show a profit. But this did not lessen the mystique of the building, which was quick to set in. While it was still in progress, publicity for the Empire State Building in the media began through the photographs of Lewis Hine, who followed the entire construction process. Countless films, from *King Kong* (1933) to *Sleepless in Seattle* (1993), have spread its fame worldwide up to the present day. The observation platform on the 86th floor, at a height of 1,050 feet (320 meters), is among the most frequently visited tourist sights throughout the world. On July 28, 1945, the Empire State Building had to demonstrate the stability of its construction when a B-25 bomber that had lost its way in the fog crashed into it between the 78th and 79th floors. Fourteen people were killed, while the building suffered only minor damage.

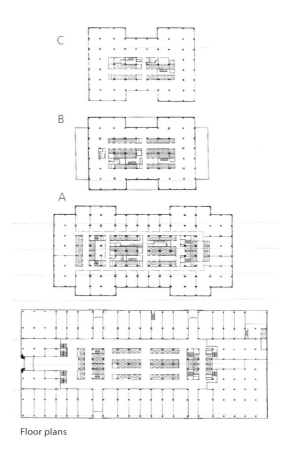

Floor plans

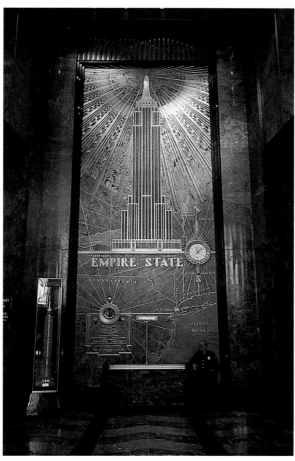

The Art Deco lobby, clad in granite and marble

The Empire State Building unites in one structure the most extreme demands: a breathtaking rate of completion, a high proportion of rentable space, status as a showpiece, and supreme technical performance, such as the fastest elevators of its day. Even if the landing-place for Zeppelins never fulfilled its function, the futuristic idea of opening-up skyscrapers to the skies lent a new intellectual dimension to this type of building. Celebrated even during the construction period as the "eighth wonder of the world," the Empire State Building has become the symbol of a cultural era which points far beyond itself, its location and the period of its creation. At any rate, it was able to boast the title of the world's tallest skyscraper for forty years, unchallenged until the completion of the World Trade Center (p. 94).

Philadelphia Saving Fund Society (PSFS) Building

George Howe and William Lescaze

Philadelphia, Pennsylvania, USA

1929–1932
492 feet / 150 meters

The PSFS Building marks a decisive turning point in the history of the skyscraper. New height records had only recently been set in New York by the Chrysler Building (p. 46) and the Empire State Building (p. 50), and with them the heyday of architectural Art Deco had reached its conclusion. In the definitive exhibition *Modern Architecture: International Exhibition* of 1932 at the Museum of Modern Art, the PSFS Building was already represented. Perhaps most astonishing is that the first high-rise building in the new International Style would be created in, of all places, conservative Philadelphia.

The client was the Philadelphia Saving Fund Society, based in the city, who commissioned local architect George Howe in 1929. Howe had recently gone into partnership with the Geneva born architect William Lescaze. Lescaze studied under Karl Moser at the ETH in Zurich, and, like Rudolf Schindler and Richard Neutra, emigrated to America in 1920. Along with Schindler and Neutra, Lescaze was one of the first generation of European architects to import their modernist architectural principles into America.

The external proportions of the building alone demonstrate the unusual conceptual approach. The street level of this corner site, which sweeps around the corner, reveals the basement which accommodates stores. An escalator leads to the customer service hall of a bank, which is exposed through horizontal glass windows almost 33 feet (10 meters) tall. Above this, the actual structure of the high-rise building recedes from its base.

In its clearly articulated, asymmetrically designed forms, which react precisely to the site location, the structure of the PSFS Building is charged with tension. The service installations are placed on the outer edge of the T-shaped outline and are visible from the outside. The facades of the building are virtually undecorated; this makes the inscription over the entrance and the oversized logo on the roof in red neon lighting all the more effective. The interior decoration of the PSFS Building was designed as a coherent whole by Howe and Lescaze. They followed a very reduced, functional aesthetic reminiscent of contemporary ship designs.

For the first time in America, the PSFS Building realizes on a grand scale all of the radical approaches that had been unsuccessfully put forward by German participants in the Chicago Tribune Tower competition (p. 40) such as by Walter Gropius and Max Taut. Even if it does not yet employ the curtain wall facade of later high-rise buildings such as the Lever House (p. 64), it was still, on account of its unusual exterior and interior design, the primary example of a new architectural variety. Today, the building is used as a hotel.

Typical floor plan

Cross section

First mezzanine of the banking hall

Banking hall on the ground floor

The Philadelphia Saving Fund Society Building with the company initials on top

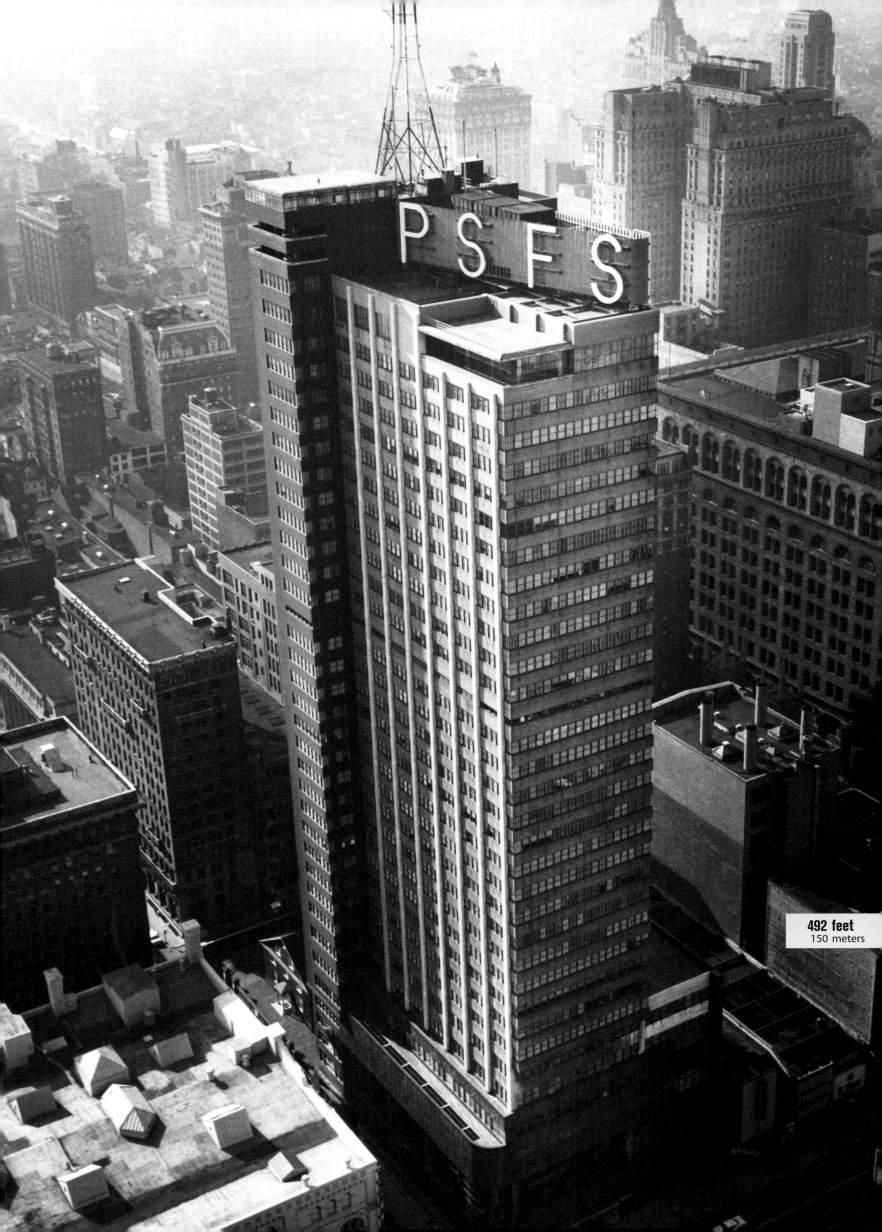

492 feet
150 meters

Rockefeller Center New York, USA

The Associated Architects: Reinhard & Hofmeister; Corbett, Harrison & McMurray; Hood, Godley & Fouilhoux

1933–1940
850 feet / 259 meters

Scheme for the Rockefeller Center

Up to the 1930s, high-rise buildings, with a few exceptions such as Tudor City in New York (1928), were individual structures. The Rockefeller Center was the first example of a group of high-rise buildings planned in detail over several blocks. In 1927 John D. Rockefeller Jr., the United States' first billionaire, rented a 15 acre (6 hectare) site between 48th and 51st Street and Fifth and Sixth Avenue. In 1928, with John R. Todd, he founded a company to create "Rockefeller City" in the heart of Manhattan.

A team of several architects, called Associated Architects, was formed to plan this enormous project. Wallace K. Harrison was joined first by Andrew Reinhard and Raymond Hood, and later by other architects. Hood, who had become famous for the Chicago Tribune Tower (p. 40) as well as the American Radiator Building (p. 44), retained a kind of overall control. From 1927 he had devoted himself intensively to the question of the extended functions of high-rise buildings and their relationship with urban planning. Hood defined the skyscraper as a "city in the city," a concept that has persisted to the present day in the theories of Rem Koolhaas.

The basic functions of this building complex were intended to be the housing of the main administration and production offices of the entertainment group RCA as well as the main administration of General Electric. Beyond this, further office space was to be created and rented out as profitably as possible. Cultural uses were also to be included. From the start, the public space with its wide pedestrian passages, stores and atria was consistently included in the development of the overall plan. At a late stage, the sunken plaza, originally laid out as an entrance to the subway, was converted to an ice-skating rink. According to the original plans, the individual high-rise buildings were to be linked together at a high level by pedestrian footbridges, but this idea was later abandoned. With the roof gardens, Hood and his team seem to have already taken up the ideas of Le Corbusier, who stated that ground used in built-up urban areas should be reclaimed on the roofs. Particular importance was placed on the concept of artistic design. Hood traveled to Europe to enlist the services of artists such as Matisse and Picasso. In the end, he engaged José Maria Sert and Diego Rivera, whose large wall fresco *Man at the Crossroads* in the entrance to the main building was however removed by the client because of Rivera's communist sympathies and the recognizable portrait of Lenin.

850 feet
259 meters

View of one of the roof gardens

Typical floor plan

In spite of the Depression, Rockefeller continued with his gigantic project for over fourteen years, to express his feeling of social responsibility as an entrepreneur. The construction of large concert halls (Radio City Music Hall) and cinemas was to heighten the popularity of the project. Originally encompassing fourteen buildings, since 1940 the complex has grown to include twenty-one buildings. Still the tallest and most central structure of the Rockefeller Center is the GE Building (earlier the RCA Building), with seventy stories and a height of 850 feet (259 meters). It is constructed out of a number of flat panels, graduated upwards. Its upward development is particularly impressive when observed on its narrower side from the public plaza.

From the urban planning viewpoint, the Rockefeller Center is linked with the building theories of contemporary European modernism, and in its functional density and complexity sets standards for all future planning. And with its impressive décor, it still remains recognizable as a late manifestation of the luxurious Art Deco period in New York.

Atlas figure by Lee Lawrie and René Paul Chambellan

Unfinished fresco by Diego Rivera, which was later removed

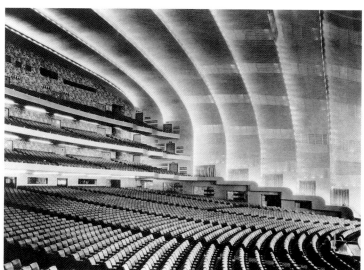

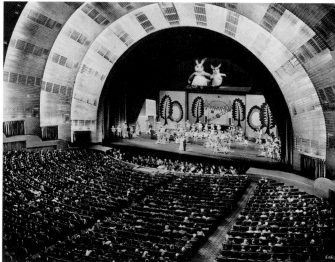

Radio City Music Hall in the Rockefeller Center, which seats 6,200

Johnson Wax Research Tower Racine, Wisconsin, USA

Frank Lloyd Wright

1944–1950
151 feet / 46 meters

A perspective drawing showing an early design for the Research Tower

The wax and paint company S. C. Johnson & Son, based in Racine, Wisconsin, was able to expand considerably in the 1920s and 1930s thanks to the newly developed market for car care products. In 1936, in spite of the Depression, the company planned a new building to meet the growing demand for office space. Not far away, in Taliesin, Frank Lloyd Wright was working on his famous house, Fallingwater, and he had not received any important commissions for a long time. Wright was very interested in the Johnson Wax commission which gave him the opportunity, more than thirty years after the construction of the Larkin Building, to reformulate his ideas about a workplace "consecrated" by architecture. By 1939 he had completed the central, horizontal administration building. This large, inwardly directed office space became known worldwide for its design using monumental mushroom-shaped supports.

Ten years later, the research department of Johnson Wax needed additional space for laboratories. Wright was again commissioned to carry out the planning and designed a fourteen-story tower building, whose story ceilings project from a central core. The core of the high-rise is not only the building's sole support, but at the same time contains the supply networks for heating, electricity, air conditioning and even the chemical pipes. The individual stories are alternately square with rounded edges, and round with a reduced diameter. In this way, the interior of the building allows views over two stories at a time. The flat facade, divided horizontally, consists of glass and brick. As in the administration building, Wright used glazing with horizontally stacked Pyrex tubes like those used for experimental purposes in the laboratories.

The Research Tower was opened in 1950, and according to statements made by employees, it worked very well despite the arrangement of space, which was somewhat unusual for a laboratory. However, the glazing on all sides, together with the equipment used, led to overheating that the air conditioning was unable to counteract. But the greatest problem with the tower was its limited structure: it offered no possibility for the expansion of laboratory space that became necessary soon after the building was first occupied.

Despite its inconsiderable height, the Johnson Wax Research Tower is indeed of significance in the architectural history of the high-rise. By positioning it in a closed courtyard, Wright was alluding to the Japanese temple complexes he had studied. The variation in the size of the floors is also reminiscent of Oriental influences, such as the design of pagodas. By providing the tower with glazing that allows no view of the exterior, Wright strengthens even further the almost religious, introspective orientation of the workplace that was already present

Detail of the facade

The tower houses the firm's laboratories

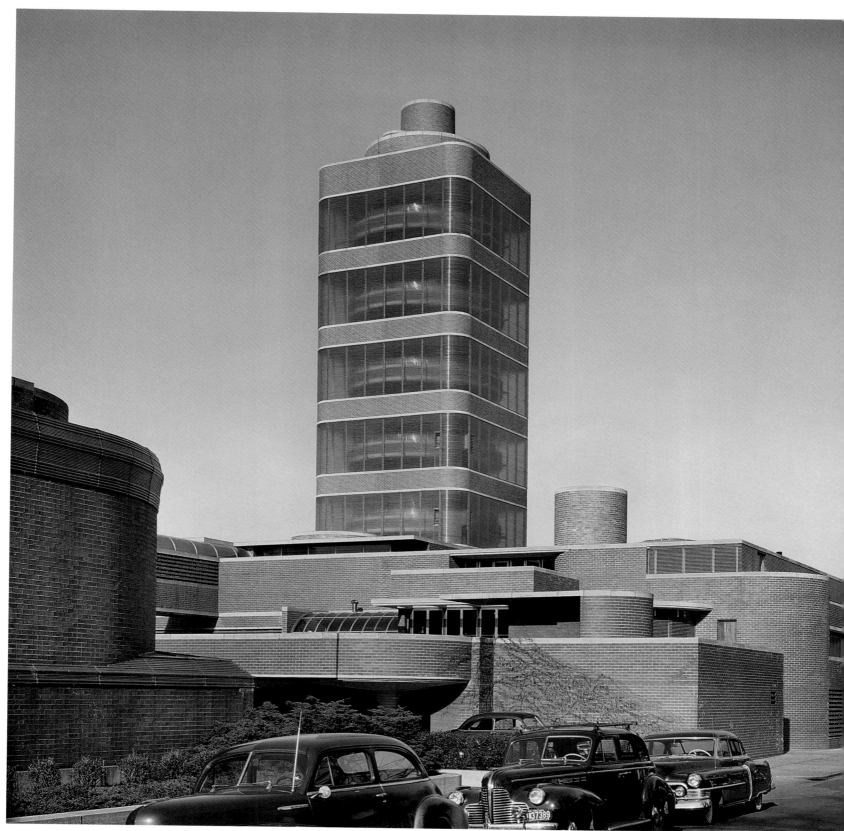

The set-back, circular stories are visible through the facade

in the administration building. He thus reverses one of the fundamental ideas of high-rise building—the constantly requested "view from above." The laboratory tower presents itself as an autonomous architectural sculpture.

As far back as 1923, Wright had occupied himself on several occasions with the structural idea of a load-bearing central support for a high-rise. After its first realization with the Johnson Wax Research Tower, he employed this idea again in the H. C. Price Company Tower in Bartlesville, Oklahoma (1952). The idea of the load-bearing coloum also became the heart of his most imaginative project, the One-Mile-High Skyscraper (published in 1956) which, had it been built, would have become the tallest skyscraper of all time.

151 feet
46 meters

860–880 Lake Shore Drive Chicago, Illinois, USA

Ludwig Mies van der Rohe

1948–1951
269 feet / 82 meters

As early as the 1920s, Ludwig Mies van der Rohe had worked intensively with the idea of the high-rise building in connection with a competition for a high-rise on Friedrichstraße in Berlin. His bold proposal of a fully glazed, crystalline office tower of 26 floors was, however, not seriously considered by the jury—quite clearly the very suggestion was dismissed as wholly unrealistic. But as far as Mies was concerned, his design was more than a mere intellectual exercise. He published it in a number of periodicals and presented the associated monumental drawing at the *Great Berlin Art Exhibition* of 1922. Even without any personal experience in high-rise construction, Mies was fascinated by steel skeleton building: "Only in the course of their construction do the skyscrapers show their bold, structural character, and then the impression made by their soaring skeletal frames is overwhelming" (in: *Frühlicht*, I, 1922, no. 4, p. 122).

After emigrating to the United States in 1938, Mies was able to realize his first high-rise building in 1946, with the Promontory Apartment Building project in Chicago. This was an apartment building of twenty-one stories, but with a slender concrete frame. Here, even if Mies was not able to implement the free-standing panel construction that he considered ideal, he used this commission to gather his first experience in the building of high-rises. In August 1948 he began his designs for 860–880 Lake Shore Drive Apartments. The steel skeleton structure he envisaged was rather unconventional for a residential building, but thanks to favorable circumstances Mies was able, for the first time, to realize his long-cherished dream. He

Ground plan of the complex

decided on two separate towers on a rectangular base in a relationship of 6:4. However, he did not place them parallel to each other but at an angle of 90 degrees, displaced by an axis and linked together at the ground-floor by a shared canopy. The construction of the two towers consists of a steel skeleton with three axes on the narrow side and five on the broad side. The Chicago building code did not permit the construction of multistory buildings using freestanding, nonfireproof materials. Steel supports were, therefore, normally provided with a concrete shell. But since Mies wanted to make the structure visible from the outside, the only solution was to apply an outer skin to the encased, load-bearing steel girders which duplicated their interior construction. For this purpose, he employed for the first time the double-T supports as a design element set on top of the vertical struts. The Lake Shore Drive Apartments, the first high-rise structure by Mies van der Rohe with a curtain facade, are a model of construction and proportion from which he developed all his later projects up to and including the Seagram Building (p. 66).

Entrance area

The two buildings are set at right angles to each other

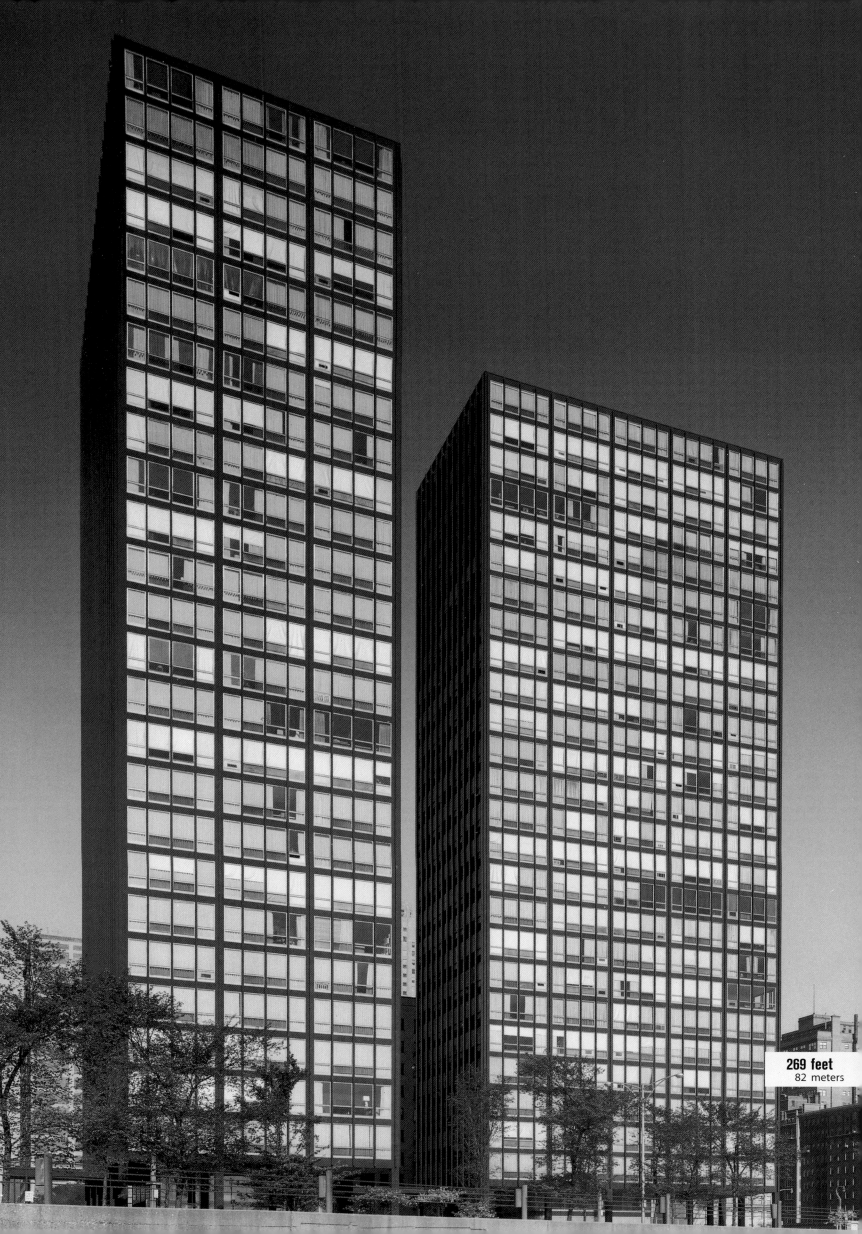

Second floor plan

Ground floor plan

The stone buildings in the surrounding area are reflected in the glass curtain wall

Lever House New York, USA

SOM Skidmore, Owings & Merrill

1950–1952
302 feet / 92 meters

With Lever House, the headquarters of the detergent company Lever Brothers, one of the most influential design ideas in architectural history made its first appearance on Park Avenue in New York—the glass curtain wall facade. At the time of its construction, Lever House, viewed in the context of its surroundings (buildings still clad mainly in stone), seemed like a building from another civilization. The facade of alternating transparent green and opaque blue glass in an aluminum frame for the first time opened the view of the load-bearing structure of the interior to the outside. No longer is any tectonic articulation applied to the facade; it has been entirely dematerialized. Ludwig Mies van der Rohe's vision of the glass skyscraper of the 1920s had become a built reality. And Lever House also translated into reality another central lesson of architectural modernism: Le Corbusier's Piloti system. Standing entirely on supports above its own site, it creates new public space underneath, and allows the edge of the building experienced by pedestrians to disappear. The concepts of interior and exterior are thus radically called into question. In the center of the site's surface, where otherwise the elevator shafts and lobbies would have been, lies a garden, lit from above through an opening cut in a rectangular shape. This further underlines the building's aspect of bodilessness and the removal of borders.

The use of the surface of the site by Lever House was extravagant. The slender, rectangular office tower of only 18 stories is placed at an angle at the north edge of the site which itself floats above the one-story, panel-shaped distribution area on the first floor. However, this positioning enabled the adoption of a new zoning provision, according to which a building could be constructed without any set-backs, if it occupied only twenty-five percent of the surface of the site. This leaves a large part of the space available for construction unused, but the structure can be designed as a perfect cube. In this way Lever House anticipated by several years the idea of the nearby Seagram Building by Ludwig Mies van der Rohe (p. 66).

The detergent company Lever wanted this building, which was originally intended for Chicago but then for strategic reasons transferred to New York, to project an innovative and "clean" image. Gordon Bunshaft, as designer in the office of Skidmore,

Under the raised first floor, the building is accessible to pedestrians

Owings & Merrill, realized this idea in exemplary fashion. Apart from the outwardly recognizable innovations, Lever House was also the first skyscraper to be fully air-conditioned; as a result, the windows could no longer be opened. To enable the facade to be cleaned, movable window-cleaning cabins running on tracks on the roof were invented, and these were later adopted throughout the world.

In Lever House, the modernist idea of the glass cube as an absolute, autonomous form without any formal reference to its urban context was realized in a totally logical manner. As such, it marks a decisive turning point in the history of high-rise construction: on the one hand, early utopias of modernism find a satisfying conclusion in this building; while on the other, it also points the way into the abyss of shallow plagiarism throughout the world.

302 feet
92 meters

Seagram Building New York, USA

Ludwig Mies van der Rohe

1954–1958
515 feet / 157 meters

Samuel Bronfman, the president of the Seagram Co., had given the contract for an office building to be ready in time for the 100th anniversary of the firm's foundation to the New York architectural office of Pereira and Luckman. However, his daughter, the architect Phyllis Lambert, felt that these architects didn't lend sufficient prestige to the project and advised that an architect of international acclaim should be chosen. To this end, she employed Philip Johnson, director of the Architectural Department of the Museum of Modern Art as a consultant. The resulting shortlist included Frank Lloyd Wright, Le Corbusier and Ludwig Mies van der Rohe. Phyllis Lambert finally decided on Mies, who had been working in Chicago since 1938. For his first commission in New York, he engaged Philip Johnson as contact architect and opened an office in partnership with him. Johnson was responsible for large parts of the interior design of the Seagram Building, including the Four Seasons restaurant.

Ground floor plan with the plaza

The Seagram Building is considered one of the most important high-rise designs in the history of architecture. This is due, above all, to its revolutionary urban placement. The rectangular office tower, placed along Park Avenue, is set back from the street leaving space in front for a wide public plaza with two fountains. For the first time, it was possible for passers-by to look at a high-rise without having to cross the road to do so. The open space in front of the building set a new standard in high-rise construction, which from 1961 became a component of the zoning laws of the city of New York.

By setting the building a significant distance back from the street, Mies, like Gordon Bunshaft with his Lever House (p. 64), was able to design it as a pure cube without set-backs at higher levels. But since the planned office tower took up only a quarter of the surface of the site, he had, from an economic point of view, far too little rentable office space. Its height was also limited by the number of elevators required for access. Mies extended the usable surface area by placing a "backbone" at the rear of the building which stands three axes wide, but only one axis deep, for all thirty-nine stories. Together with an attached T-shaped volume of four and ten stories respectively, it enlarges the office area by more than one-third.

Side view of the building

The building, set back from the street, forms a spacious plaza on Park Avenue

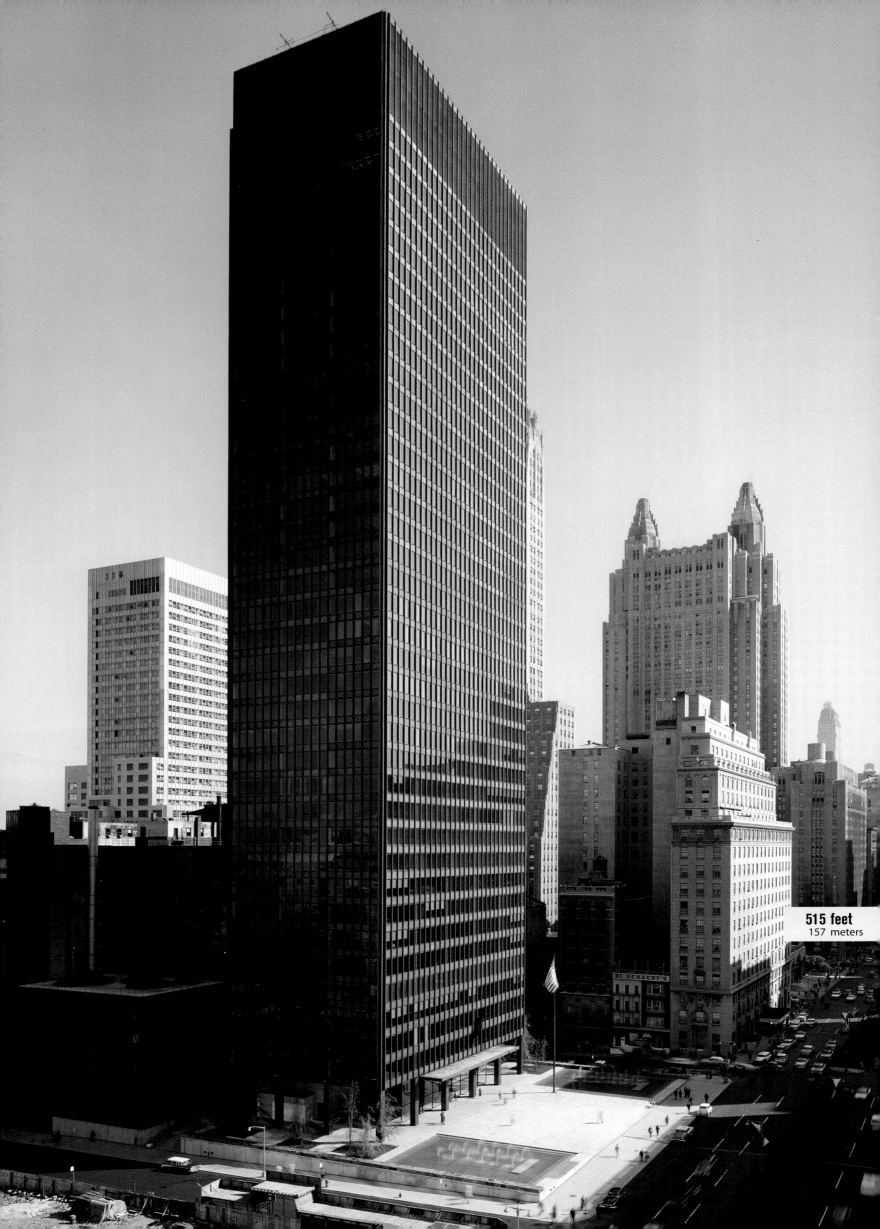

515 feet
157 meters

Design sketch for the plaza by Mies van der Rohe (1955)

The Seagram Building in its urban context

Base zone of the Seagram Building

Office interior

The design of the building is based on a modular pattern which determines all proportions relating to size. Mies's theoretical requirement for a clear, rational structure for all buildings is realized once more in exemplary fashion in the Seagram Building. The office tower itself is in its ground plan a rectangle with the harmonious relationship of 5:3 axes. The two-story entrance hall, faced with travertine, lies directly behind the plaza. A bronze curtain wall surrounds the tower and allows clear recognition of the load-bearing structure. As with the Lake Shore Drive Apartments (p. 62), double-T supports are placed in front of the window posts which run vertically around the building, giving an element of relief to the facade. For the first time, a skyscraper was provided with windows of the same height as the room. With their topaz coloring they relieve the impression of the uncompromising transparency of colorless panes, harmonize perfectly with the bronze frame, and give an impression of closure to the building.

In the Seagram Building, Ludwig Mies van der Rohe combined his visions of the 1920s with the practical experience he had gained in America since 1938. In the realm of high-rise building, modernist architecture attained, from an aesthetic point of view, its unsurpassed peak. The Seagram Building became the icon of the modern high-rises and thus, in the decades that followed, the most frequently imitated example of its genre worldwide.

⑮ Torre Pirelli Milan, Italy

Gio Ponti with Pier Luigi Nervi

1956–1958
417 feet / 127 meters

With the Torre Pirelli, the skyscraper finally finds its realization in Europe as a concept of intensified building in the center of a city. That this should have appeared in, of all places, Italy and directly next to the railroad station in Milan, reflects the courage displayed by both client and city authorities for this particular phase of postwar architecture. Here, one clearly wanted to prove something to America, and Gio Ponti, architect, designer and longtime editor of the magazine *Domus* chose as his partner for this project undoubtedly the most innovative structural engineer in Italy, if not of his entire era, Pier Luigi Nervi.

For the Italian car tire company Pirelli, Ponti and Nervi designed one of the most elegant, expressive and frequently imitated high-rise buildings. Walter Gropius' Pan Am Building (today the MetLife Building) in New York, built in 1963, was the first tribute to the structure in Milan. The Torre Pirelli rises from a greatly extended polygonal base, 230 feet (70 meters) long and only 61 feet (18.5 meters) wide at the center. Because of its extremely flat profile, the structure had to be designed for maximum stability to withstand the force of expected high winds. An additional challenge was posed by the unfavorable soil of the site, which at that location consists of layers of sand and gravel to a depth of 164 feet (50 meters). The load-bearing structure, custom-made by Luigi Nervi, consists of reinforced concrete and is clearly detectable from the outside. Two triangular supports on each of the short sides and two upward-tapering concrete supports in the center form the vertical framework which harnesses the horizontal structure. A general impression of tension is created by the fact that the corners of the building do not join, but are separated by a gap and the roof also does not lie on the upper edge of the building. The construction elements of the interior were also expressively designed by Nervi and clearly demonstrate the relationships of the forces of energy. The individual sections of the load-bearing structure taper upwards and are calculated to precisely match the height of the building. This results in a structure that is logically closed in on itself and, unlike American steel skeleton structures, cannot be extended at will.

The Torre Pirelli is a landmark in Milan

In its integration into its surroundings, the Torre Pirelli follows its own path too. It is positioned in the center of the site and, with a sloping platform, creates a drive to the main entrance suitable for motorists and access to the lobby on the first floor. At ground level, the Torre Pirelli does not form its own base, but rises directly from the ground behind the deliberately empty spaces between the outlying access platform on one side and the low, adjoining buildings in the back. Below the outlying platform is an auditorium with 600 seats and in the back the cafeteria, personnel entrance and delivery ramps.

Contemporary reactions to the Torre Pirelli among architectural critics were not particularly positive. In 1961, for instance, the architectural writer Reyner Banham called it a "giant billboard" and a "piece of advertising architecture." Nevertheless, the Torre Pirelli is today considered among the most successful and elegant high-rise buildings and represents a late, highly significant Euro-pean contribution to the international discussion. Currently, the building belongs to the regional administration of Lombardy, which bought it in 1978.

On April 18, 2002, for reasons still unexplained, a small aircraft crashed into the 26th story of the Torre Pirelli. Two employees and the pilot were killed. However, the suspicion of a terrorist attack, such as was feared in the aftermath of September 11, 2001, proved to be unfounded. In 2003 the building was restored in accordance with principles for the preservation of historic monuments.

Typical floor plan

Total view of this very elegant and balanced high-rise building

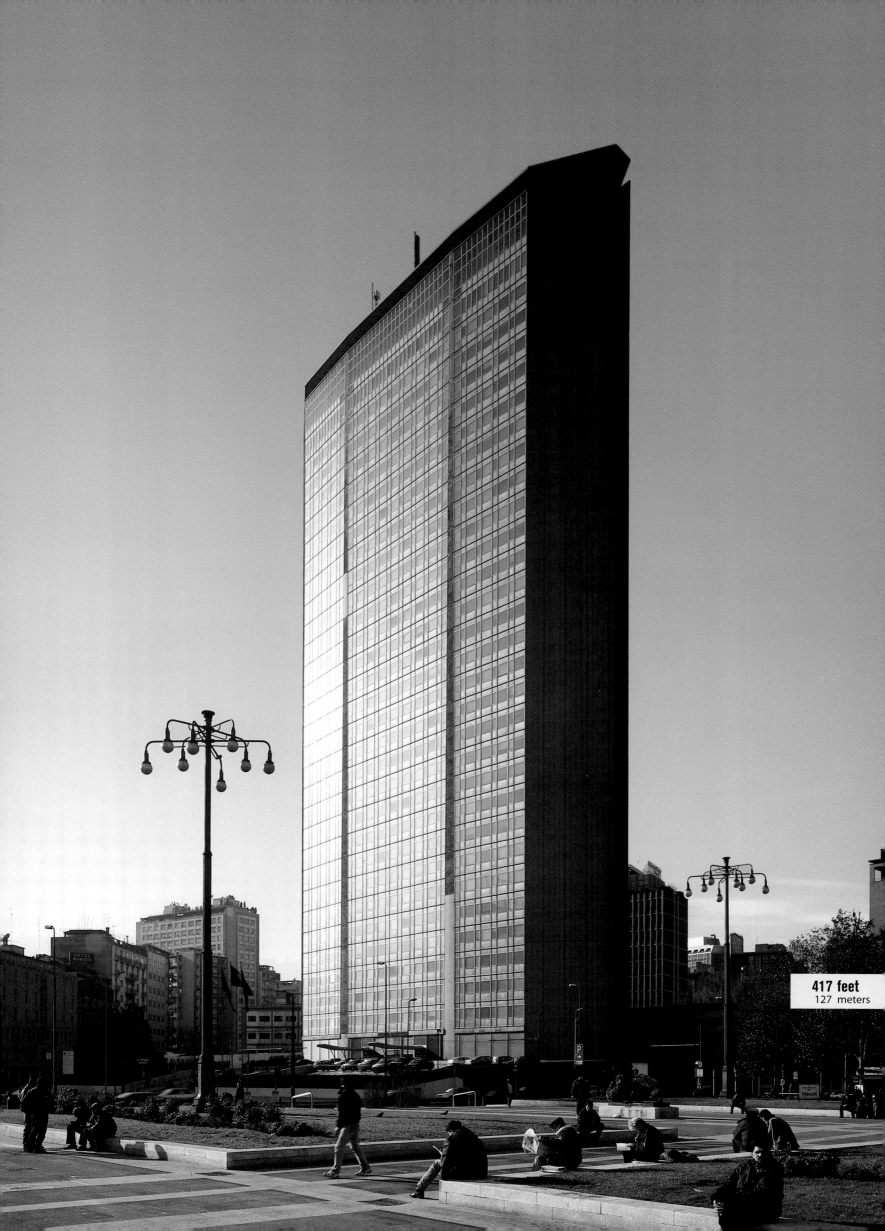

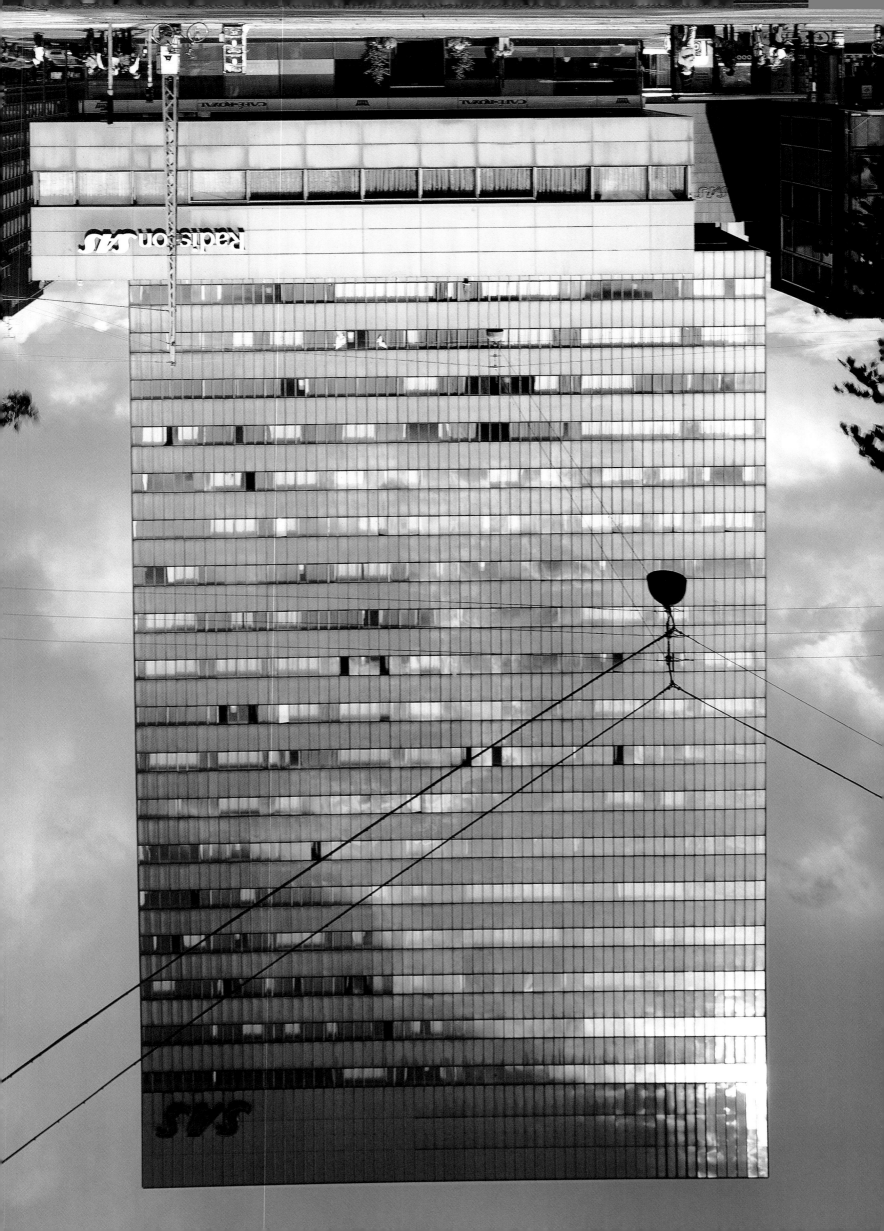

Lever House New York, USA

SOM Skidmore, Owings & Merrill

1950–1952
302 feet / 92 meters

With Lever House, the headquarters of the detergent company Lever Brothers, one of the most influential design ideas in architectural history made its first appearance on Park Avenue in New York—the glass curtain wall facade. At the time of its construction, Lever House, viewed in the context of its surroundings (buildings still clad mainly in stone), seemed like a building from another civilization. The facade of alternating transparent green and opaque blue glass in an aluminum frame for the first time opened the view of the load-bearing structure of the interior to the outside. No longer is any tectonic articulation applied to the facade; it has been entirely dematerialized. Ludwig Mies van der Rohe's vision of the glass skyscraper of the 1920s had become a built reality. And Lever House also translated into reality another central lesson of architectural modernism: Le Corbusier's Piloti system. Standing entirely on supports above its own site, it creates new public space underneath, and allows the edge of the building experienced by pedestrians to disappear. The concepts of interior and exterior are thus radically called into question. In the center of the site's surface, where otherwise the elevator shafts and lobbies would have been, lies a garden, lit from above through an opening cut in a rectangular shape. This further underlines the building's aspect of bodilessness and the removal of borders.

The use of the surface of the site by Lever House was extravagant. The slender, rectangular office tower of only 18 stories is placed at an angle at the north edge of the site which itself floats above the one-story, panel-shaped distribution area on the first floor. However, this positioning enabled the adoption of a new zoning provision, according to which a building could be constructed without any set-backs, if it occupied only twenty-five percent of the surface of the site. This leaves a large part of the space available for construction unused, but the structure can be designed as a perfect cube. In this way Lever House anticipated by several years the idea of the nearby Seagram Building by Ludwig Mies van der Rohe (p. 66).

The detergent company Lever wanted this building, which was originally intended for Chicago but then for strategic reasons transferred to New York, to project an innovative and "clean" image. Gordon Bunshaft, as designer in the office of Skidmore,

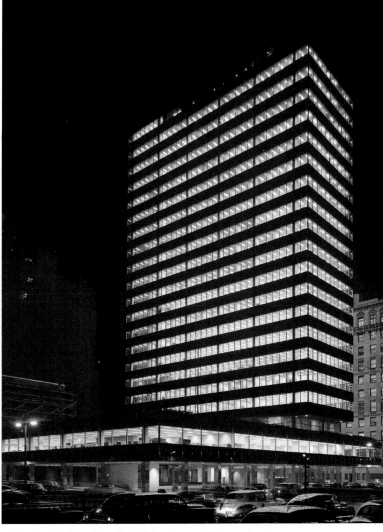

Under the raised first floor, the building is accessible to pedestrians

Owings & Merrill, realized this idea in exemplary fashion. Apart from the outwardly recognizable innovations, Lever House was also the first skyscraper to be fully air-conditioned; as a result, the windows could no longer be opened. To enable the facade to be cleaned, movable window-cleaning cabins running on tracks on the roof were invented, and these were later adopted throughout the world.

In Lever House, the modernist idea of the glass cube as an absolute, autonomous form without any formal reference to its urban context was realized in a totally logical manner. As such, it marks a decisive turning point in the history of high-rise construction: on the one hand, early utopias of modernism find a satisfying conclusion in this building; while on the other, it also points the way into the abyss of shallow plagiarism throughout the world.

302 feet
92 meters

Seagram Building New York, USA

Ludwig Mies van der Rohe

1954–1958
515 feet / 157 meters

Samuel Bronfman, the president of the Seagram Co., had given the contract for an office building to be ready in time for the 100th anniversary of the firm's foundation to the New York architectural office of Pereira and Luckman. However, his daughter, the architect Phyllis Lambert, felt that these architects didn't lend sufficient prestige to the project and advised that an architect of international acclaim should be chosen. To this end, she employed Philip Johnson, director of the Architectural Department of the Museum of Modern Art as a consultant. The resulting shortlist included Frank Lloyd Wright, Le Corbusier and Ludwig Mies van der Rohe. Phyllis Lambert finally decided on Mies, who had been working in Chicago since 1938. For his first commission in New York, he engaged Philip Johnson as contact architect and opened an office in partnership with him. Johnson was responsible for large parts of the interior design of the Seagram Building, including the Four Seasons restaurant.

Ground floor plan with the plaza

The Seagram Building is considered one of the most important high-rise designs in the history of architecture. This is due, above all, to its revolutionary urban placement. The rectangular office tower, placed along Park Avenue, is set back from the street leaving space in front for a wide public plaza with two fountains. For the first time, it was possible for passers-by to look at a high-rise without having to cross the road to do so. The open space in front of the building set a new standard in high-rise construction, which from 1961 became a component of the zoning laws of the city of New York.

By setting the building a significant distance back from the street, Mies, like Gordon Bunshaft with his Lever House (p. 64), was able to design it as a pure cube without set-backs at higher levels. But since the planned office tower took up only a quarter of the surface of the site, he had, from an economic point of view, far too little rentable office space. Its height was also limited by the number of elevators required for access. Mies extended the usable surface area by placing a "backbone" at the rear of the building which stands three axes wide, but only one axis deep, for all thirty-nine stories. Together with an attached T-shaped volume of four and ten stories respectively, it enlarges the office area by more than one-third.

Side view of the building

The building, set back from the street, forms a spacious plaza on Park Avenue

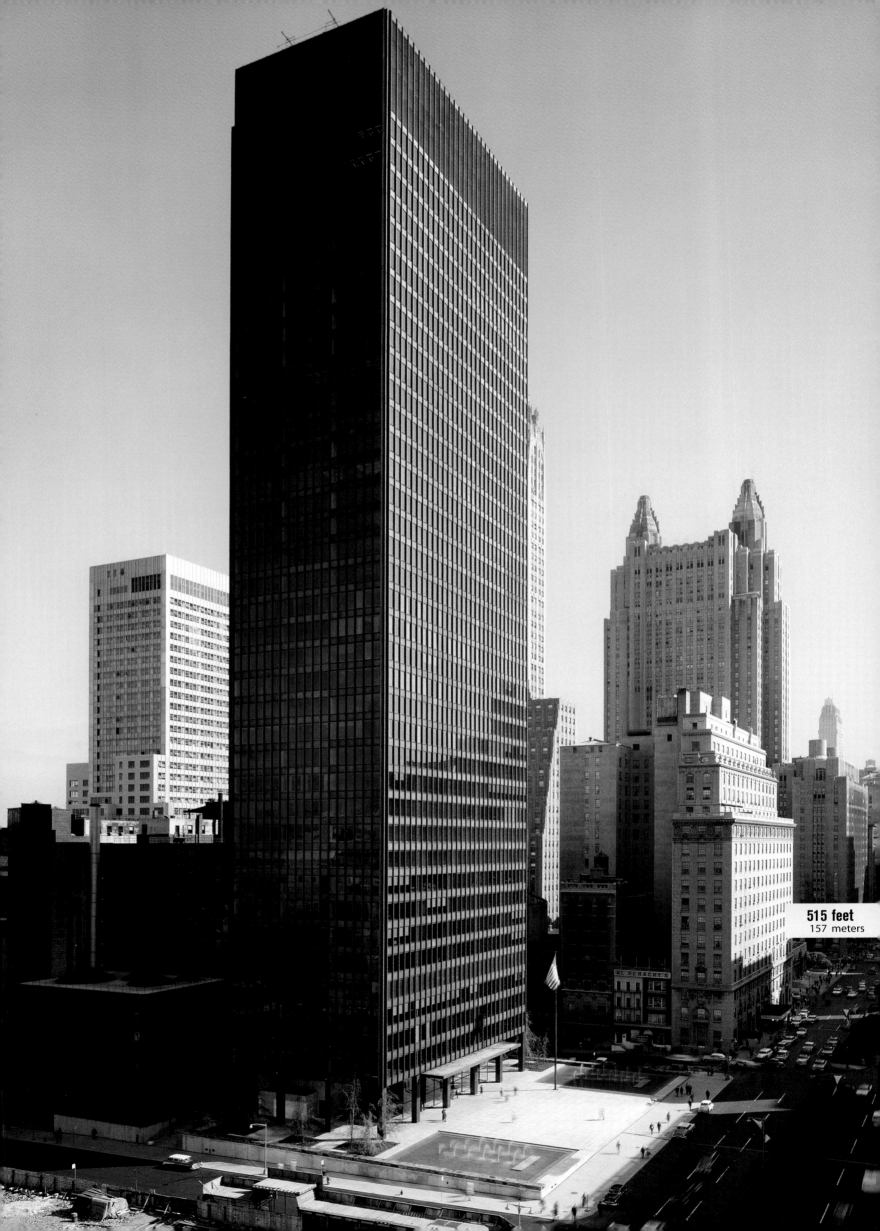

515 feet
157 meters

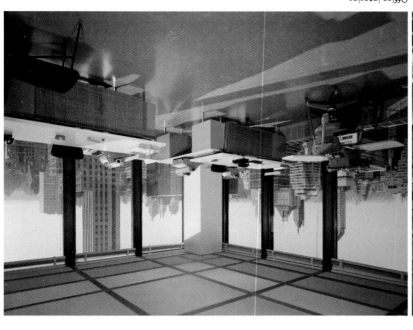

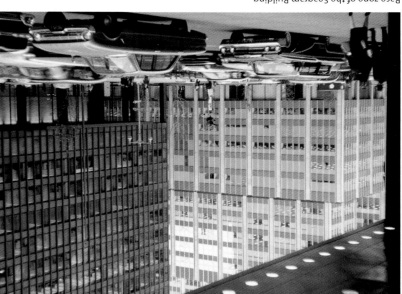

The Seagram Building in its urban context

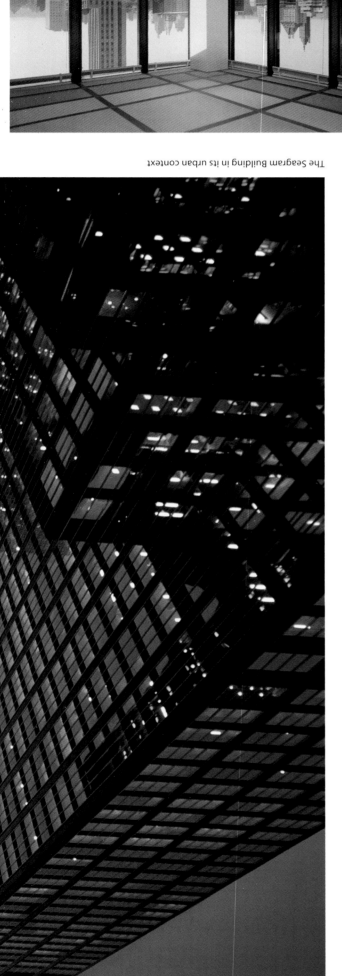

Design sketch for the plaza by Mies van der Rohe (1955)

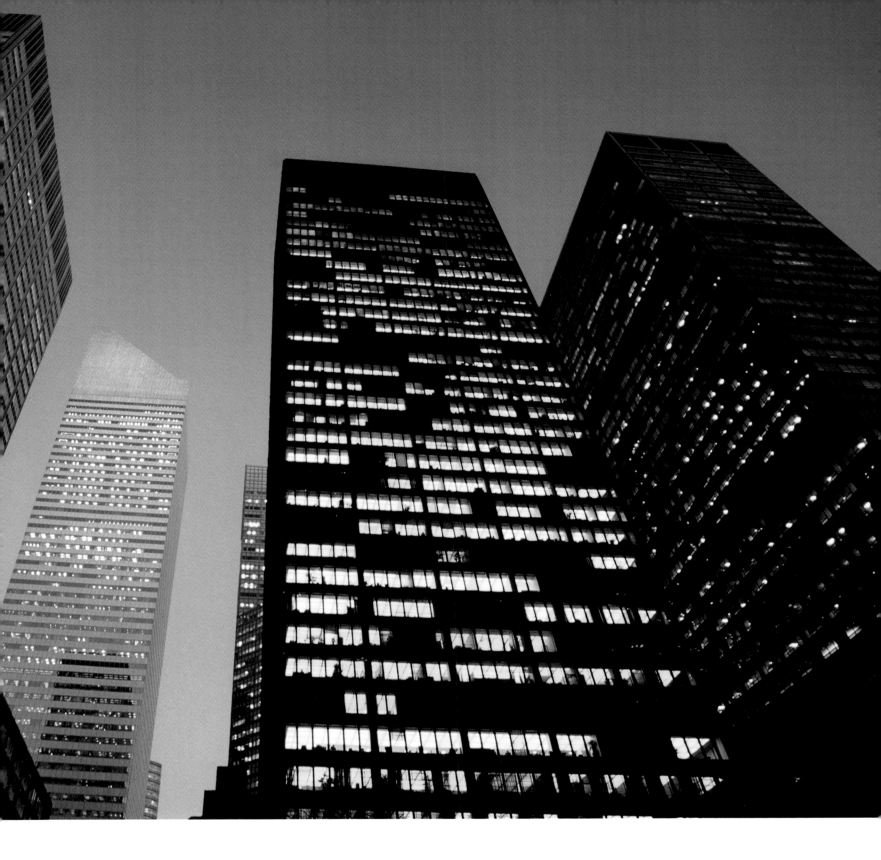

The design of the building is based on a modular pattern which determines all proportions relating to size. Mies's theoretical requirement for a clear, rational structure for all buildings is realized once more in exemplary fashion in the Seagram Building. The office tower itself is in its ground plan a rectangle with the harmonious relationship of 5:3 axes. The two-story entrance hall, faced with travertine, lies directly behind the plaza. A bronze curtain wall surrounds the tower and allows clear recognition of the load-bearing structure. As with the Lake Shore Drive Apartments (p. 62), double-T supports are placed in front of the window posts which run vertically around the building, giving an element of relief to the facade. For the first time, a skyscraper was provided with windows of the same height as the room. With their topaz coloring they relieve the impression of the uncompromising transparency of colorless panes, harmonize perfectly with the bronze frame, and give an impression of closure to the building.

In the Seagram Building, Ludwig Mies van der Rohe combined his visions of the 1920s with the practical experience he had gained in America since 1938. In the realm of high-rise building, modernist architecture attained, from an aesthetic point of view, its unsurpassed peak. The Seagram Building became the icon of the modern high-rises and thus, in the decades that followed, the most frequently imitated example of its genre worldwide.

Torre Pirelli Milan, Italy

15

Gio Ponti with Pier Luigi Nervi

1956–1958
417 feet / 127 meters

With the Torre Pirelli, the skyscraper finally finds its realization in Europe as a concept of intensified building in the center of a city. That this should have appeared in, of all places, Italy and directly next to the railroad station in Milan, reflects the courage displayed by both client and city authorities for this particular phase of postwar architecture. Here, one clearly wanted to prove something to America, and Gio Ponti, architect, designer and longtime editor of the magazine *Domus* chose as his partner for this project undoubtedly the most innovative structural engineer in Italy, if not of his entire era, Pier Luigi Nervi.

For the Italian car tire company Pirelli, Ponti and Nervi designed one of the most elegant, expressive and frequently imitated high-rise buildings. Walter Gropius' Pan Am Building (today the MetLife Building) in New York, built in 1963, was the first tribute to the structure in Milan. The Torre Pirelli rises from a greatly extended polygonal base, 230 feet (70 meters) long and only 61 feet (18.5 meters) wide at the center. Because of its extremely flat profile, the structure had to be designed for maximum stability to withstand the force of expected high winds. An additional challenge was posed by the unfavorable soil of the site, which at that location consists of layers of sand and gravel to a depth of 164 feet (50 meters). The load-bearing structure, custom-made by Luigi Nervi, consists of reinforced concrete and is clearly detectable from the outside. Two triangular supports on each of the short sides and two upward-tapering concrete supports in the center form the vertical framework which harnesses the horizontal structure. A general impression of tension is created by the fact that the corners of the building do not join, but are separated by a gap and the roof also does not lie on the upper edge of the building. The construction elements of the interior were also expressively designed by Nervi and clearly demonstrate the relationships of the forces of energy. The individual sections of the load-bearing structure taper upwards and are calculated to precisely match the height of the building. This results in a structure that is logically closed in on itself and, unlike American steel skeleton structures, cannot be extended at will.

The Torre Pirelli is a landmark in Milan

In its integration into its surroundings, the Torre Pirelli follows its own path too. It is positioned in the center of the site and, with a sloping platform, creates a drive to the main entrance suitable for motorists and access to the lobby on the first floor. At ground level, the Torre Pirelli does not form its own base, but rises directly from the ground behind the deliberately empty spaces between the outlying access platform on one side and the low, adjoining buildings in the back. Below the outlying platform is an auditorium with 600 seats and in the back the cafeteria, personnel entrance and delivery ramps.

Contemporary reactions to the Torre Pirelli among architectural critics were not particularly positive. In 1961, for instance, the architectural writer Reyner Banham called it a "giant billboard" and a "piece of advertising architecture." Nevertheless, the Torre Pirelli is today considered among the most successful and elegant high-rise buildings and represents a late, highly significant European contribution to the international discussion. Currently, the building belongs to the regional administration of Lombardy, which bought it in 1978.

On April 18, 2002, for reasons still unexplained, a small aircraft crashed into the 26th story of the Torre Pirelli. Two employees and the pilot were killed. However, the suspicion of a terrorist attack, such as was feared in the aftermath of September 11, 2001, proved to be unfounded. In 2003 the building was restored in accordance with principles for the preservation of historic monuments.

Typical floor plan

Total view of this very elegant and balanced high-rise building

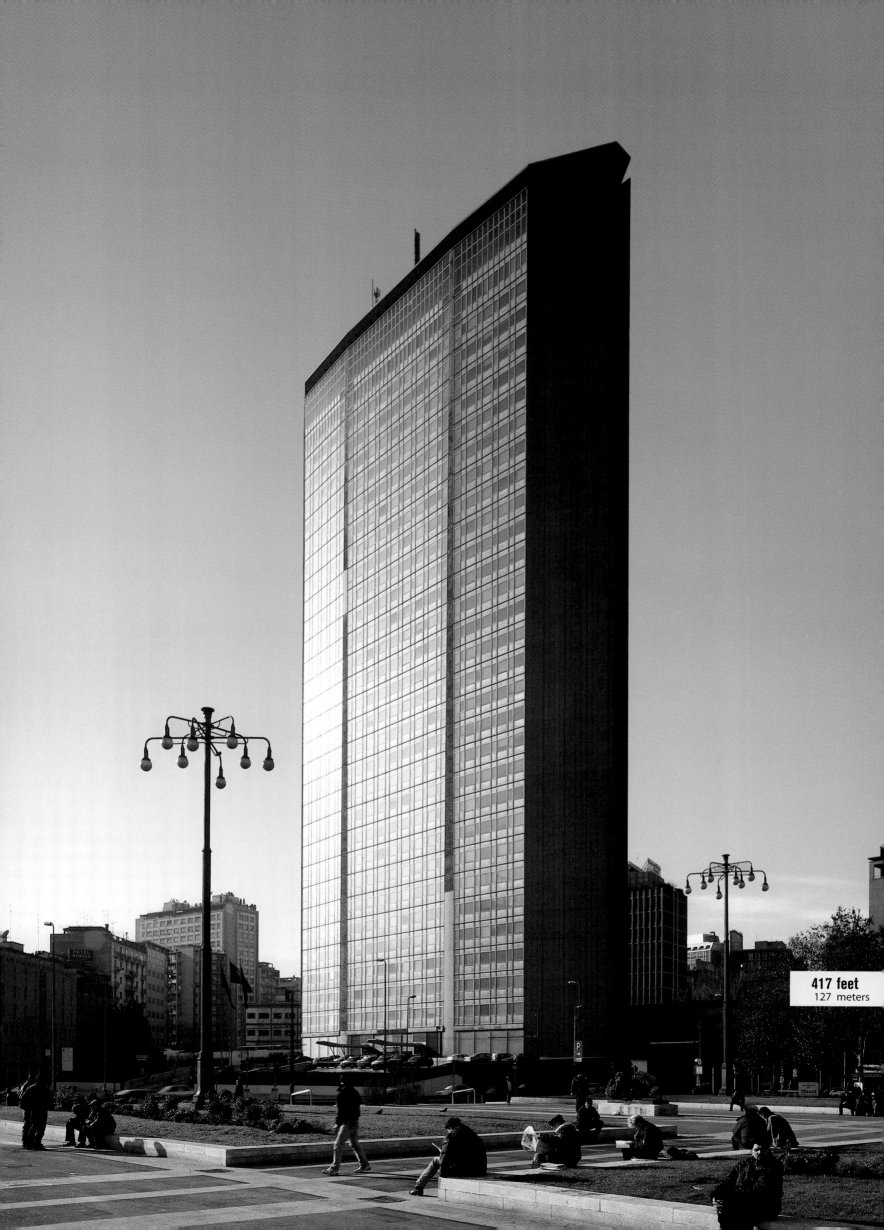

417 feet
127 meters

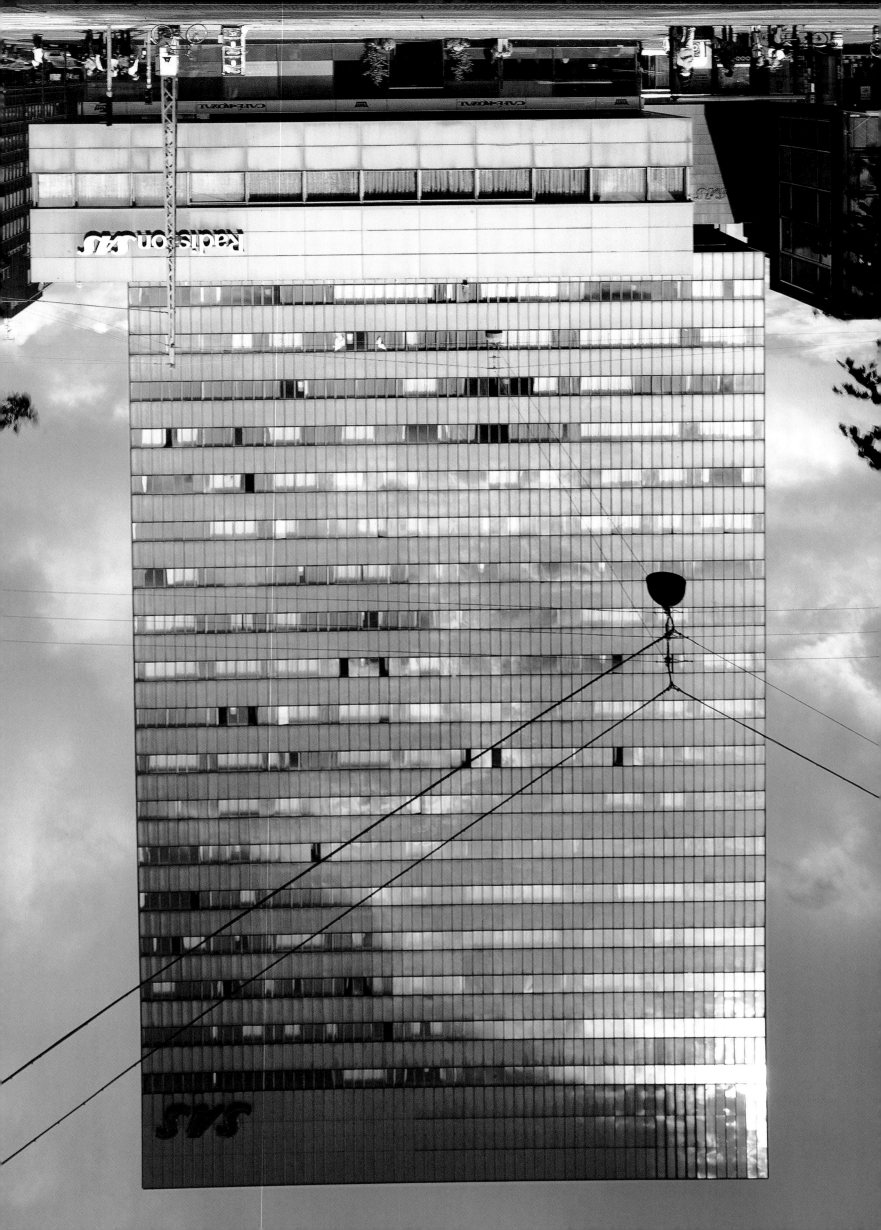

Radisson SAS Royal Hotel Copenhagen, Danmark

Arne Jacobsen

1956–1960
228 feet / 70 meters

Because of steadily increasing commercial airline traffic in the postwar period, in the mid-fifties Scandinavian Airlines System (SAS) made plans for a central city terminal with an adjoining hotel in Copenhagen, near the railway station. Airline passengers who arrived by train or by ferry to continue their journey by air were to be able to check in straight away at the city terminal. And conversely, passengers arriving by air could use the terminal with its own hotel for stopovers. Stores, restaurants, a bar and sauna would all serve to make the waiting and transfer periods as pleasant as possible. The general enthusiasm for this push toward modernization combined with an ambitious building project of this kind was, however, tempered by public concern. Since the twenty-two-story highrise was to be located right on the edge of the old city, there were fears of excessive traffic and impairment of the cityscape.

The Danish architect Arne Jacobsen provided the design for the hotel, thereby transferring the concept of the modern American high-rise to the Nordic countries. Discussions of the day made mention of the obvious connection to Lever House in New York (p. 64). Like Lever House, the SAS Hotel is a closed cube which rises diagonally from a low two-story base, above which it seems to float. In contrast, the SAS Hotel is closed at street level and its load-bearing structure consists not of steel but of concrete. It is the multiple use of the ground floor for the hotel lobby and city terminal with travel agencies, a bank, waiting and transit areas that creates a direct and functional relationship with the city. On the ground floor of the base there is a quiet area with restaurant, offices and conference rooms.

The exterior effect of the SAS Hotel is determined by the finely structured curtain facade with its grayish-green glass in an aluminum frame. Jacobsen chose these colors in order to soften the block-like effect of the high-rise through the light coloring and the reflection of the sky in the glass. Since the surface proportion of the transparent

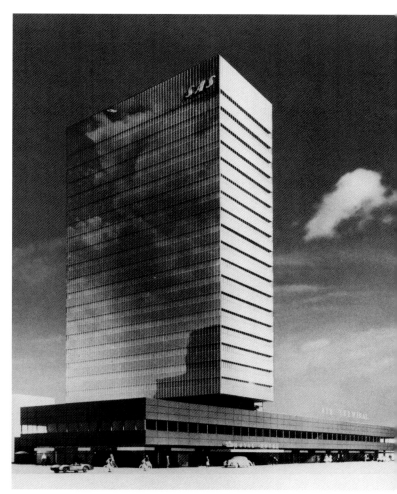

The structure of the building is similar to that of the Lever House in New York

windows is somewhat lower than the opaque glass panels lying between them, an impression is created of a light structure which is however closed in on itself. Because of the hotel windows, which can be opened from the inside, the facade in everyday life appears not to be a hermetically sealed surface, but one dynamically structured by the varied apertures.

Arne Jacobsen had been given the commission to provide a total design for the SAS Hotel in all its details, from the furnishings to the wall design, from the lamps to the ashtrays. In the SAS Hotel, he combined his personal interpretation of international modernism with Nordic design into a sort of *Gesamtkunstwerk* of the 1960s. Unfortunately the interior decoration was altered only a few years after the opening, and after drastic renovation in the 1990s, only room 606 was preserved with its original furnishings.

228 feet
70 meters

Room 606, the only room still preserved with its original furnishings

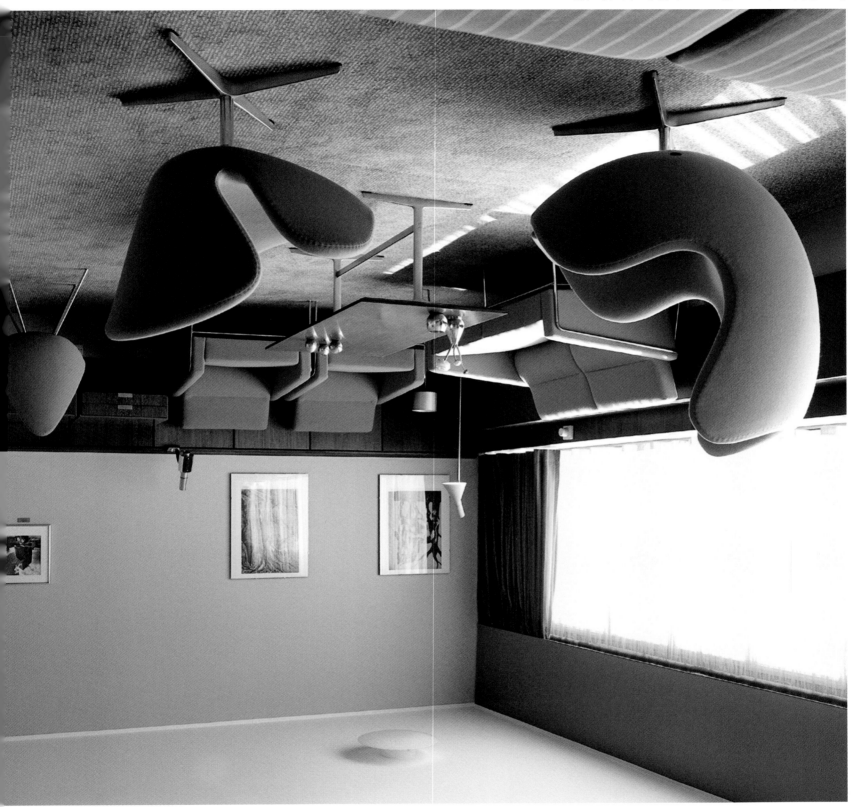

Typical floor plan of the hotel

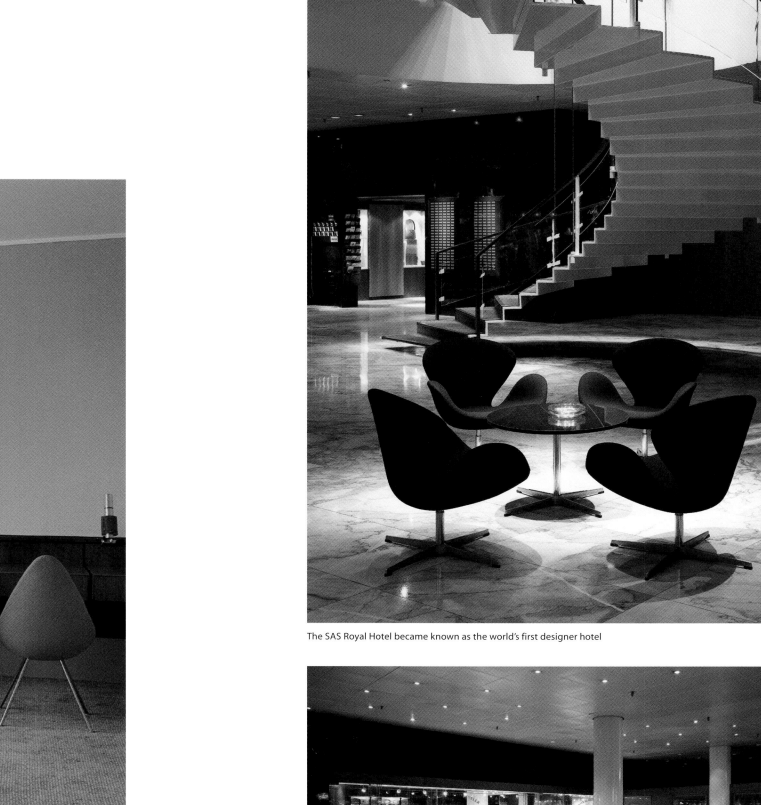

The SAS Royal Hotel became known as the world's first designer hotel

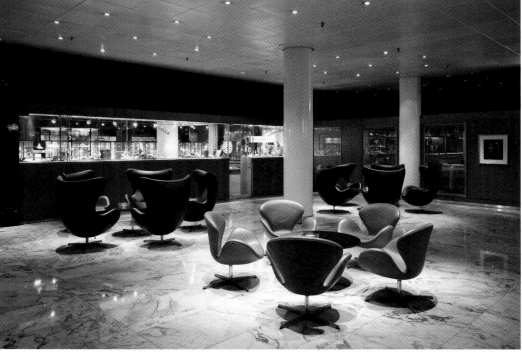

The hotel lobby with the classic Egg and Swan chairs

Thyssenhaus Düsseldorf, Germany

HPP Hentrich-Petschnigg & Partner

1957–1960
311 feet / 95 meters

The so-called *Dreischeibenhochhaus*, or Three Slices High-rise, in Düsseldorf was built between 1957 and 1960 as an administrative building for the steel firm Phoenix-Rheinrohr AG (later Thyssen Krupp AG). It was designed by the German architect Helmut Hentrich in partnership with Hubert Petschnigg. This slender, elegant building, an urban solitaire in the city center, stands directly on the main traffic axis into the city and near the green zone of the Hofgarten. Its longitudinal axis runs north to south, and the 279-foot-long (85 meter) side views face east and west. The horizontally striped facades, consisting of alternate transparent and opaque blue glass in an aluminum frame, are freely suspended as a curtain wall in front of the structural framework of the building. The windowless fronts are faced with sheets of reflective stainless steel, which is also used as wall cladding within the lobby.

The floor plan of the Three Slices High-rise is indicative in its composition. The three narrow volumes are placed parallel to each other, each staggered by one-third. The central volume is taller by eight axes and contains the supply core with the elevators, stairwells and sanitation area in its center. All three volumes overlap by eight axes around the supply core. The two side structures do not reach the full height of the central one. They are also not flush with it at the points of contact, but recede slightly. This in turn creates the impression from the exterior of three separate structures.

The entrance hall after renovation

The interior spaces are functional and effective. All office spaces receive natural light, and those situated at the ends of the central structure receive natural light from two sides. The corridors run lengthwise between the office volumes and receive daylight from the contact points between the structures. The entrance lobby extends over two stories and has a view to both the east and the west. Above the 22nd floor, used by the board of directors, is the employee's dinning hall for the 1,800 staff members.

As one might expect from a company in the steel business, the high-rise was constructed using a steel frame. The round supports lie directly behind the glass facade and are clearly visible slightly above ground level where the curtain facade ends. The need to stabilize the narrow volumes of the building in order to protect them from enormous wind forces of up to 1,200 tons represented a special static challenge. The diagonal supports used for this purpose are recognizable only in the glazed connections between the three structures. In 1994 the building was renovated in accordance with principles for the preservation of landmarks by the architectural office of Hentrich-Petschnigg & Partner.

The Thyssenhaus has remained to the present day both a landmark for the city of Düsseldorf and a symbol of the rapid economic growth in Germany after the Second World War. It transmits the lessons of the first modernist high-rise buildings from the USA to German postwar architecture. Through its exceptionally elegant, sculptural form and its complex ground plan it has set standards which are even recognized in America.

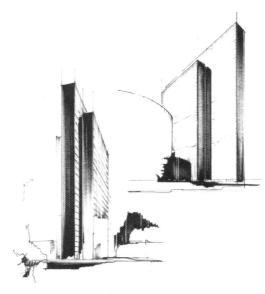

Design sketches from the competition for the Thyssenhaus

311 feet
95 meters

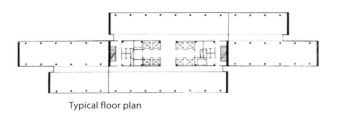

Typical floor plan

 18 # Marina City Chicago, Illinois, USA

Bertrand Goldberg

1960–1962
588 feet / 179 meters

Typical floor plan

After completing his studies at Harvard, the architect Bertrand Goldberg, born in Chicago in 1913, studied with Ludwig Mies van der Rohe at the Bauhaus in Berlin in 1932, the last year of its existence. After working in Mies's office, he then broke away from his teachers and began his own research into the functional utilization of spaces. The high-rise project Marina City was designed by him as a "microcity" or "city within a city." With new, functionally varied living concepts he sought to oppose the increasing depopulation of city centers. With this in mind, the total complex includes, apart from the two restrained tower structures, an office high-rise, a theater and a private landing stage on the Chicago River; there are also green spaces and an ice-skating rink.

The two round towers represented an aesthetic breakthrough in the inner city of Chicago, dominated for decades by right angles. At the same time, they were the tallest buildings of their day to be executed in reinforced concrete, and were thus a reminder of its structural possibilities. Goldberg showed that with the sixteen-sided ground plan, which produced a circular effect, it was possible to achieve an optimized relationship between the exterior surface and the interior space. With a height of 588 feet (179 meters), the towers contain a total of sixty-five stories above ground. The lowest twenty-three stories form a car park, which is reached by a spiral drive starting from the street. Above this base, which allows car-friendly access directly into the building, is a service area located on the 25th floor. Then come forty residential floors with a total of 896 apartments. All of the stories are arranged radially around a central supply core, which at the same time forms the structural backbone. In the construction of the two towers, the floors were built upwards in a graduated series from the central core. Marina City thus translates the idea of the tree-like high-rise, which had been used by Frank Lloyd Wright in the Johnson Wax Research Tower (p. 60), into the urban scale, and combines it with new approaches. The facades of Marina City have a look which was until then entirely unknown in high-rise building. The lower stories with the parking spiral are open to the exterior and, with the constantly changing movement of vehicles being parked, form a dynamic, popular sight. The balconies in the residential stories, attached in semicircular form to the towers, form a biomorphic relief that lent them the nickname of "corn cobs."

With their aerodynamic shape, the double towers of Marina City anticipate the solution to a late twentieth century discussion concerning ideal forms and protection from winds. At the same time, with their architectural adaptation of biological forms, the towers also allude to the latest architectural applications from bionics. At the time of their construction, they represented a significant new direction in terms of theory, building and urban planning which, however, had no direct consequences for sometime thereafter.

Facade details of Marina City, reminiscent of corn cobs

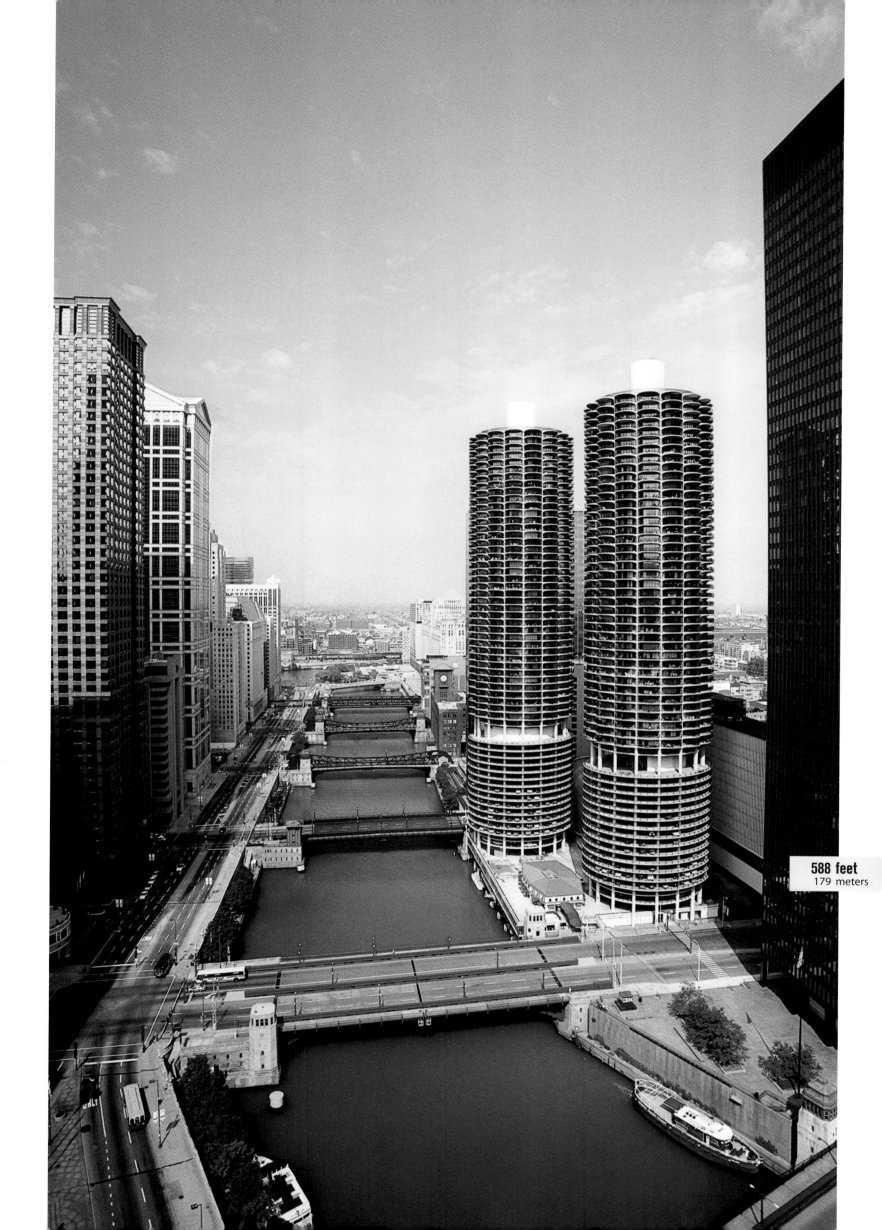

588 feet
179 meters

Economist Building London, UK

Alison and Peter Smithson

1959–1964
174 feet / 53 meters

Around 1960 the Economist Newspaper Group was planning a new building for an editorial office with an attached economic research organization, called the Economist Intelligence Unit. To start with, the client owned only a corner site between Bury and Ryder Streets. When the building authority specified a mixed use for office and residential space in a ratio of 5:1 and a greater overall building area, the publishing group bought further sites in St. James's Street.

St. James's Street extends from Piccadilly in a gentle descent down to St. James's Palace. The character of the street had been mainly determined by historic eighteenth-century buildings. According to the urban planning guidelines, the uniformity of the street was to be preserved, and at the same time views were to be available through the site which should be open to the street. After a limited competition, the British architectural team of Alison and Peter Smithson emerged as victors. They divided up the planned functions of the building project and designed a grouping of three spatially separated new buildings, oriented to the center of the block with an inner plaza. A four-story bank building stands on the front corner of St. James's Street, the office tower of seventeen stories is at the back, and the remaining corner accommodates an apartment block of seven stories.

The whole complex is constructed uniformly as a steel skeleton structure. The basic outline of the bank and office tower is based on a geometric pattern of 10.5 x 10.5 feet (3.20 x 3.20 meters), and that of the residential tower on a halved pattern. The facades are clad with Roach Bed Portland stone, inset between aluminum profiles. The outline of the office units is flexibly divisible and all workplaces receive natural light.

The first striking high-rise building of the postwar period in London was Richard Seifert's Centre Point, completed in 1963. On account of its isolated position in urban planning terms and above all because of its dominating height (365 feet / 111 meters), it was severely criticized on its completion. The Economist Building complex, however, indicated another way forward. The consideration of its historic environment that had been stipulated re-

Axonometric drawing: view from the southwest

sulted in a much discussed and well accepted urban solution. The Smithsons, who had been critically preoccupied with the heritage of modernism since the 1950s, succeeded in producing in the Economist Building a high-rise that was certainly of modest dimensions, but became exemplary on account of its incorporation into its urban surroundings.

174 feet
53 meters

Australia Square Sydney, Australia

Harry Seidler & Associates

1965–1967
600 feet / 183 meters

View of the lobby by night with a tapestry by Le Corbusier

When, in 1957, the city of Sydney lifted the restriction on building height of 148 feet (45 meters), the path lay open for the construction of high-rises in the city center. The stimulus for the first significant skyscraper came from the project developer G. J. Dusseldorp, who had immigrated from Holland. On the area of a city block, he planned an office tower of fifty stories, which however would take up only twenty-five percent of the site, leaving the rest free to be used as a public space. Harry Seidler was commissioned as architect.

Harry Seidler was born in Austria in 1923 and had fled in 1938, at first to England. After studying architecture in America, with Walter Gropius in Harvard among others, he was for a short time an assistant to Marcel Breuer. In 1948 he emigrated to his family in Australia. There he established himself as a valiant representative of the International Style. For the Australia Square Tower project he proposed two separate buildings on the site: a rectangular thirteen-story structure on one side and a round office tower of forty-five stories in the center of the site. Between the tower and the rectangular building he planned a two-level plaza with public cafés, fountains and benches.

The tower is built on a circular ground plan. In the center of the circle, with a diameter of 138 feet (42 meters), stands the static core with a diameter of 36 feet (11 meters). It contains eighteen elevators as well as the supply facilities and staircases. This division resulted in an excellent proportion of eighty percent usable floor space to twenty per-

cent traffic and functional space. The construction of the building came from Pier Luigi Nervi. He developed a dynamic load-bearing frame of reinforced concrete, similar to that of the Torre Pirelli in Milan (p. 70), in which the facade pillars retreat progressively upward according to the decreasing load. In the building of the high-rise, prefabricated concrete parts were used in significant numbers. The facade appears very sculptural through the lattice of the light-colored concrete buttresses, and the construction of the building is clearly comprehensible from the outside. On the 14th and 30th stories are installation spaces that, with their setback walls, give the building a structure divided into three parts. The office floors are completely free of supports and at the same time can be divided up in various ways. The 42nd story accommodates a revolving restaurant and the 43rd an observation platform.

Construction of the high-rise on Australia Square was linked with the intention to give Australia a further architectural landmark in addition to Jørn Utzon's Sydney Opera House. In the run-up to the completion of the high-rise tower, however, there were public protests because it was feared that such high-rises heralded the "Manhattanization" of Australia. The two Europeans Seidler and Nervi did indeed provide the impetus for further high-rises in the center of Sydney, including two more by Seidler himself. However, Australia Square still stands out on Sydney's skyline as among the best proportioned and best thought-out in terms of urban planning.

Upper and lower plaza plan

View of the Tower from above with a sculpture by Alexander Calder in the foreground

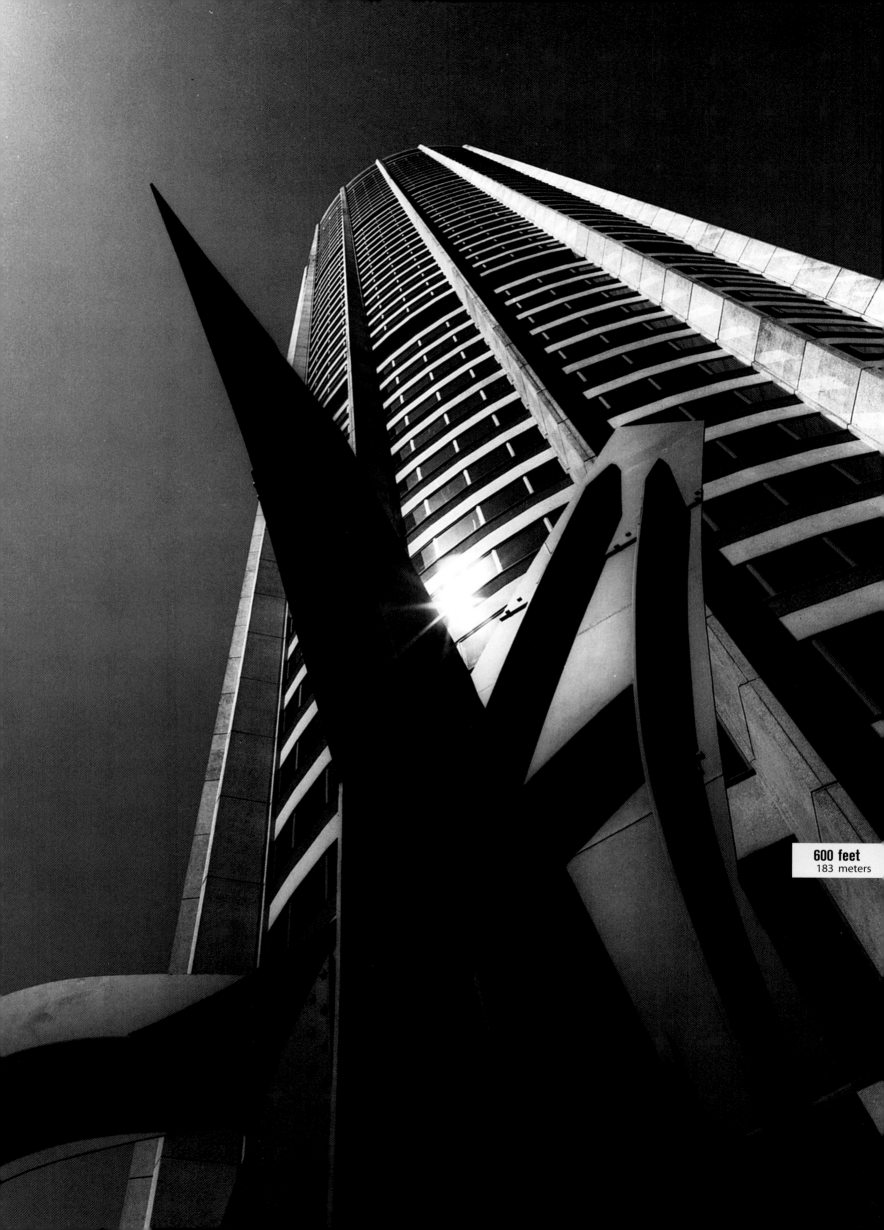

600 feet
183 meters

Lake Point Tower Chicago, Illinois, USA

Schipporeit–Heinrich Associates

1965–1968
645 feet / 197 meters

View of the cloverleaf-shaped building

Lake Point Tower is a residential high-rise on the shores of Lake Michigan, on a raised piece of land that extends out into the lake. Almost all of the approximately 900 apartments enjoy both a view of the lake, which has almost the aspect of an ocean, and a part of the Chicago skyline. The designing architects, George Schipporeit and John Heinrich, studied at the Illinois Institute of Technology with Mies van der Rohe, and subsequently worked in his office. After founding their own office, they received their first independent commission, Lake Point Tower. Their design was oriented on Mies's work in general, but not on his the nearby Lake Shore Drive Apartments (p. 62). Rather, they turned to Mies's famous idea of a glass high-rise building of 1922. At that time, Mies had presented a model in which he had explored the effect of reflected light on a curved, entirely transparent glass high-rise facade. His Berlin design of 1922 was considered an unrealizable utopia in its day, but in Lake Point Tower, Schipporeit and Heinrich transformed it into a real-life building project. They adapted the idea of the curved glass facade, combined with the effect of the structure as a large sculpture, to the functional needs of the building.

Lake Point Tower stands on a two-story, rectangular base. This base accommodates a garage with space for almost 700 vehicles, as well as two floors containing stores. The entrance to the apartments is in a circular courtyard on the ground floor. On its roof are a garden with pond and a playground for the residents. The load-bearing framework of Lake Point Tower is constructed of reinforced concrete. A triangular supply core 59 feet (18 meters) in length forms the central support, and includes the nine elevators, three stairwells and an installation shaft. The cloverleaf-shaped floor plan of the sixty-five residential floors, each with three corridor arms which protrude from the core, is efficient and comfortable. Originally a four-armed design was planned, but the three-armed variation offers the advantage that residents cannot see into each other's apartments. Each of the relatively short corridors leads to a maximum of six apartments, so that there is an uncomplicated overview of the passages. The connections for water supply, power, etc. are placed so that the apartment designs can be adapted to varying requirements.

The facade consists of bronze-colored sun-resistant glass in dark aluminum profiles. Like a net stocking, it forms a curtain wall drawn tight around the wave-like building and shows neither horizontal nor vertical subdivisions. On account of the strong winds from the immediately adjoining lake, it was decided not to add balconies. Each apartment has its own separately regulated air-conditioning unit placed between the facade and structural skeleton. Fresh air can also be introduced directly through ventilation slits.

Lake Point Tower continues the principles of high-rise construction formulated by Mies van der Rohe in the International Style and enriches it with both earlier elements and contemporary functions. With its box-shaped base, the building is admittedly completely isolated from its urban surroundings, presenting itself as a hermetically sealed sculpture, open only on the inside and thus exclusively to its residents.

The residential high-rise lies directly on the shores of Lake Michigan

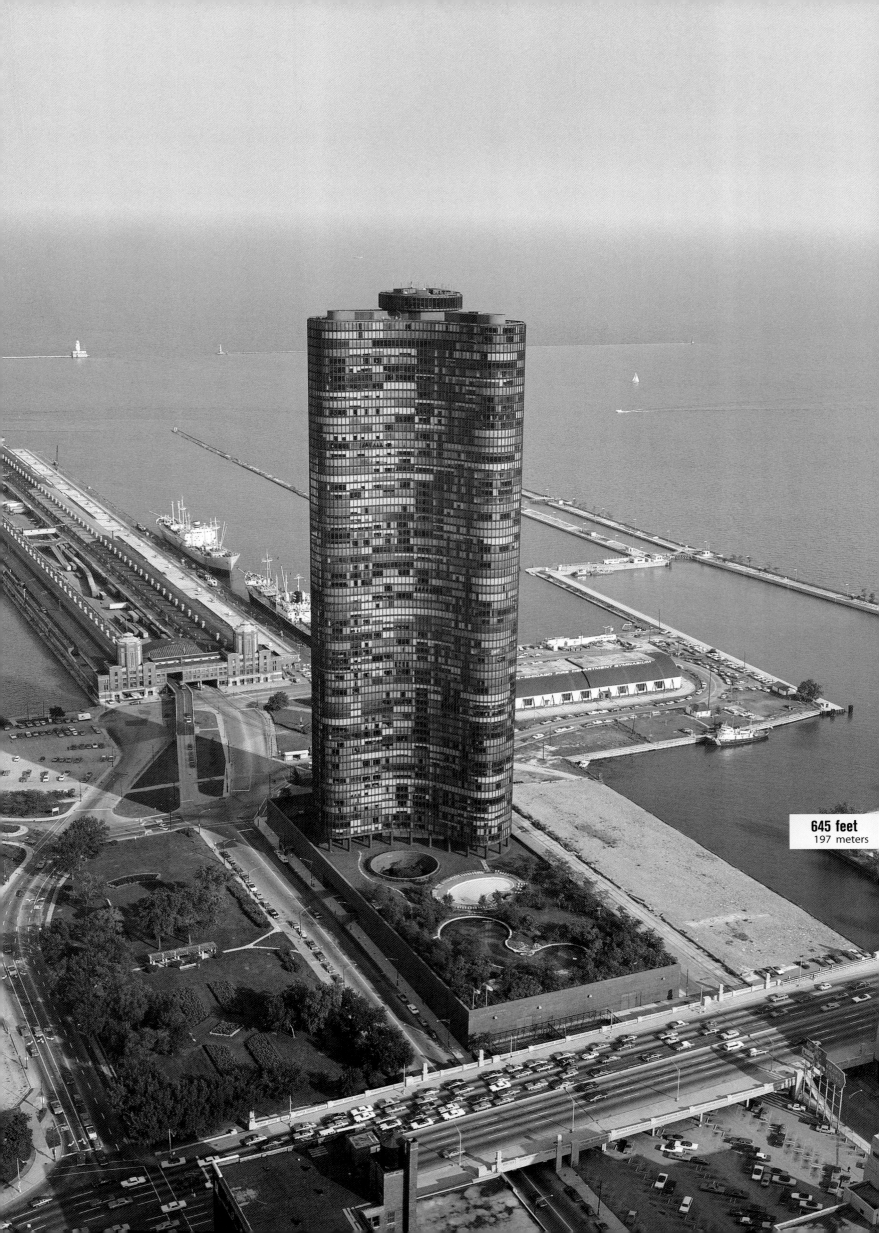

645 feet
197 meters

The curved glass facade is modeled on Mies van der Rohe's design for a glass high-rise

Detail view of the facade

Access to the apartments is from the circular inner courtyard

Site plan

John Hancock Center

SOM Skidmore, Owings & Merrill

1965–1969
1,127 feet / 344 meters

View from the interior

In the early 1970s the competition for the title of tallest high-rise building in the world flared up yet again. For economic reasons most high-rises of this period remained between 650 and 820 feet (200 to 250 meters). In New York, for example, the tallest buildings of the 1960s were One Chase Manhattan Plaza at 813 feet (248 meters), followed by the Pan Am Building at 807 feet (246 meters). In Chicago they were Marina City (p. 78) at 588 feet (179 meters), the Richard J. Daley Center at 635 feet (194 meters) and the Lake Point Tower at 645 feet (197 meters)(p. 84). Chicago began a new generation of height records with the John Hancock Center, which was only 123 feet (37 meters) short of the record-holder at the time, the Empire State Building (p. 50).

The basis for this new thrust was provided by new structural concepts. The revolution in the development of high-rise construction, however, did not originate with architects but rather from engineers. The primary innovation was in of all things, the facade, where it was least expected. Fazlur Khan, an engineer working for SOM, simply dismissed the system of the non-load-bearing facade that had become a credo since the advent of modernism. For the John Hancock Center he developed a system in which a steel tube, load-bearing framework forms a very stable and at the same time visible megastructure. Compared with traditional construction methods, this concept enabled building to greater heights with a lesser quantity of steel. Thus, a building of 100 stories could be produced at a cost similar to that of a forty-five story high-rise. As a result, height records once again became interesting in economic terms.

At the same time the John Hancock Center set a new milestone in the architectural dramatization of height. The building, a slender, linear, upward-tapering obelisk has the effect of an oversized minimalist sculpture. The structure terminates above the 100th story, but its converging contours meet in an imagined continuation in a spire far above the top of the building. The facade of the skyscraper is once again both component and expression of its load-bearing structure. By placing the windows in the spatial center of the steel load-bearing structure, the facade is transformed into an expressive, dynamic relief. Bruce Graham, the architect designing for SOM, said: "It was essential to us to expose the structure of this mammoth as it is to perceive the structure of the Eiffel Tower…" Here, the engineering aesthetics of the nineteenth century indirectly return as a design method in the high-rise buildings of the twentieth century.

The John Hancock Center, in the Chicago tradition, is designed for varied functional use. In its lower area it contains five business floors topped by a six story garage. Above these are twenty-nine stories of office space. Next comes a hotel, and above, in stories continually reduced in terms of floor space, forty-eight stories of apartments. The concept of a high-rise formulated as early as the 1920s by Raymond Hood as a "city within a city" finds its expression in the John Hancock Center with its integrated supermarket, post office and swimming pool. On the 94th floor, one finds an observation platform, on the 95th and 96th a bar and restaurant. From the viewpoint of urban planning integration, the John Hancock Center is admittedly hardly exemplary. The sunken plaza in front of it, since its redesign in 1995, does not reveal any clear relationship between the monumental building and the urban space in which it stands.

Ground floor plan

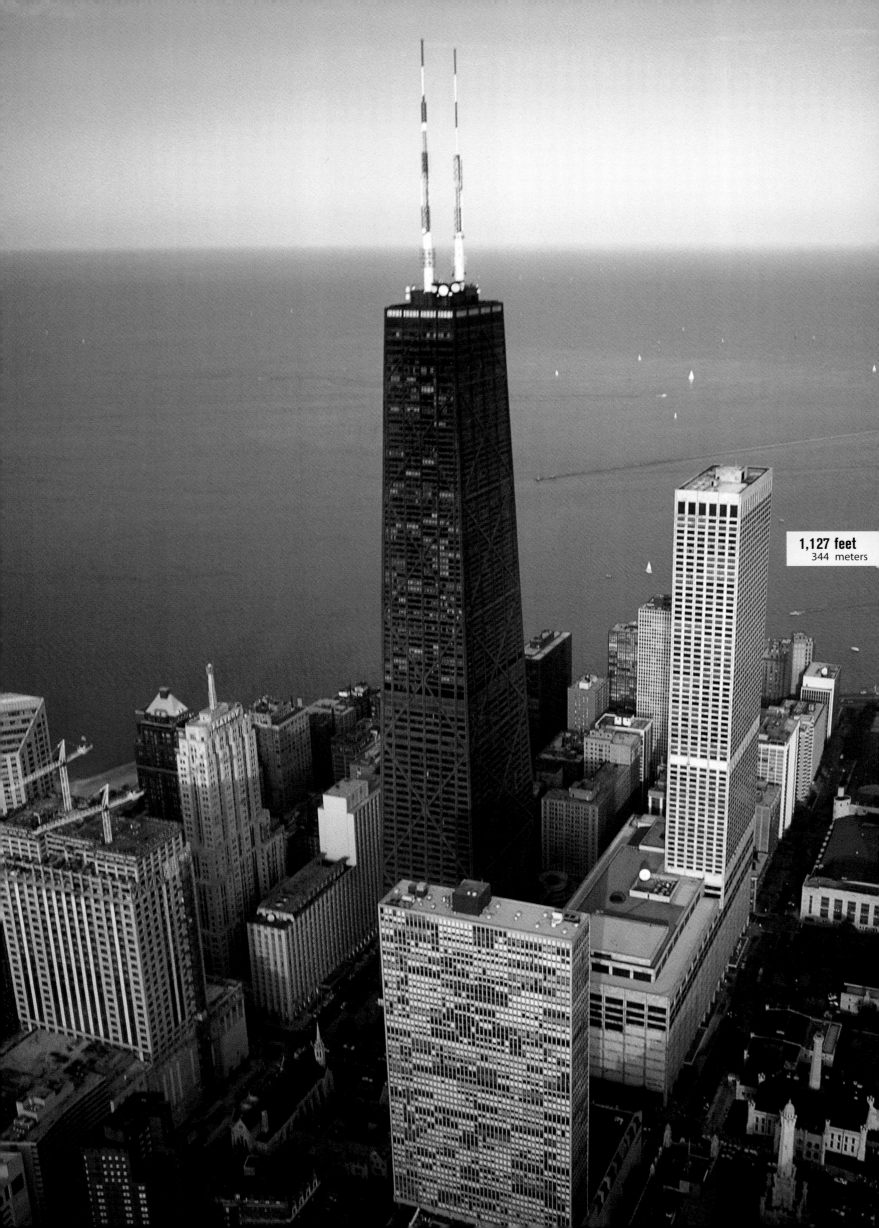

1,127 feet
344 meters

Nakagin Capsule Tower Tokyo, Japan

Kisho Kurokawa

1970–1972
177 feet / 54 meters

Model of the Nakagin Capsule Tower

Typical floor plan

Around 1960, a group of young Japanese architects reacted to the increasing population density of Japan's big cities by creating the theoretical approach of Metabolism. The Metabolists developed concepts through which architecture could react to the ever more rapidly changing needs of individuals, society and cities. These concepts included ideas about floating cities and other structures which are not hierarchically organized and are intended to take account of future growth and functional alterations.

While the large urban concepts of the Metabolists remained unrealized, the Nakagin Capsule Tower is among the few individual projects to have been executed. It fulfills the two essential demands of the Metabolists, a durable primary structure on the one hand and a flexible secondary structure on the other. In this case, the primary structure consists of two parallel square towers of reinforced concrete, which represent the static framework. Inside, they contain stairs, an elevator and the supply networks. The secondary structure is composed of prefabricated residential cells, which are fitted spirally around the two central cores. They are conceived as elements that can be linked to one another and are interchangeable. The residential cells consist of a steel frame construction clad with sheet metal paneling, for which ship containers served as constructive models. Inside, they are fully furnished with a permanently fitted bath, bed, seating, storage space, television, an air-conditioning unit, and a circular window. In theory, these cells could be removed at any time and installed again elsewhere. Another possibility of connecting several cells together to form larger units was never carried out in practice.

The interior spaces are reminiscent of ship furnishings

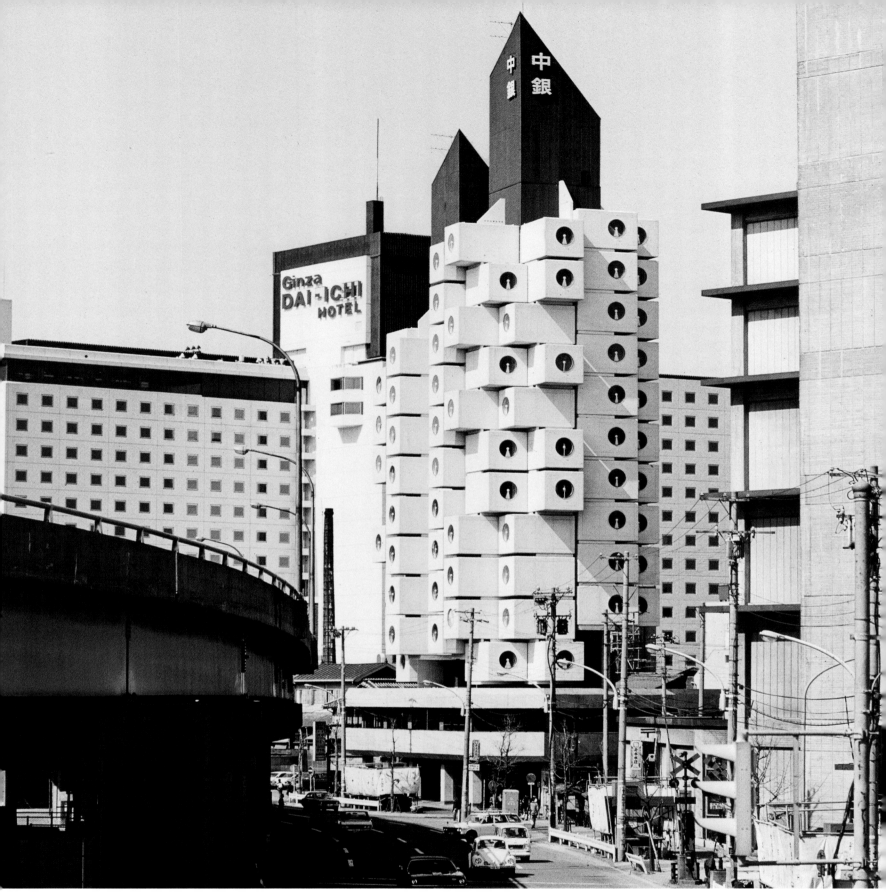

View of the Nakagin Capsule Tower

Thirty years after being built, the Nakagin Capsule Tower still creates an impression that is unusual in every respect. While the two-story base with its office space, lobby and restaurant for the residents seems comparatively conventional, the tower building that rises above it manifests a very complex structure, not readily comprehensible from the exterior. Because of the added residential capsules, the building has no facade, but rather resembles an organic relief. The arrangement of the capsules follows an aesthetic principle derived from the traditional structures of Japanese temples. The Nakagin Capsule Tower is the tangible result of an ambitious and much-debated theory whose utopian approach, however, had little real effect on later architecture. In spite of international protests, the owners decided to demolish the building in 2007.

177 feet
54 meters

Transamerica Pyramid San Francisco, California, USA

William L. Pereira

1969–1972
853 feet / 260 meters

In 1956 Frank Lloyd Wright had already given his utopian project, the One-Mile-High Skyscraper, the form of a needle-shaped pyramid. In practice, the pyramid in high-rise construction had been mostly used only in a truncated form as a roof decoration, the disadvantage being that the more its height increases, the less usable space it offers.

In 1968 the Transamerica Corporation, one of the greatest purveyors of financial services in America, was planning a new building for its headquarters in the inner city of San Francisco, at the entrance to the financial district. The Chicago-born architect William L. Pereira decided in favor of a pyramid design, so that the tall building could be given as much light and room as possible in the narrow space available. In addition, Pereira wanted to give the building a form that would be significant for the cityscape. When his plans became known, there was strong public resistance. Since the 1950s, high-rise buildings had mostly appeared as rectangular boxes, so the pyramid was considered unsuitable in the context of the inner city. But with the simultaneous development of postmodernism, opinions soon changed. Symbolic buildings became recognized as part of the formation of a local profile, and so the Transamerica Pyramid too acquired the status of a landmark, an urban symbol of recognition that was marketed in films, postcards and souvenirs.

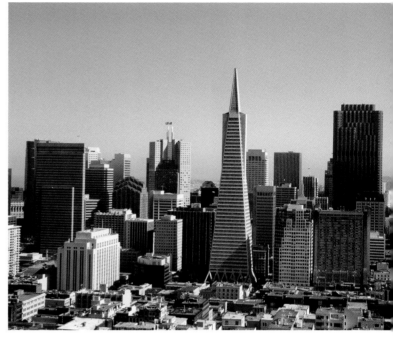

With its silhouette, this high-rise emerges prominently from the skyline of San Francisco

Since San Francisco is located in an area threatened by severe earthquakes, the construction of the Transamerica Pyramid, as with all high-rises in this region, had to comply with strict security specifications. The building must be able to resist a tremor of up to 8.3 on the Richter scale. Under these conditions, the pyramid form in and of itself is advantageous, as its main weight lies in its lower part. The steel frame construction had special pyramidal rigid elements built in between the second and fifth floors, which are visible from the outside, and earthquake-resistant elements were also incorporated in the facade. In 1989 an earthquake of magnitude 7.1 shook the building, which swayed for more than a minute without incurring any damage.

853 feet
260 meters

Of the building's forty-eight floors, the lowest four are used for a restaurant, lobby and garage. Above these, all the floors are used for offices, including the top floor which is a conference room with an all-round panoramic view. The aluminum-clad peak is a purely decorative addition. The two "ears" protruding at the sides from the 29th floor up are, however, functional and contain on one side the elevator shafts and on the other a stairwell.

On account of its striking form, the Transamerica Pyramid very rapidly became a well-known building within and beyond the United States. The firm itself now uses only a small part of the surface area, but the firm's logo which is derived from the architecture remains a familiar symbol.

Detail of the load-bearing structure

The striking pyramidal form was adopted as the commercial logo of the Transamerica Corporation

World Trade Center New York, USA

Minoru Yamasaki with Emery Roth & Sons

1966–1973 (WTC I) / 1973 (WTC II), both destroyed in 2001
1,368 feet / 417 meters (WTC I)
1,362 feet / 415 meters (WTC II)

Worm's eye view

On September 11, 2001, some 3,000 people were killed in a terrorist attack by two passenger aircraft on the Twin Towers of the World Trade Center. One of the most spectacular accomplishments of high-rise building thus became indissolubly associated with one of the greatest civil catastrophes of postwar times. Most of the victims died in the collapse of the two skyscrapers.

Looking back, no one will claim that in the thirty years of its existence the World Trade Center had been a building loved by the general public or indeed by architectural critics. Its dimensions were incomprehensible and its design was of minimalist severity. It was almost an abstract monument to itself, an architecture of the sublime whose only effect on the observer was one of stunned astonishment. But the powerful reactions to its destruction made it clear that the Twin Towers had become both an inseparable part of the urban landscape of New York and a symbolic structure for the nation.

The client who commissioned the World Trade Center was the partially state-run institution, the Port Authority (PA). The PA was founded in 1920 by the two states of New York and New Jersey in order to develop the bridges, tunnels and harbor areas and operate them profitably. By the early 1960s, the PA had become one of the most powerful organizations of New York, and was beginning to plan a gigantic office complex which was to give Lower Manhattan a new economic impetus. The contract for the design went to the Japanese-American architect Minoru Yamasaki. He had to accommodate almost 10 million square feet (1 million square meters) of office space! After producing more than 100 draft designs, he found the solution in a double tower with additional, smaller buildings in and around a linking plaza at the base. The idea of also making this into the tallest high-rise building in the world arose only in the course of planning and came from the client.

The last remnants of the facade after the attack of September 11, 2001

Beams of light recall the Twin Towers

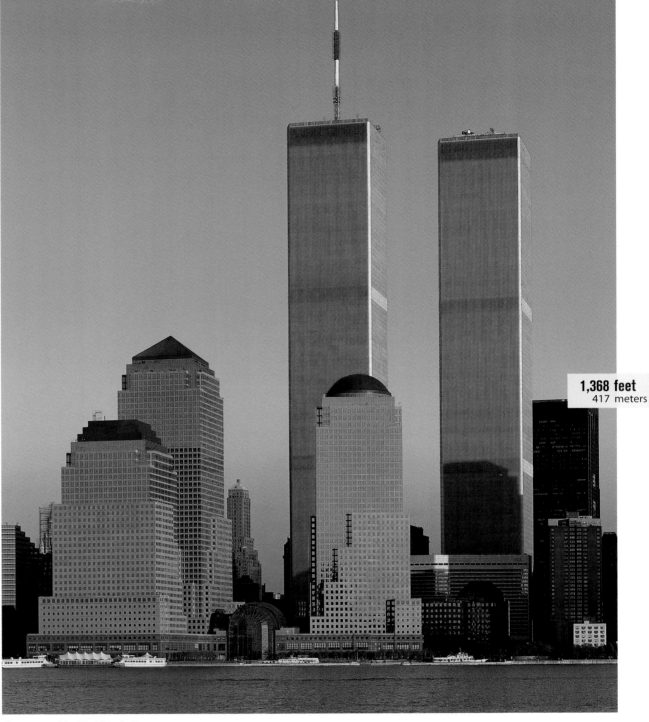

The towers of the World Trade Center

The static construction of the WTC developed by Yamasaki was similar to that of the John Hancock Tower in Chicago. It was a rigid structure of tubes, in which about half of the total load was carried by the fifty-nine steel supports on all sides of the facade. The interior surfaces remained flexible and unsupported. Yamasaki also reduced the spatial requirements of the supply core with a new concept for the elevators. The excavated material for the hugely extensive foundations, about 35 million cubic feet (1 million cubic meters) of soil, was piled up immediately next to the shores of the Hudson and later formed the site for the high-rise complex of Battery Park City.

The effect of the completed WTC surpassed all expectations and all fears. From then on the Twin Towers dominated the skyline of south Manhattan as sole architectural ruler. The reactions of critics were overwhelmingly negative; the building complex was reproached with total lack of standards and gigantism (A. L. Huxtable). And yet it became a permanent component of city tours and a much-employed symbol in advertising and films. The viewing platform on the south tower was opened in 1975 and became as great a success as the legendary restaurant Windows of the World on the 106th and 107th stories of the north tower.

The World Trade Center had been planned during the period of euphoric economic growth in the 1960s. Its completion took place at the time of the worldwide oil crisis, and it was not until 1981 that its office space was profitably rented out. But from then on it became the symbol of a new national —and at the same time worldwide—economic boom, thus becoming a potential target for attacks. As early as February 26, 1993, the WTC was shaken by a terrorist bomb attack that cost the lives of six people and also caused great damage to the building. At that time it became shockingly clear to the entire world to what extent the World Trade Center had risen to become a transnational symbol.

 # Sears Tower Chicago, Illinois, USA

SOM Skidmore, Owings & Merrill

1970–1974
1,450 feet / 442 meters

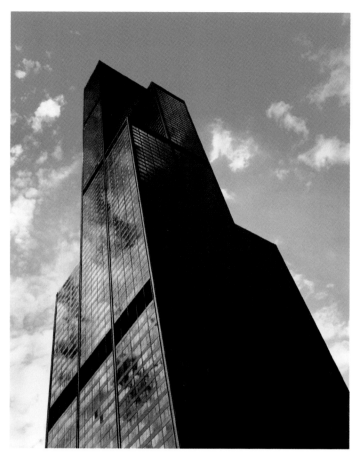

The surrounding area is reflected in the facade

1,450 feet
442 meters

Only two years after its completion, the World Trade Center in New York lost its position as the tallest skyscraper in the world to the Sears Tower in Chicago. The builder was the department store company Sears, Roebuck and Co. With a total usable floor space of some 4.4 million square feet (410,000 square meters), the Sears Tower was not only the tallest building in the word, but at the same time the second largest in the USA in terms of surface area, second only to the Pentagon. It was designed to provide space for a total of 10,000 Sears employees and a further 6,000 tenants.

The construction was conceived by the engineer Fazlur Khan of SOM, who had previously been responsible for the John Hancock Center in Chicago (p. 88). Once again, he developed a new construction approach, which made it possible to advance to new record heights at a comparatively moderate cost. The static framework of the Sears Tower consists of nine squared tubes, each one rigid in itself, with no internal supports. Each of the tubes is 75 feet (23 meters) long and is divided into five supports, 14 feet (4.3 meters) apart. Above the first fifty stories the nine tubes are bundled together as a closed square. Their heights vary.

Two of them terminate between the 51st and 66th stories, a further two between the 67th and 90th, and from the 91st to the 109th story only two still remain. Thus, the usable floor space decreases with the height of the building.

The bundling together of the load-bearing tube structure is the decisive factor in the outward appearance of the Sears Tower. But the sculptural effect of the graduated tubes only becomes apparent from the upper half of the 109-story building. The lower half, with its thoroughly black-colored aluminum facade and its black-tinted windows appears massive and closed off. In clustering the tubes together at varying heights, Bruce Graham, the SOM designer, says he was thinking of the effect of seeing the Italian town of San Gimignano with its towers from a distance: "The Sears Tower itself is much like the idea behind San Gimignano…" In practice, the building is admittedly far removed from this idea.

Together with the World Trade Center, the Sears Tower marks the high-point and at the same time the end of a second wave of record heights and surface areas in American high-rise construction. Together, they provide the ultimate examples of minimalist architecture's language of forms: hard geometric forms beyond any human scale or imaginative power and with a totally forbidding, abstract surface. The Sears Tower achieved even less of an inner link to the city than did the World Trade Center. It did remain for more than twenty-three years, up to 1997, the tallest high-rise building in the world, but as a dark, lonely giant, little known and hardly accepted.

Floor plans

The constructive tubes with their varying heights determine the form of the building

97

Citicorp Center New York, USA

The Stubbins Associates with Emery Roth & Sons

1974–1977
915 feet / 279 meters

Ground floor plan

The Citicorp Group, a leading international bank, had acquired almost the entire area of the block between 53rd and 54th Avenue on Lexington Avenue in New York. However, one corner of the site had been in the possession of the Lutheran parish of St. Peter's for more than 100 years. The parish, which owned the right to light above its church, agreed to the planned building of a high-rise structure on the rest of the site on two conditions. A new church was to be built on the site of the old one, and it was to be open to the sky ("nothing but free sky overhead"). This was only possible if the planned structure was to be positioned as close as possible to the opposite edge of the site and if the necessary extension of space set in only from a certain height upwards. The architectural office Stubbins Associates, who were commissioned for the project, therefore constructed the building on megasupports almost 115 feet (35 meters) tall. The parish also demanded the opening of the plaza below the supported building with stores, which proved to be very sensible as a way of integrating the building into its urban surroundings.

The upper part of the load-bearing structure of the Citicorp Center consists of a tube strengthened by diagonals, and is by comparison very light using very little steel. Here, unlike the John Hancock Center (p. 88), the diagonal struts are not visible on the facade itself, but lie immediately behind the horizontally striped cladding of aluminum and reflective blue glass. On account of its construction, which enables a large proportion of the total load to be diverted to the four free-standing, ten-story-high megasupports in the lower part of the building, and because of its own moderate weight, the high-rise was particularly vulnerable to the lateral swaying that can be caused by strong winds. By means of a tuned-mass damper, used for the first time in the Citicorp Center, swaying was reduced to an acceptable degree for the occupants of the building. On the 59th floor, there is a 400-ton concrete block lying on top of an oil film which is able to move horizontally in both directions. In the event of violent movement, the block, controlled by sensors, is always propelled in the opposite direction. This can reduce the oscillation by half. This invention was later used in a number of other high-rise structures. A problem arose when a construction fault was detected after completion. The intersections of the steel framework had not been made sufficiently rigid to withstand diagonally approaching winds. In theory, the tower could have toppled over in one of the storms that take place in New York about every sixteen years. The struts, until then linked only by rivets, were rapidly welded together and strengthened with steel plates—a costly procedure.

The strikingly slanted roof extension was originally intended as a gigantic solar collector which was, however, never realized. But the roof shape was retained and lends the building a new symbolic identity in the context of the high-rises of the time which mostly had flat roofs. In this way the Citicorp Center anticipates a development of postmodernism, which once again turned toward striking individuality in the tops of buildings.

The tower stands on gigantic supports almost 115 feet (35 meters) high

The unusual triangular conclusion of the roof makes the Citicorp Center unmistakable in the cityscape

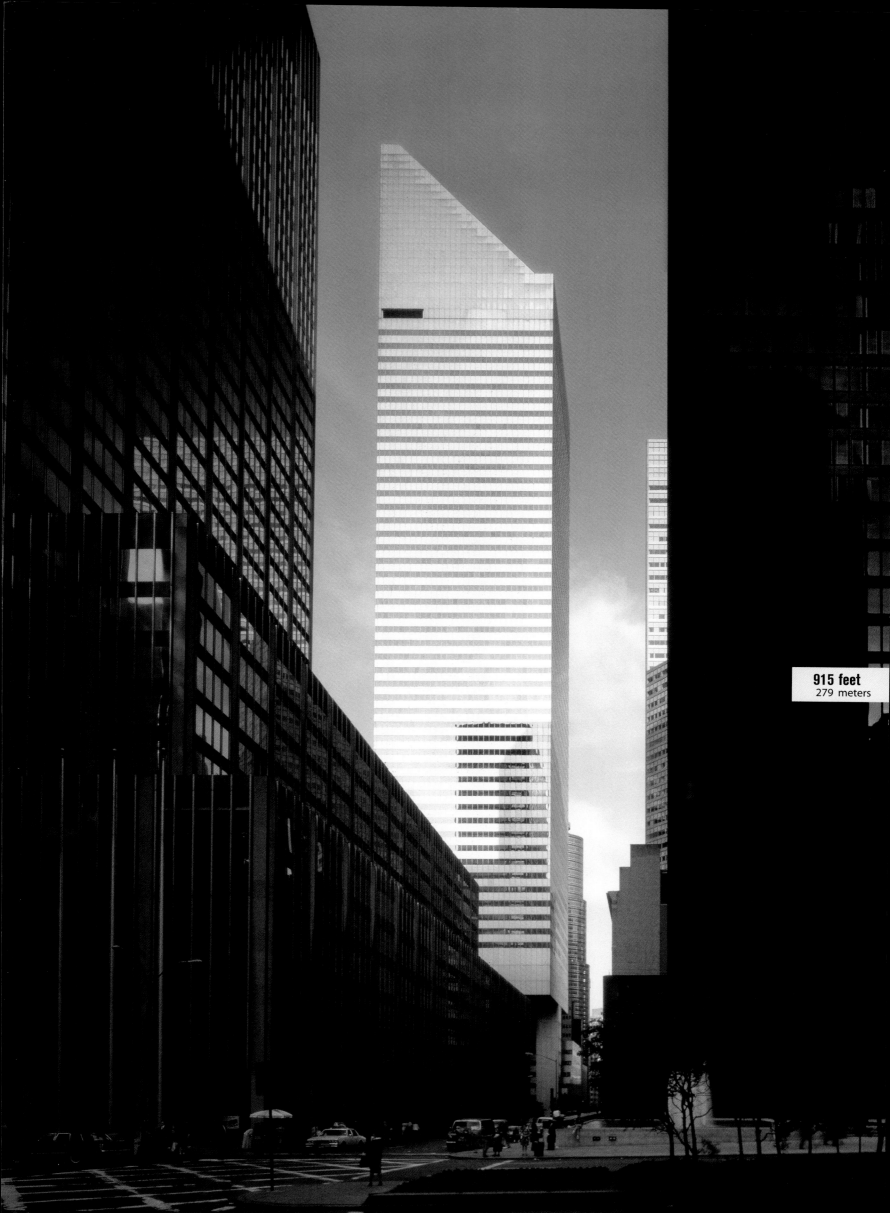

915 feet
279 meters

National Commercial Bank Jeddah, Saudi Arabia

SOM Skidmore, Owings & Merrill

1981–1984
413 feet / 126 meters

View of the atrium of the building

The former port of Jeddah had developed in the second half of the twentieth century into one of Saudi Arabia's financial centers. The National Commercial Bank, the largest merchant bank in the Middle East at that time, was planning to build a new main administrative building with public counters as a high-rise on a site between the old city and the sea. The bank commissioned SOM, a firm operating in Chicago and New York, which at that time was already building the Haj Terminal at the international airport. The board of the National Commercial Bank wanted an impressive and trend-setting structure which would link the latest technologies of high-rise construction with the special climatic conditions and building traditions of the country.

With this commission, Gordon Bunshaft, the designer of Lever House (p. 64), once again realized one of the most unusual high-rises in history. Bearing in mind the extremely hot desert climate, the building is oriented entirely toward the interior. On an equilateral triangular base, a windowless block rises from the outside which contains one square opening on one side, and two on the other. Within these lie triangular, green inner courtyards on which all the offices are oriented. The openings, seven and nine stories high, are placed so that no direct sunlight can enter the windows of the office floors. The facades, clad with light-colored Roman travertine, reflect the sunlight. From the inner courtyards there is a view on one side of the old city and on the other of the Red Sea. By overlapping the inner courtyards a vertical opening results on the inside which passes through all stories, and serves to provide light as well as ventilation to the building. In front of the third side, which has no opening, stands a protruding supply tower with elevators and staircases. By placing this in a protruding position, the outline of the office tower is kept entirely independent and flexible.

The twenty-seven-story high-rise contains the central banking hall on the ground floor. Access is either via the main entrance under a large canopy, or from the rear by way of a circular car park with space for 650 vehicles. At the level of the green terrace of the first opening are an auditorium, a cafeteria and a lounge, and above these are the office floors. The top floor houses the board offices with a central hall and conference rooms. Only on this floor is a window area inserted in the external facade, going right around the building.

In the traditional architecture of Arab countries, houses are for the most part entirely inward-oriented in order to protect the residents from sun and wind. Inner courtyards create the additional possibility of air circulation. The National Commercial Bank's high-rise picks up these elements and links them both with the modern building form of the high-rise and also with contemporary demands for energy-saving building forms. In the merging of a variety of traditions and demands, Bunschaft created a totally independent building with an impressive monumental effect. With this building he proved how adaptable the skyscraper genre can be, even in a culturally varied context.

Cross section of the grassed-over interior courtyards

Entrance area of the bank Large square incisions in the facade provide lighting for the offices

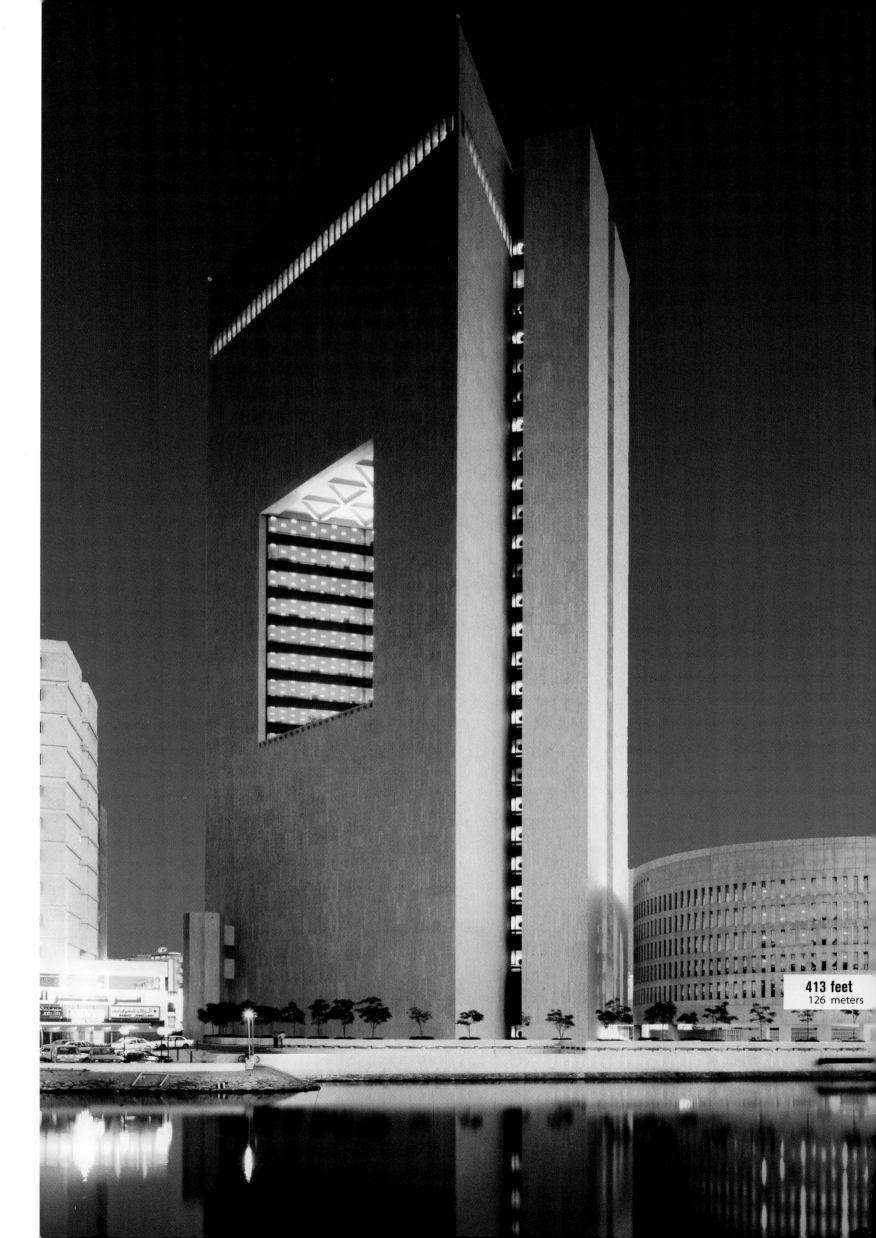

413 feet
126 meters

AT&T Headquarters New York, USA

Johnson / Burgee Architects

1980–1984
647 feet / 197 meters

View of the lobby area with marble cladding

Philip Johnson is among the most important architects of the twentieth century and has exerted a lasting influence on architectural history over several generations. He began his career in the 1930s as curator of architecture at the Museum of Modern Art, then studied architecture and from the 1940s practiced in the field. At first he was strongly influenced by Mies van der Rohe, with whom he had worked on the Seagram Building (p. 66). In 1973 Johnson created his first office high-rise, the IDS Center in Minneapolis. In this and further high-rises, such as the double tower of Pennzoil Place in Houston, Johnson presented variations on the architectural vocabulary of modernism.

In his design for the AT&T Building in New York (today the Sony Building), Philip Johnson emphatically broke with the rules of modernism that in the past he himself had formulated in the famous exhibition at the Museum of Modern Art, *Modern Architecture: International Exhibition*, but that in the course of the years he had come to follow less and less strictly. In 1978 he received a commission from the American Telephone and Telegraph Company for its main administrative building. During the planning period, when the designs became known, the project was discussed causing great controversy. Johnson, who had often surprised both his supporters as well as his detractors, wanted to equal Mies and his Seagram Building.

The building was aesthetically provoking in many respects. The first surprise was the heavy granite of the facade cladding. After decades of curtain facades made of steel, glass and aluminum, endlessly repeated around the world, here again natural stone covered the surfaces. The uniform, closed form of the whole structure caused further annoyance. With the AT&T Building, the skyscraper, as in its early period, again possessed a base, a shaft and a decorative peak. The gable, bursting open with a circular hole, as a purely decorative conclusion to the building, awakened memories of historic models, from classical antiquity up to Chippendale furniture. Further deviations from the doctrines of modernist architecture are the originally open arcade at street level as well as the mighty entrance portal, 115 feet (35 meters) high, clearly modeled on the Municipal Building in New York by McKim, Mead & White (1908). The splendid entrance lobby with its gilded cross vault and abstract Romanesque capitals alludes to the tradition of stylistically imitative entrance halls such as that of the Woolworth Building.

As a result of its size and striking location in New York, the AT&T Building marks a high point in public perception of postmodernism. It is the very personal manifesto of a style counter to modernism, yet in its ironic breakaway still remains totally dependent on it. Despite many positive aspects such as the successful link with its urban surroundings by means of the arcades, unfortunately later closed, the AT&T Building as a whole is after all a building very much of its time, without a new approach spurring further development. Philip Johnson did not invent postmodernism, but this building made him its best-known representative throughout the world.

Drawing with views and details of the building

View of the high-rise with its striking gable

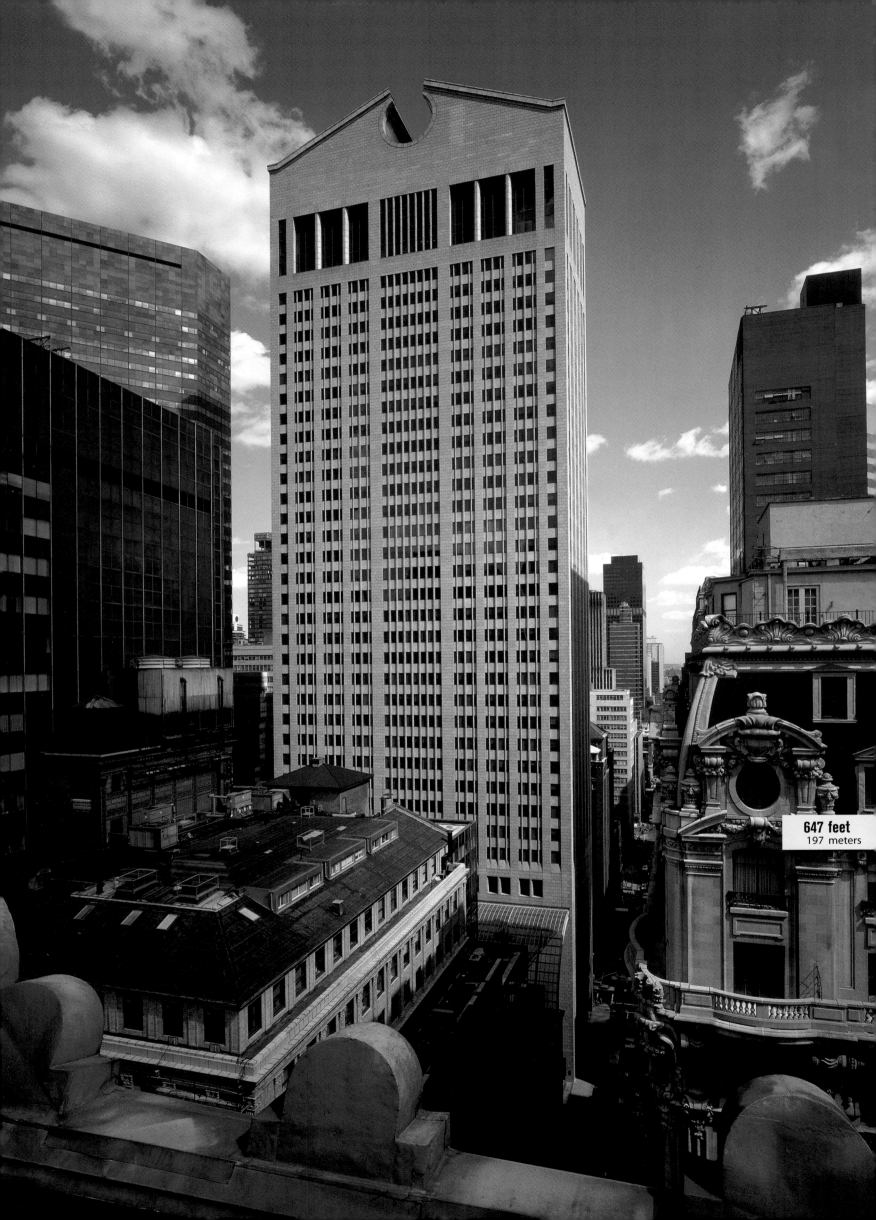

647 feet
197 meters

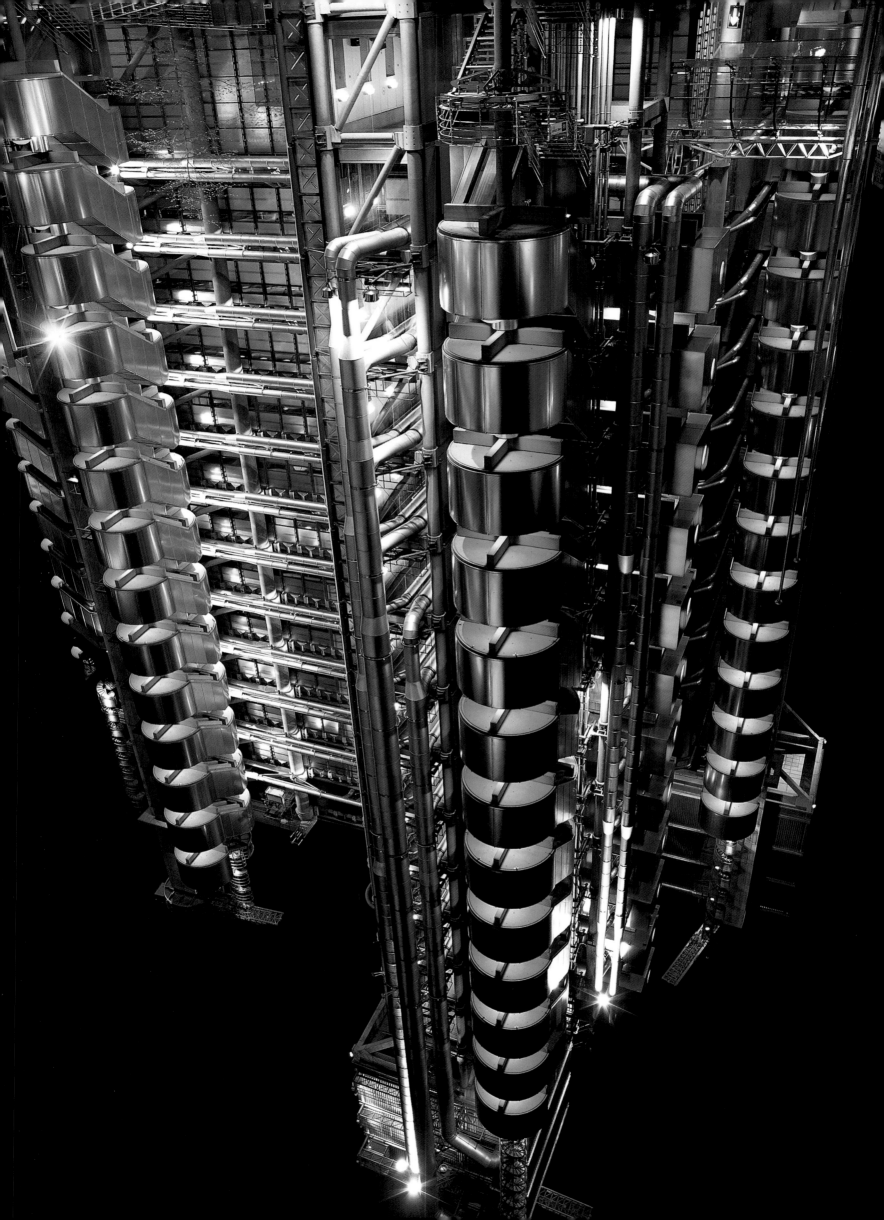

Lloyd's Building London, UK

Richard Rogers Partnership

1978–1986
285 feet / 87 meters

By the 1960s, modernist architecture had largely exhausted itself through endless repetition, and in many places counter-reactions were springing up. In England these included Team 4, founded in 1963 by Richard Rogers together with Norman Foster. New materials and construction techniques were tried out, and technological aspects gained more and more in importance. In 1971 Rogers, together with Renzo Piano, won the competition for the Centre Pompidou in Paris. This was one of the first significant buildings to make it shockingly clear to the general public that the time of smooth facades and "dull boxes" was coming to an end.

In 1977 the long-established insurance firm Lloyd's (founded in 1688) was making plans for a new building for its main administrative offices in the center of London. It demanded the greatest possible flexibility for its interior, the continuation of the Lloyd's tradition, and moreover the potential for spatial expansion. This would be the fourth building that Lloyd's had built in fifty years, and it was intended to serve the firm for the next fifty years. In 1978, after a competition, Richard Rogers received the commission to execute his sensational design. He placed the office floors on a rectangular base in the center of the irregular site. He grouped the supply components with stairs, engineering, elevators and sanitary facilities, in six towers on the outside of this rectangle. Rogers placed the insurance firm's central open conference room, the heart of the building, in the sunken area of the ground floor. A six-story-high atrium rises in the center of the building which includes escalators that link the first three floors.

The structure of the building consists of a reinforced concrete skeleton, whose circular supports are visible both inside and outside. The staircase towers are clad with stainless steel, as are the sanitary containers, which, like the capsules of the Nakagin Capsule Tower (p. 90) were added as prefabricated units. The engineering rooms protrude from the tops of the towers like building containers. The heating and air-conditioning networks linked with them appear like the gleaming exhaust pipes of a racing car and emphasize the effect of the building as a great "money machine." The glass outside elevators also underline the impression of dynamic technology. But in contrast, the 249-foot-high (76 meter) glass atrium with its barrel vault is reminiscent of Victorian models such as Paxton's Crystal Palace of 1854. The only colored accent is provided by the blue cranes for the window-cleaners' gondolas.

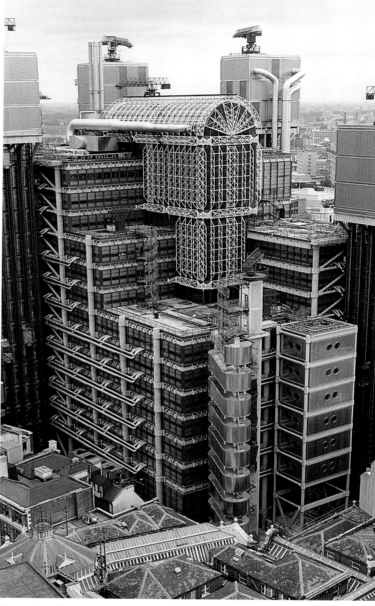

The machine-like building complex in its urban context

As early as 1909 the Italian futurists had praised the beauty of racing cars adorned with their large exhaust pipes and had demanded that future architecture should, like a car engine, achieve the greatest possible performance. In the Lloyd's Building, as with the Centre Pompidou, these demands have been translated literally into the context of the European city. This involves, of course, an element of provocation which this building consciously exploits. Richard Rogers' building has often been compared to Norman Foster's Hongkong and Shanghai Bank (p. 106) on account of its outward-directed structure and technology. But the Lloyd's Building is even more dramatic, and in its obvious over-instrumentation appears almost ironic.

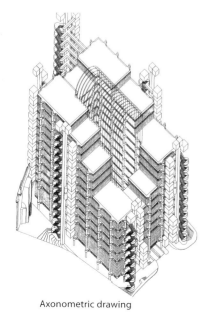

Axonometric drawing

Total view of the Lloyd's Building by night

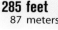

285 feet
87 meters

Hongkong and Shanghai Bank Headquarters Hong Kong, China

Norman Foster & Partners

1979–1986
590 feet / 180 meters

The load-bearing structure of the building is openly visible

Hong Kong, a British Crown Colony until 1997, on account of its special political situation had risen in the second half of the twentieth century to become one of the most economically successful cities in Asia. Because of extreme space limitations and intense economic pressure, the building of high-rises for both office and residential buildings had long been a necessity. In the summer of 1979 the British architect Norman Foster was invited by the Hongkong and Shanghai Bank (HSBC) to take part in the competition for their new bank building. Foster took up the bank's initial proposal not to demolish the existing building immediately, and put forward a concept of phased redesigning. However, after granting the commission to Foster, the client quickly dropped the idea of temporarily preserving the old building. Nevertheless, in the

course of planning and execution, he used his original idea of a bridge-like over structure for his ultimate solution.

A total of eight masts, each consisting of four steel tubes linked to each other by square supports, divert the total weight of the building into the foundations. A carrying framework two stories high is attached to the masts, onto which the individual stories are in turn affixed. This unusual division of the load results in virtually unlimited design possibilities for the floor-plan of the individual stories, as there are no load-bearing walls. The overall effect of the Hongkong and Shanghai Bank is provided by its supporting structure, unmistakably evident both within and without. The building, therefore, has no facade in the traditional sense, for the steel framework appears in front of the glazed facade. The supports and struts remain the determining element in the interior as well. A comparison with the impact of Gothic cathedrals is unavoidable. However, the framework which is very slender throughout had to be faced with aluminum fire protection coverings, which make it appear somewhat more robust.

Below the building lies a public square, from which escalators rise to give access to the atrium on the second floor, which is glazed underneath. The dark access core, usually located in the center of high-rise buildings, has here given way to an open and transparent inner space extending over ten floors. This serves as a central banking hall, which is supplied with natural light by means of a computerized mirror and reflectors.

Foster developed a number of new innovations for this building, both in the lighting of the workplaces and in the air-conditioning which functions by means of fresh air cooled by sea-water. These innovations anticipate later discussions about the ecological high-rise building. The linking of the building's zones by means of escalators is unusual and yet very functional. A helicopter landing pad is located on the roof, reviving the idea of access to the skyscraper from the air which originated with the Empire State Building albeit in an altered form.

With the Hongkong and Shanghai Bank, Norman Foster realized the first high-rise building of his career and in doing so established new standards. Almost never before had a skyscraper appeared so powerfully and self-confidently in the fabric of a city and yet remained so sensitively linked to its surroundings. Not least, the timely involvement of a feng shui expert in the planning and execution secured the acceptance of the building from

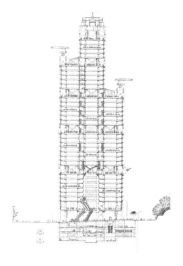

Cross section through the building

non–European viewpoints. In this building, the old dreams of the futurists are merged in a functional unity with the new utopias of Archigram. The Hongkong and Shanghai Bank is among the first buildings to make clear to the world that the future of high-rise building is to be found from now on in Asia. Designed by a British architect and composed of prefabricated parts from all over the world, the building is also an example of the increasing globalization of architecture.

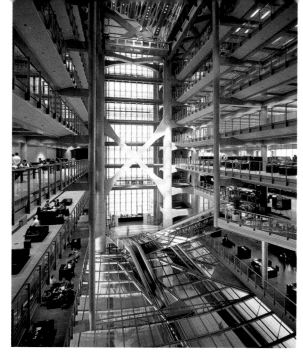

View of the atrium extending over ten floors

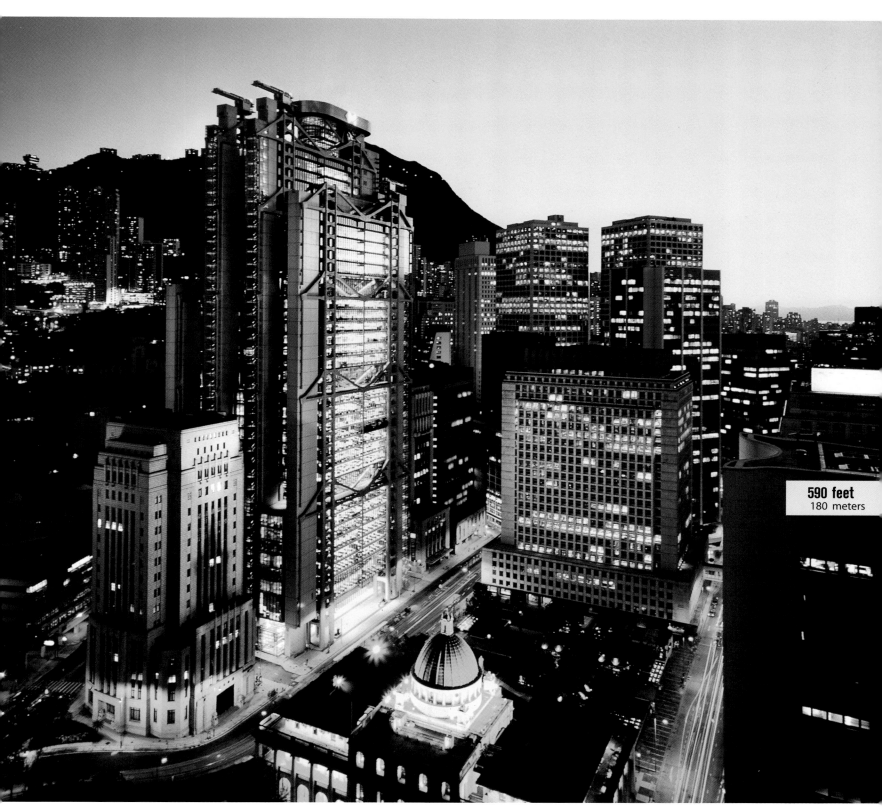

Total view of the bank by night

590 feet
180 meters

Lipstick Building New York, USA

Johnson / Burgee Architects

1983–1986
436 feet / 133 meters

Detail of the facade

Ground floor plan

After the AT&T Building (p. 102) Philip Johnson, together with his business partner John Burgee, executed several further high-rise buildings within a short period of time. These included the PPG Place in Pittsburgh (1984)—a glass cathedral in the Gothic style—as well as the Republic Bank Center (1984) and the Transco Tower in Houston (1985), which were once more based on formal models of the 1920s. But with the Lipstick Building in New York which followed immediately after them, Johnson once again embarked on a new approach.

The nickname of the building derives from its elliptical form, doubly staggered in an upward direction. Here, Johnson was additionally rejecting the rectangular ground plan of the modernist high-rise, aiming at an effect which would contrast with its urban environment on Third Avenue. The facade is constructed with horizontal bands of red granite and stainless steel, whose decorative color scheme attracts the eye as strongly as does its eccentric dynamism. The motif of a horizontally striped curtain facade wrapped around the building like a curled-up stocking had already been used by Johnson in the building complex of the Post Oak Central in Houston, Texas (1982). As with the AT&T Building, the construction is conventional with reinforced concrete, which is supported by an outer ring of visible supports on the ground floor and the supply core on the inside. Elevators and staircases are placed at the back edge of the site, so that the office space is as free and flexible as possible. At street level, the building creates additional public space through its elliptical form; a public café is incorporated into the two-story lobby.

The Lipstick Building was developed as an investment project by Gerald Hines, Philip Johnson's long-time client. Johnson admirably fulfilled the commission to create an unmistakable, memorable building. The Lipstick Building has long been one of New York's best-known high-rises. In this building Johnson for once denied himself any formal allusion to historical models. At the same time the building is an example of the way in which Johnson, already eighty years old at this time, was once again seeking out new paths to follow after modernism and postmodernism. In 1985 he moved with his office, which had previously been located in the Seagram Building, into the Lipstick Building, a clear sign of a weakening link with Ludwig Mies van der Rohe.

The building was given its name from its elliptical, stepped shape

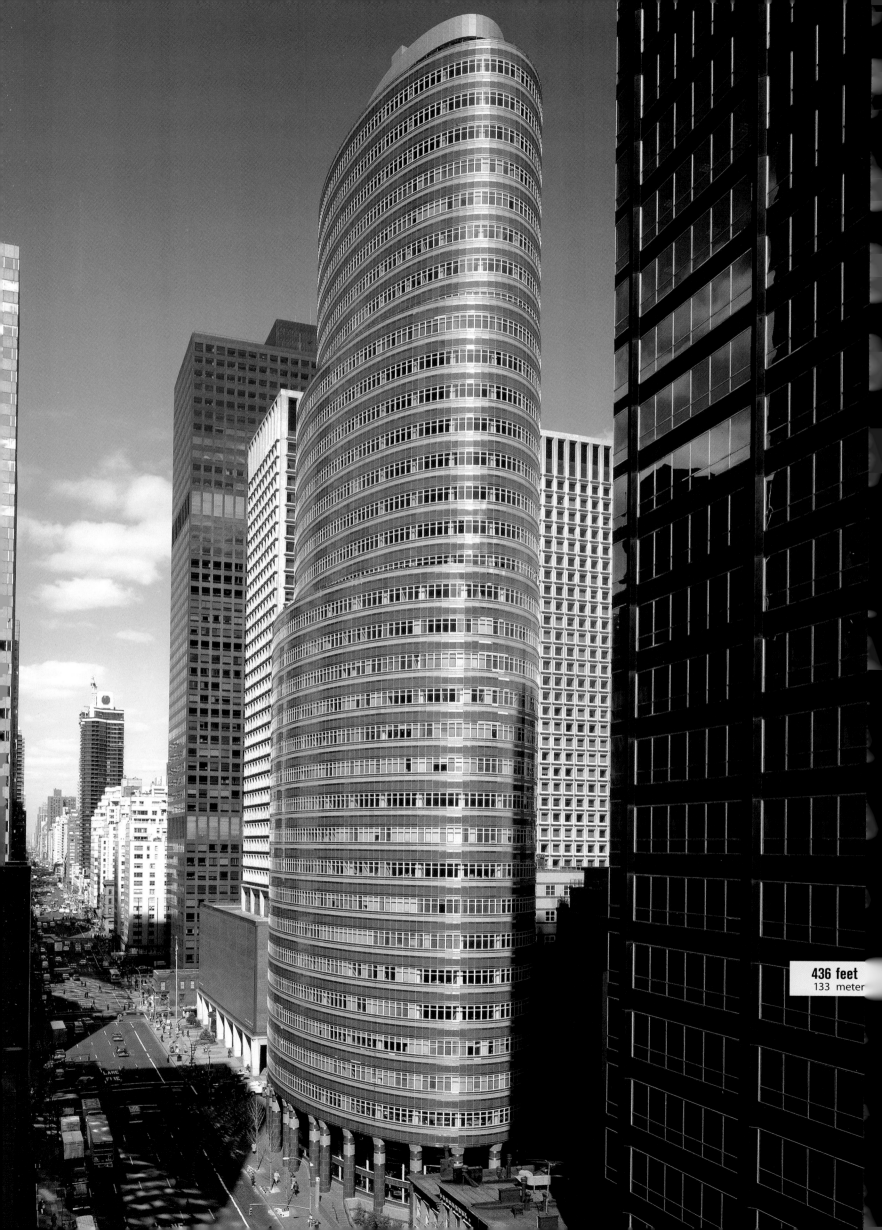

436 feet
133 meter

Bank of China Hong Kong, China

I. M. Pei & Partners

1982–1990

1,209 feet / 369 meters

The triangular motif that determines the form of the facade appears again in the interior of the building

Typical floor configurations

Ieoh Ming Pei was born in Canton, China, in 1917, the son of the then director of the local branch of the Bank of China. In 1919 the family moved first to Hong Kong and Shanghai, and then in 1935 to the USA, where I. M. Pei studied architecture from 1936 and became an American citizen. After setting up his own practice, Pei became world famous for his museum buildings, among others. As early as 1976 he also executed important high-rise buildings, including the Oversea-Chinese Bank Corporation in Singapore.

In 1982 the Chinese state bank, the Bank of China, made plans for the construction of a new administrative building in the center of Hong Kong. The building was to become a conspicuous symbol of the future of the city, a former British Crown Colony which was, according to agreement, handed back to China in 1997. It was therefore a surprising and at the same time symbolic decision to turn to Pei for the design. In order to gain his services for the commission in Hong Kong, representatives of the Bank of China first contacted his 89-year-old father in the USA. When the latter left the decision to his son, Pei accepted.

Hardly any other skyscraper is of such elegant proportions and so rich in variety on all sides. Pei designed an unpretentious, geometrically simple form which was at the same time highly efficient in its construction. At the base, the outline of the tower grows out of a square which is divided by its diagonals into four triangles. In the verticals, these triangles form the static tubes that support the building. Higher up, the triangles are gradually staggered, but not in horizontal steps, rather over diagonally sloping glass surfaces. The set-backs are the 25th, 38th and 51st floors, leaving only one of the triangles remaining up to the top. Through the diagonal rigid elements that are visible through the facades, the building looks like a three-dimensional tangram toy.

Since buildings in Hong Kong must be able to withstand powerful typhoons, the specifications for their stability are twice as high as, for example, high-rises in New York. The structure devised by Pei was devised to handle just such conditions. All vertical forces are diverted by the diagonals to the four main supports at the base and a central support in the core. In addition, construction costs were, by comparison, very reasonable; despite its greater height and usable floor space, the building cost not even one-fifth of what was spent on the

Total view of the bank building

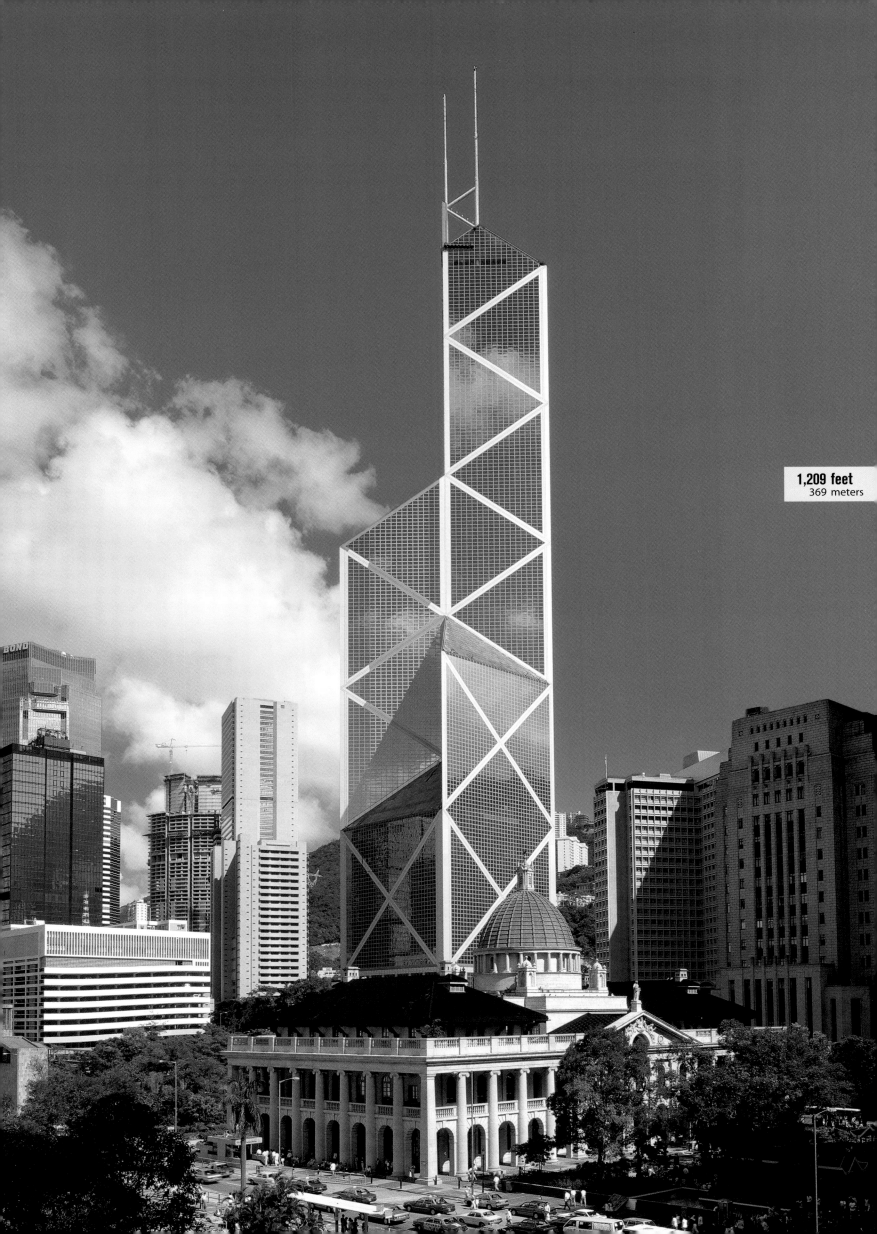

1,209 feet
369 meters

This building consists of four triangular towers of varying height

Hongkong and Shanghai Bank building (p. 106). Nevertheless, its unconventional form created some difficulties. Firstly, there was the problem of vertical access, which could not be solved by the use of a central elevator core. Additional problems arose from the exterior design of the building, which originally was not in accordance with feng shui principles, and was brought into line with these only in the course of planning.

With the Bank of China, Pei set a personal note. At the same time he fulfilled in most elegant fashion the wishes of his client for a building that would symbolize the economic awakening of China. The Bank of China marks an architectural high point of the twentieth century, since it translates the central theme of the skyscraper, the architectural striving toward height, into an absolutely timeless and aesthetically perfect form.

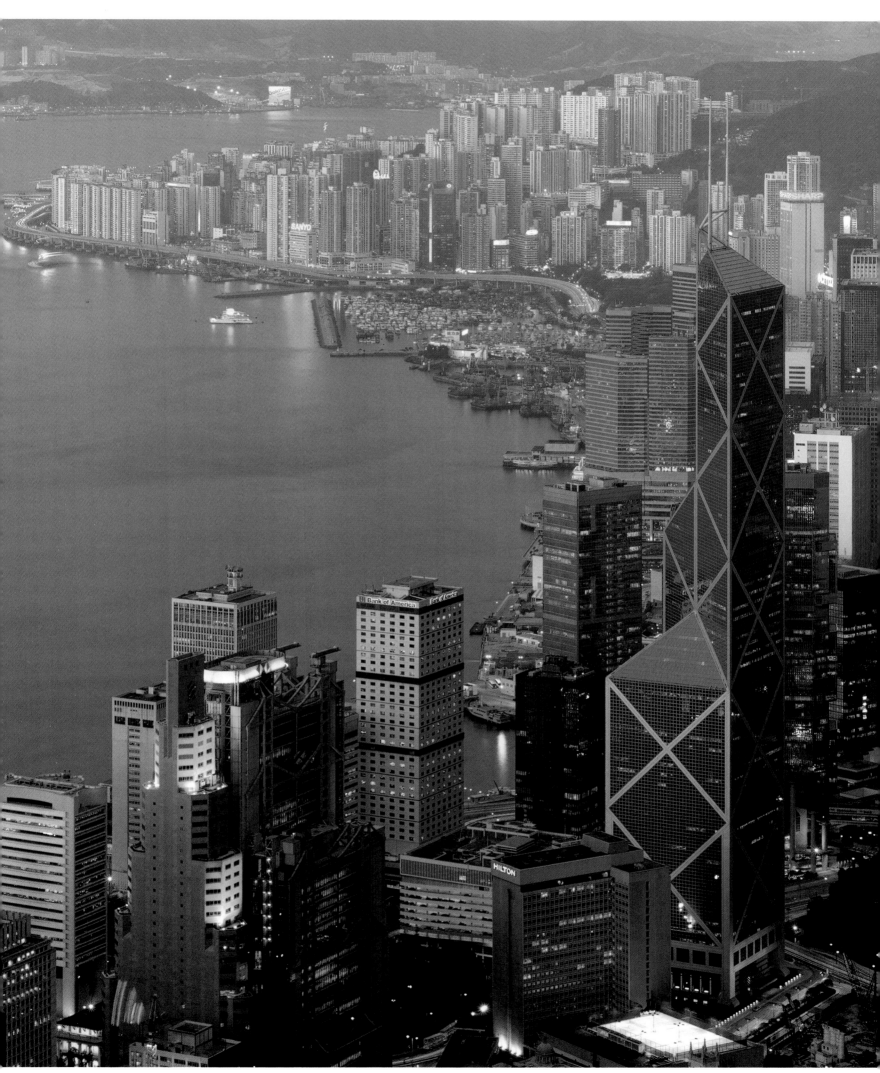

The striking shape of this high-rise makes it stand out from the Hong Kong skyline

| 34 |

Messeturm Frankfurt / Main, Germany

Murphy / Jahn Architects

1985–1991
840 feet / 256 meters

Born in Nuremberg, Helmut Jahn first studied architecture at the Technical University of Munich and in 1996 received a scholarship which enabled him to transfer to the Illinois Institute of Technology in Chicago—the architectural school where Ludwig Mies van der Rohe had taught from 1938. Jahn stayed in the USA and starting in 1967 worked for the architectural office of Charles Murphy, a student of Mies. Jahn soon took on a leading role in the office and provided a decisive impetus to high-rise architecture in Chicago with the State of Illinois Center (1985) and many other buildings.

Beginning in 1980, the trade fair site in Frankfurt / Main was redesigned and extended. In the direction of the inner city, the entrance area was to be extended with a separate entrance pavilion, an office tower and a new exhibition hall. Helmut Jahn received the commission for the project from the American property developers Tishman / Speyer. A central problem for the design of the office tower resulted from German fire protection regulations, according to which fire escapes in high-rise buildings must be on the outside. And to guarantee the prescribed distance of all workplaces to natural light, the exhibition tower, like all skyscrapers in Germany, had to remain very slender. Thus, placing the fire escapes on the outside would have meant an additional loss of rentable space. After a visit to comparable high-rise buildings in Chicago and New York by members of the German building commission, permission was finally granted for interior fire escape staircases.

The form of the Messeturm is a mixture of abstract historical quotation and modernist elements. Here Jahn reverts to Sullivan's trisection of the high-rise. On a square base, a shaft in the form of a glass cylinder rises up, but only emerges just below the top, where the granite facade narrows. At the very top, a three-story pyramid crowns the building. This part houses cooling towers and a tank for drinking water. But with its incisions it appears to be more like an advertisement than of a part of the building.

Typical floor plan

114

Helmut Jahn cites the Campanile of San Marco in Venice as the model for his exhibition tower. But pyramidal tops had already been used in the high-rises of the 1910s and 1930s (Bankers Trust Company Building, 1912, and 40 Wall Street, 1930) and returned as a design element in the 1980s, for example in the work of SOM (Worldwide Plaza, New York, 1989) and Cesar Pelli. The Frankfurt Messeturm, with its play of geometric elements, belongs to an architectural movement which draws its strength by placing references to historic forms in the foreground.

A specific urban connection was not demanded or sought in the case of the Messeturm. The 62-foot-high (19 meter) entrance lobby is not open to the public and the tower does not include an observation deck. Despite its lack of a functional relationship with the city, the Frankfurt Messeturm brought about a turning point in public opinion regarding to high-rise buildings in Germany. This is probably due not least to its location: it is free to unfold its symbolic form without coming too close to the old city. At the same time, with its formal reversion to the historic skyscrapers of New York, it gave the city of Frankfurt the feeling that it had found an architectural link to the high-rise culture of the United States. But one argument was possibly the most decisive: the Messeturm brought the city a genuine height record as it was the tallest skyscraper in Europe for six years.

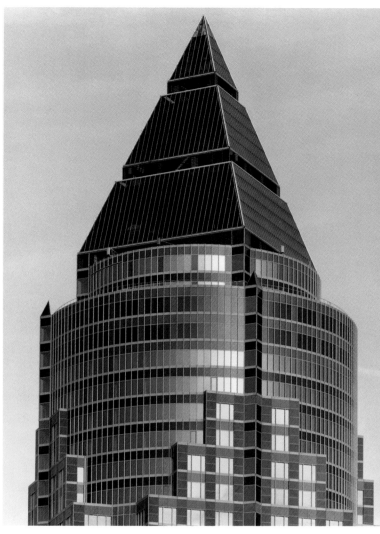

Detail of the pyramidal peak

840 feet
256 meters

Drawing by Helmut Jahn

New Tokyo City Hall Tokyo, Japan

Kenzo Tange Associates

1986–1991
799 feet / 243 meters

There are probably very few architects who have had the experience of receiving the same building commission from the same public client on two occasions separated by some twenty-eight years. Kenzo Tange had already planned and executed the Tokyo City Hall in 1957—a building that demonstrated much of his deep admiration for Le Corbusier. In the decades that followed, it became too small for the steadily growing administration of this city of over a million people, and parts of the administration had to be distributed over various buildings around City Hall. Only twenty-three years later, the governor of Tokyo was planning a new City Hall building, with which he intended to set a new direction for Tokyo's entry into the twenty-first century. A preparatory expert opinion of 1982 recommended placing the new building in the Shinjuku district of Tokyo, outside the old center, in a location where there were already several highrises.

The contract for building the new City Hall went to Tange in 1986 on the basis of a limited national competition. Out of nine competitors, he gained approval for his design, which specified a high-rise with a double tower, as well as a lower building with three descending staggered structures immediately adjoining. Opposite stands a further, seven-story structure which serves as a conference center and is linked to the main building by footbridges which lead over an expressway. In front, a semicircular plaza is bounded by a sort of colonnaded passage, which is intended for public events. Like a theater from classical times, it slopes gently downward toward a stage in the center.

The main City Hall building, forty-eight stories high in all, is quite clearly reminiscent in its general form of examples of double-tower facades such as that of the Cathedral of Notre Dame in Paris. According to his own account, Tange wanted to break up the broad structure at a high level in order to moderate the impression of excessive massiveness. The ground plan shows the total area as a very complex variation of the basic geometric form of the square. Eight supply towers in all, with staircases and elevators, are placed at the outer sides of the building, and at a high level they emerge visibly through their lighter coloration. By turning the upper structures at an angle of 45 degrees, the otherwise very rigid-looking double towers are given a lighter dynamic. The facade of Swedish and Spanish granite was developed according to traditional Japanese models. When Tange noticed at the planning stage that there was a similarity to the design of electronic wiring diagrams or microchips, he deliberately emphasized this aspect.

The new Tokyo City Hall is an impressive, severe high-rise building in which the geometric play with form and historic references to American skyscrapers are merged with European and Asian influences. Its general approach to urban planning links this large structure functionally with the dense fabric of the city.

The structure of the subtly intersecting squares is clearly seen in the ground plan

View of the lobby

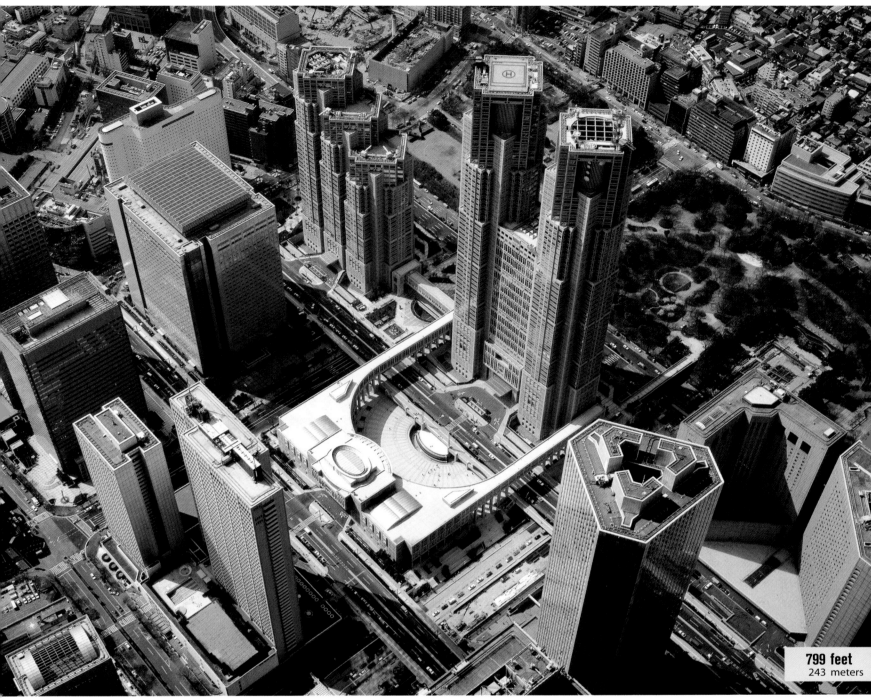

799 feet
243 meters

The total complex of the New City Hall with its semicircular plaza

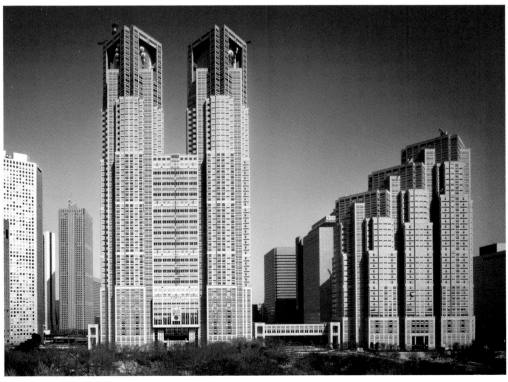

The twin towers of the New City Hall

Menara Mesiniaga Subang Jaya, Malaysia

Ken Yeang

1989–1992
207 feet / 63 meters

The grassed area winds upward through the building

Ken Yeang, born in Penang, Malaysia, studied architecture from 1966 at the Architectural Association in London and from 1971 at Wolfson College, Cambridge. Early on, he became interested in ecological issues in architecture and gained his doctorate on the theme of *Designing with Nature: The Ecological Basis for Architectural Design*. In 1976 Yeang returned to Malaysia and was given his first commissions in which he at first translated the architectural vocabulary of modernism into the context of the tropics. Some time later, however, he began to place the ecological aspect at the center of his designs, and to dedicate himself more intensively in his research and practice to the task of creating the bioclimatic skyscraper.

In 1989 the IBM corporation gave Yeang the contract for a new building to house their main administrative offices in Malaysia, at Subang Jaya, near Kuala Lumpur. The client asked for a building whose technological progressiveness would be visible from the outside, even at a distance. At the same time it was required that as little energy as possible be consumed in the production and in the running of the building. Yeang created a tower fifteen floors high, carried on eight clearly visible supports. The building is not surrounded by a continuous facade, but opens and closes in sections arranged in stages around the tower. The building

has an exterior load-bearing structure of steel, aluminum and glass, and a crowning superstructure for the roof, planned as a support for solar cells. When these elements are viewed together, the tower creates the impression of a great machine.

The interior and exterior structure of the tower building is planned around climatic considerations, in particular the orientation toward the daily path of the sun. The massive core of the building, with staircases and elevator shafts, faces east and screens off the penetrating heat up to midday. To the south, deep incisions and suspended aluminum sunscreens ward off the direct rays of the noon and afternoon sun into the interior. Most of the office space faces west and north. Around the base of the tower lies a semicircular, steeply sloping garden, which continues into the building itself in the form of spiral terraces planted with grass. This visibly brings the natural environment into the architecture. The terraces, three stories high, can be used by the office staff as relaxation areas, and in addition there is a sundeck and swimming pool on the roof.

The Menara Mesiniaga presents an early model building for the physical translation of ecological principles into high-rise architecture. Here, Ken Yeang has eloquently converted his theoretical approaches, already undertaken in earlier buildings for IBM and other clients in Kuala Lumpur (for example, Menara Boustead, 1986), into a complex unity. Traditional points of view on building in the tropics are taken into account to the same extent as the lessons of contemporary technology and ecological issues. As a high-rise, Menara Mesiniaga sets no records for height, but its approach has made it a determining influence on an international level.

Ground floor plan

The bioclimatic high-rise with its clearly visible load-bearing structure of steel, aluminum and glass

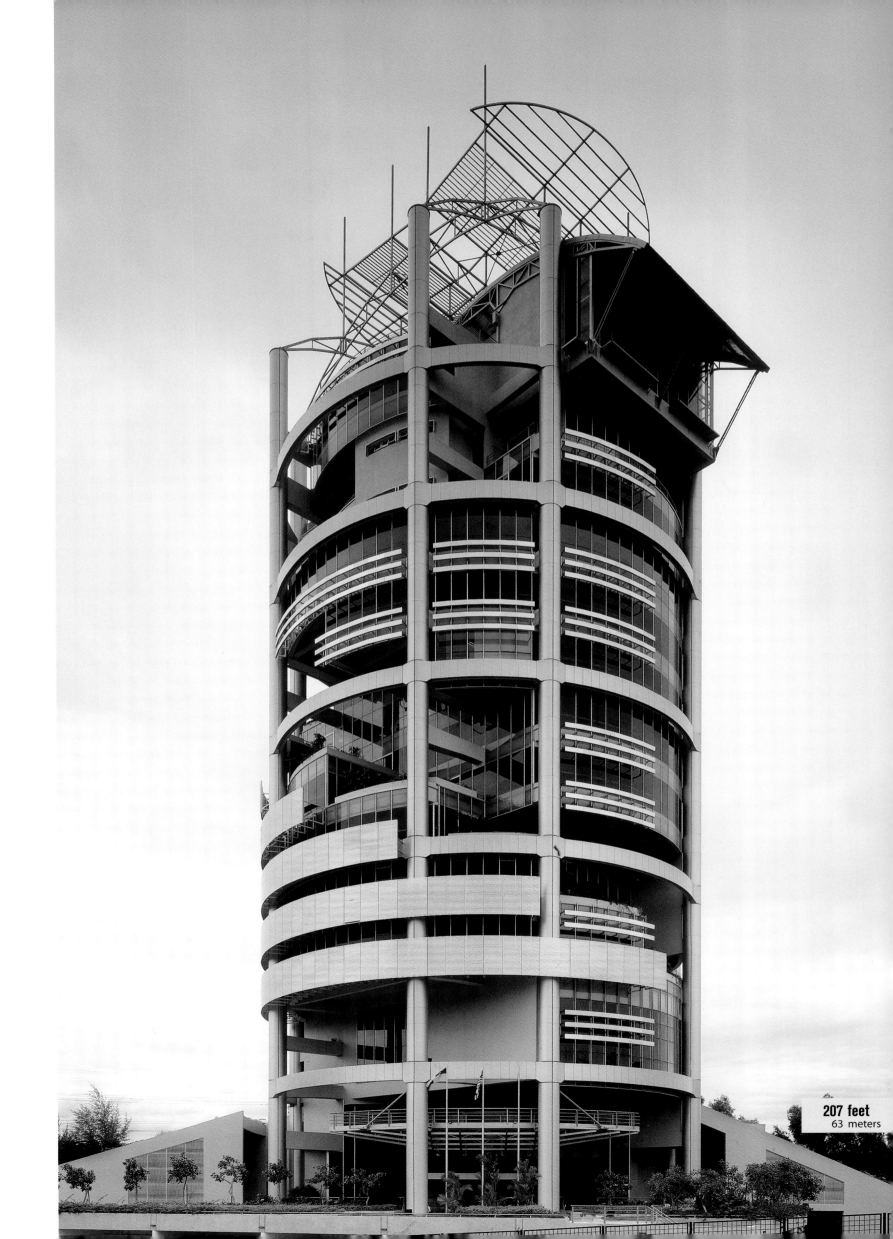

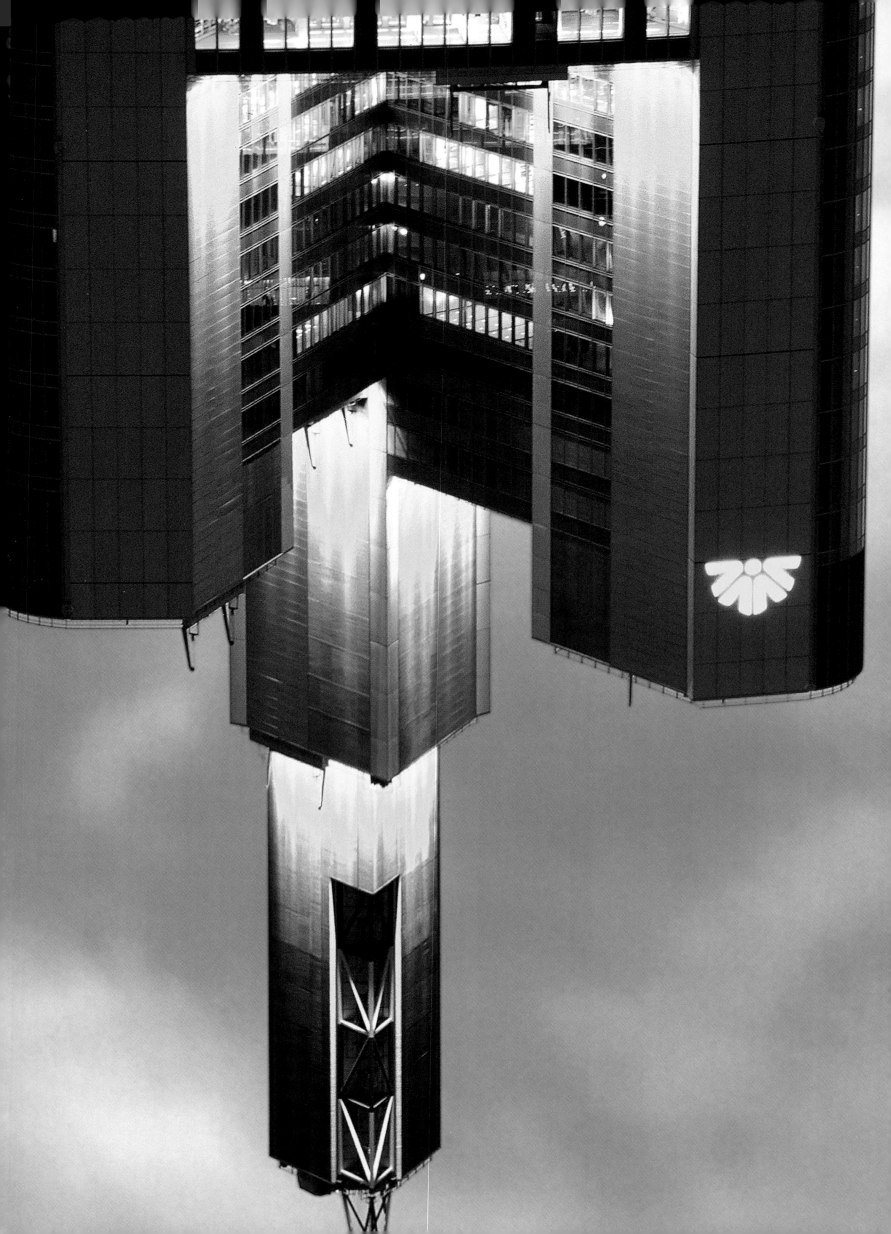

Commerzbank Frankfurt / Main, Germany

Norman Foster & Partners

1994–1997
850 feet / 259 meters

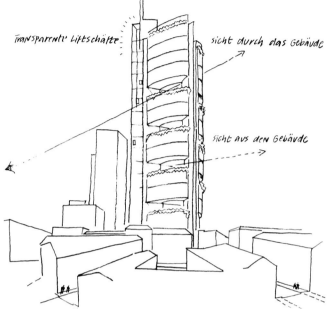

Aus der Ferne erlebt man Frankfurt als Gruppierungen von
Hochhaeusern - Diese sollten im Idealfall so ausgebildet
sein, dass sie Durchblicke gewaehren und an ihren
Fusspunkten das Mikroklima verbessern.

Transparente Liftschäfte

sicht durch das Gebäude

sicht aus den Gebäude

Auf Strassen Niveau sollte Frankfurt als Niedrige Bebauung mit
hochwertigen, kleinmasstaeblichen Raumkanten, von Strassen
und Plaetzen, erlebt werden Hochhaeser sollten sich
zurueckgesetzt im Blockinneren befinden und Anreize schaffen
für Abkürzungen, kleine Platzsituationen und Grünflächen.

850 feet
259 meters

The skyline of Frankfurt had developed only hesitantly in the postwar period up to the 1980s. The urban planning *"Fingerplan"* of 1969, which provided for an increase in density of high-rise buildings around the former city wall of the old city at the five main roads going north and west, was to remain a rough draft for a long time because of public opposition to high-rise buildings. The high-rises that were eventually built on schedule were predominantly functionalist office containers. The towers of the Deutsche Bank (1979–84), each 506 feet (155 meters) high, certainly dominated the cityscape and, with their twin-like double image, unmistakably alluded to the design of the World Trade Center. But they failed to achieve acceptance in the city—in part because they were sealed off from the public space. It was only with Helmut Jahn's Messeturm (1988–91, p. 114) that a shift in opinion set in. High-rise buildings were no longer seen as threatening, but interpreted as positive vehicles for the image of the city. Later, the catch-phrase "Mainhattan" (from the river Main on which Frankfurt is located) became established.

Twelve years after the completion of his Hongkong and Shanghai Bank (p. 106), Norman Foster built the Commerzbank in Frankfurt, the tallest office building in Europe, and placed a further architectural milestone in high-rise construction. The guidelines provided by the clients and the municipal authorities were very demanding. The old office tower of the 1970s Commerzbank, located nearby, was to be retained, and the new building was at the same time to be integrated in the city space. Furthermore, intensive consideration of ecological aspects was also required. The aim was to build the first high-rise in the world with natural ventilation air-conditioning and, at the same time, natural lighting. Building regulations in Germany, in contrast to the USA, stipulate that all office workplaces must have daylight and visual contact with the outside world.

Detail of the facade

Cross section of the atrium and winter gardens

Foster's design, based on a triangular ground plan, curves slightly outward with an inner open atrium at whose corners are located the structural columns with the transport, supply and waste disposal facilities. Because of its tubular, steel-frame construction the building is extremely stable and at 132,000 tons hardly heavier than the old building, despite its great height. Between the columns there are offices in each of the two wings, and a garden on the third side. After four stories, above which extends a sky garden, the floor plan twists by 120 degrees, so that the "hanging gardens" spiral upwards. The grassed winter gardens, nine in all, ensure an adequate supply of daylight to the inner workplaces. At this height, they offer unique views of the city center.

An intelligent air-conditioning system allows the natural ventilation of all the office space by means of slits between the inner and outer facades up to the highest floors. Through the recovery of heat and other innovative technologies, the consumption of energy is greatly reduced in comparison with traditional high-rise buildings. Even though the catchphrase "ecological high-rise" basically remains a contradiction in terms, this building should come fairly close to such an ideal. Together with its exceptional spatial qualities, the Commerzbank sets new standards for the development of high-rise construction.

Petronas Towers Kuala Lumpur, Malaysia

Cesar Pelli & Associates

1992–1998
1,483 feet / 452 meters

Top of the Petronas Towers

From 1990, Malaysia's state petroleum company planned to build a large complex for a variety of public and commercial uses in the newly developed commercial district, the Golden Triangle. In 1991, eight internationally active architecture firms were invited to take part in a competition in order to develop a concept that would not only include a high-rise building with a significant form, but also to create a symbolic connection with the country. The commission went to the office of Cesar Pelli, who had become known worldwide in 1984 with his extension to the Museum of Modern Art in New York City. In the period that followed, Pelli and his office had executed a number of further high-rise buildings, including the World Financial Center, completed in 1988, close to the World Trade Center in New York.

Pelli's design for an office high-rise in Kuala Lumpur envisioned a precisely symmetrical double tower. With this design, he was consciously deviating from the double high-rises familiar in modernism, such as the Lake Shore Drive Apartments (p. 62) and the World Trade Center (p. 94) and returning to the idea of the twin-tower facade traditionally used in church construction. Pelli's idea was to symbolize an enormously large gate. The polygonal, almost round cross-section of the tower structures was developed from the form of two squares superimposed at an angle of 45 degrees, to form an eight-pointed star. A further eight semicircles are inserted at the points of intersection which together create a 16-leaved form. Here Pelli was borrowing from Islamic patterns. At the higher level the cross section becomes gradually more diminished, ending in a thorn-like peak. The total form of the towers recalls organic models, in particular shoots like those of the horsetail. A two-story "skybridge" links the two towers at 525 feet (160 meters), at the 41st and 42nd stories. It had to be constructed so that it remained structurally independent of the varying individual movement of the towers.

The support structure of Petronas Towers consists of highly stable reinforced concrete. As with the Jin Mao Building in Shanghai (p. 126), so-called outrigger structures are used in order to increase the rigidity. The sixteen concrete supports standing as an outer ring in the bends of the base are thus linked with the inner concrete core. As a result of this extremely stable construction method, the addition of a motion damper to counteract the swaying produced by the wind at a great height is not necessary. The facade is structurally independent and consists of polished steel elements and glass, which reflect light from the surrounding area.

As with other structures, the idea of making Petronas Towers into the tallest high-rise building in the world arose only in the course of planning. Originally the height was planned at only 1,247 feet (380 meters), but in the end the towers with their tops reached a height of 1,483 feet (452 meters), surpassing the Sears Tower (p. 96) by 33 feet (10 meters). It was the first time that the record for the tallest building in the world had been broken by a building outside North America.

The star-shaped ground plan is composed of various geometric forms

The two towers are linked together by a skybridge

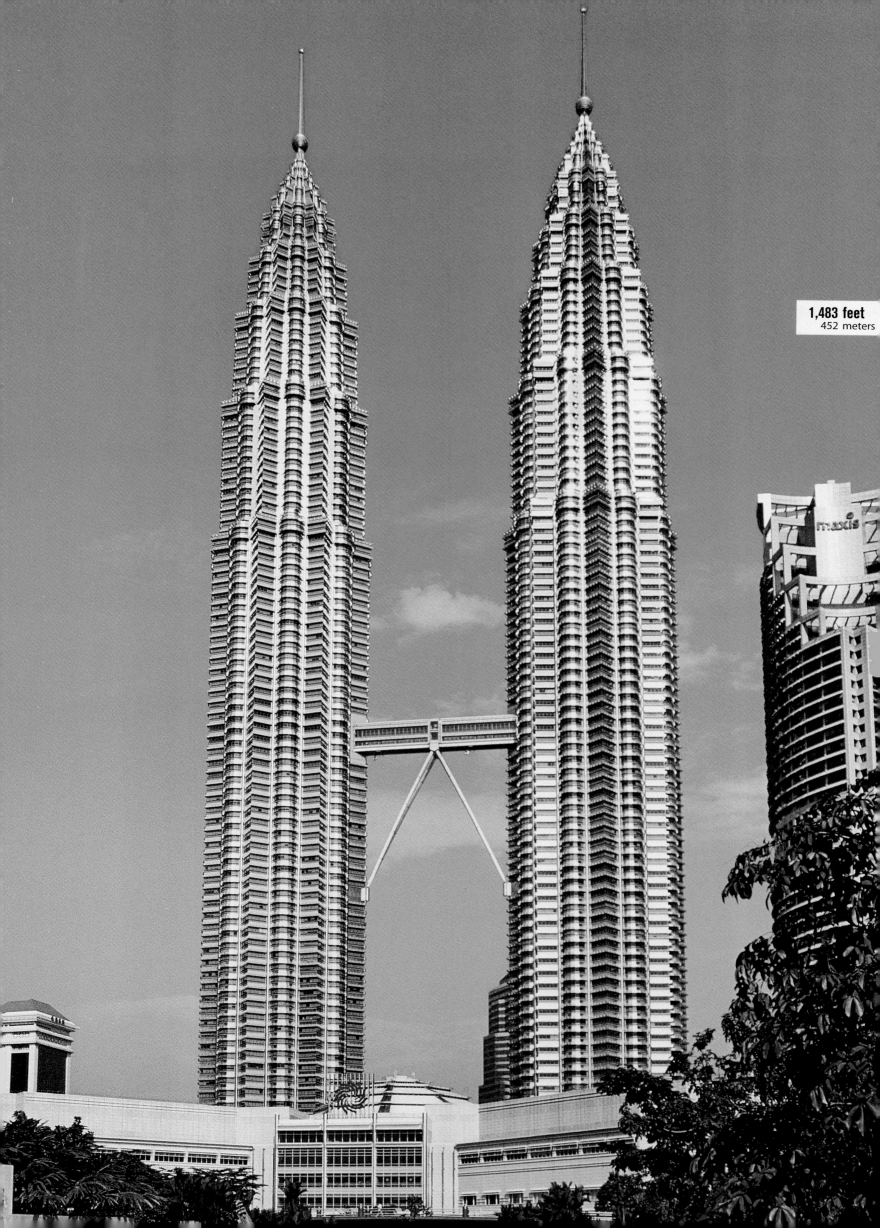

1,483 feet
452 meters

Jin Mao Tower Shanghai, China

SOM Skidmore, Owings & Merrill

1994–1999
1,380 feet / 421 meters

The Jin Mao Tower in Shanghai, together with the Petronas Towers in Kuala Lumpur, is part of a series of a new generation of extremely tall skyscrapers in Asia which shot up in rapid succession in the late twentieth century. While the Petronas Towers (p. 124) were outwardly oriented toward an abstract biomorphic design, the Jin Mao Tower reverts to the traditional form of the Chinese pagoda, consisting of a series of steps. Until the completion of the World Financial Center (p. 142) in its immediate vicinity, it will be the tallest building in China.

The Jin Mao Tower rises up in the office district of Pudong, which has been entirely newly developed since the 1990s. Beside it, an adjacent building was erected with conference rooms, auditorium and retail stores. The ground plan of the tower and its staggered construction at high levels are developed around numerous references to the number eight, a lucky number in China—even the number of stories, eighty-eight in all, contains the lucky number twice. The static core in the center is octagonal, as is the outer framework. Above the base of sixteen stories, the next section narrows by 2.6 feet (0.8 meters). The height is diminished to one-eighth of the base, so in this section there are only another fourteen stories. This gradual decrease continues upward until a section comprises only eight stories. From then on, each succeeding section is decreased by one story, up to the peak of the tower, which consists of a crown-like steel finial, clearly reminiscent in its design of Art Deco models.

In its interior, the Jin Mao Tower is divided into two zones of varying functions. The lower fifty stories are assigned to office use, and the upper thirty-eight stories accommodate a hotel with 555 rooms. Above the 53rd floor, the hotel contains an open atrium in its core extending right up to the top which, with its open galleries, is among the most spectacular inner spaces of the present day. The elevators are located on one side of it in a semicircular glazed fitting.

The Jin Mao Tower, like the Petronas Towers, is constructed from a mixture of steel and concrete. Since in this case the foundations also do not rest on supporting bedrock, special solutions had to be found to ensure stability. An inner reinforced concrete core is linked at various heights by means of two-story-high outrigger trusses with the megasupports, which stand immediately behind the facade. This achieves an extremely high vertical rigidity and weight-bearing capacity. The interior construction however is not visible in the exterior

View upward from the atrium on the 53rd floor

Detail showing the structure of the facade

form of the building. The suspended facade consists of granite, steel, glass and aluminum. In accordance with Chinese safety regulations, escape spaces had to be incorporated every fifteen floors, which can also be used as conference rooms.

The Jin Mao Tower has become a new architectural symbol of China. By virtue of its mixed use, including a hotel, restaurants and observation platform at the top, it also provides the general public the opportunity to enjoy spectacular views and spatial impressions. But in spite of attempts to align it with Chinese building traditions, it remains recognizable in its aesthetics and construction as the typical product of an American architectural firm specializing in skyscrapers.

In its form, Jin Mao Tower is based on the model of Chinese pagodas

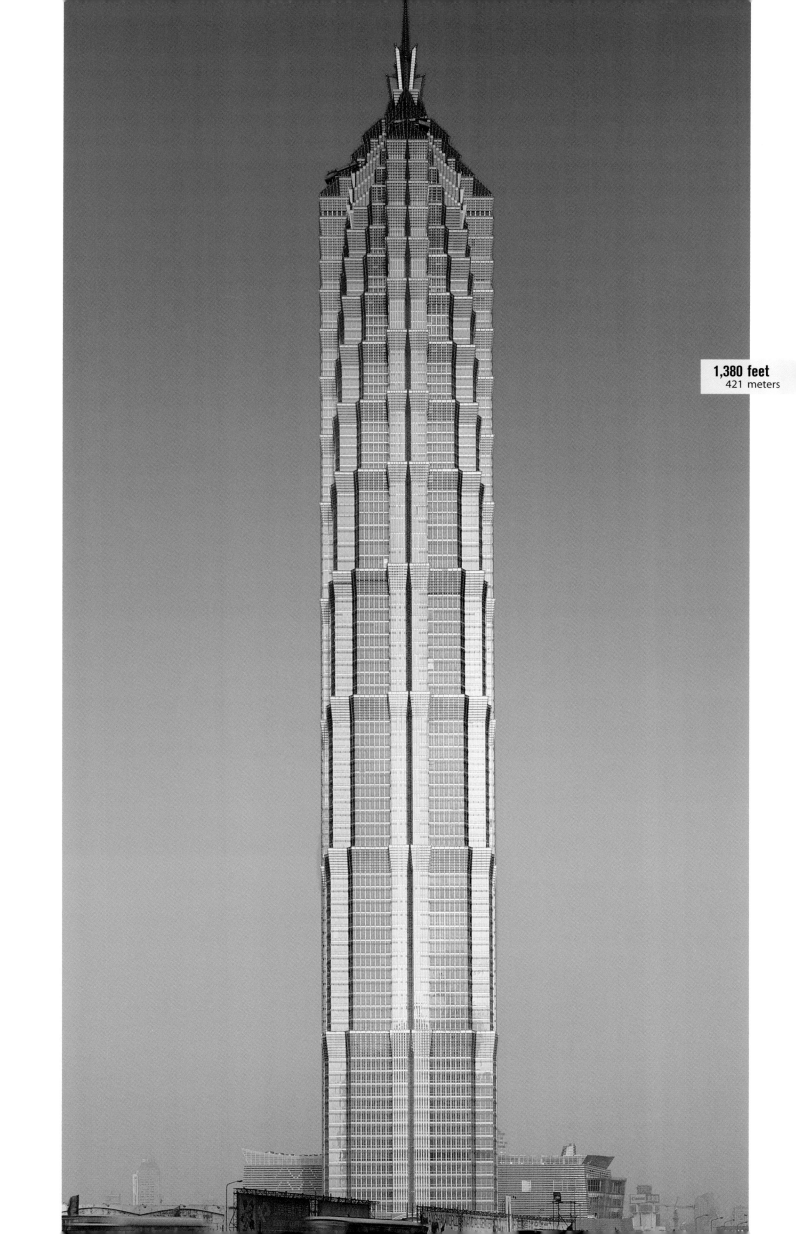

1,380 feet
421 meters

Burj al Arab Hotel Dubai, United Arab Emirates

W.S. Atkins & Partners

1994–1999

1,053 feet / 321 meters

The form of the hotel is reminiscent of a sail billowing in the wind

The luxury hotel "Tower of the Arabs" stands on an artificial island 985 feet (300 meters) from the coast

At the end of the millennium, the sheikdom of Dubai, shoppers' paradise and favorite destination of luxury tourism, felt the need for an internationally effective architectural landmark. The reigning sheikh, Muhammad bin Rashid al Maktoum, commissioned the English project development firm W.S. Atkins to design and build a unique luxury hotel, the "Arabian Tower." It was to set new standards in every respect and create a sensation for the luxury of its furnishings and its design and size.

The building was brought into being on an artificial island 984 feet (300 meters) from the coast, created as the central point of an already established holiday complex. This not only guaranteed that each of the hotel rooms would have an unobstructed view, but that the hotel would from its location alone acquire a special, effective status, isolated from the city. Tom Wright, the designing architect at W.S. Atkins, developed the hotel in the shape of an enormous sail, billowing in the wind in the direction of the city. This sail is suspended from a steel load-bearing skeleton with a straight mast at the top and two bent supports. The V-shaped building structure is set into a corresponding V-shaped support system. The hotel suites are located in the two wings, and an atrium, 590 feet (180 meters) high, lies in the open space between them. The open side between the hotel wings and the atrium is closed by a double membrane of

fiberglass fabric strengthened with Teflon, which represents the actual sail. This transparent material enables the natural lighting of the atrium in the daytime, and at night it is used as a projection screen.

With its 196-foot-high (60 meter) lattice mast at the top, the building reaches a height of 1,053 feet (321 meters) and can therefore lay claim to the title of the tallest hotel in the world. Since the building site was not built on bedrock but only sandy soil, the foundations posed a special challenge. Two hundred fifty reinforced concrete piles were driven up to 131 feet (40 meters) deep into the sand.

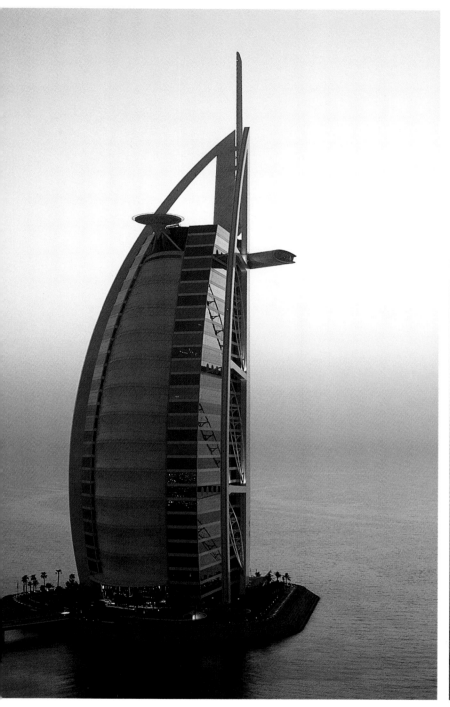

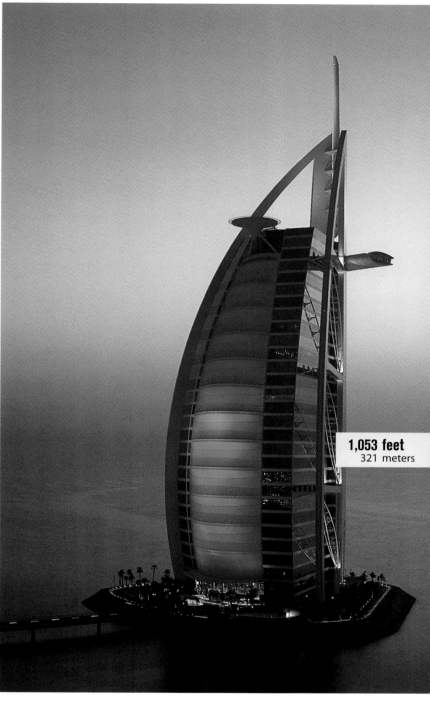

1,053 feet
321 meters

Apart from its extravagant form, the interior of the hotel offers many fabulous furnishing features, which make it the most luxurious hotel in the world. In total, it offers 202 duplex suites, 1,830 to 7,621 square feet (170 to 708 square meters) in size. And with a height of 23 feet (7 meters), the rooms are beyond any comparable hotel norms, and accordingly the building contains only 28 stories. A helicopter landing-pad on a platform protruding by 88 feet (27 meters) at a height of 656 feet (200 meters), once again revives and implements the idea first put forward in the 1930s of access to skyscrapers from the sky.

The Burj al Arab Hotel provides a symbol for a future hoped for by Dubai and other neighboring states of Saudi Arabia. In a region of extreme climatic conditions, exceptional buildings create landmarks and at the same time provide a unique experience. The interior of the hotel surpasses all desires of luxury and has thus become a tourist destination of a very special kind. Quite clearly, it is linked to hopes of an economic future which lies beyond the economic resources that have prevailed up to the present day. But its all too evident symbolism places the building very much in the vicinity of the "theme architecture" of Las Vegas.

Highcliff & The Summit Hong Kong, China

Dennis Lau & Ng Chun Man Architects

1999–2003
828 feet / 252 meters (Highcliff)
722 feet / 220 meters (The Summit)

Typical floor plans of Highcliff (left) and The Summit (right)

By preference, residential high-rise buildings are created in locations that offer spectacular views. Only there can the property prices be achieved that correspond to the high cost of construction. The two exclusive apartment high-rises Highcliff and The Summit stand on a common site in Hong Kong, on a steep mountainside above the city. Both were designed by the local architectural office of Dennis Lau & Ng Chun Man. While they are different in form and facade design, they are matched to each other in their general composition.

Highcliff is among the tallest skyscrapers in the world to serve exclusively residential purposes. Above a nine-story base area, which accommodates a multistory car park, an entrance hall and a swimming pool, the tower rises up sixty-five stories high. On sixty stories, there are two, four-bedroom apartments, while the 34th and 57th floors are designated as escape areas. The top three floors contain the building's mechanics. The ground plan is formally based on two intersecting ellipses, whose sectional surface contains the rigid core of the building with four elevators and a stairwell.

The Summit is developed on a butterfly-shaped ground plan and contains fifty-two duplexes on fifty-six floors, also with four bedrooms, as well as two duplexes with five bedrooms. Here too, the 31st and 51st floors are designated as escape areas. The two passenger elevators take residents and visitors directly into a private elevator lobby of the apartment itself.

Both Highcliff and The Summit are based on a concrete structure with a rigid core and a suspended facade. Because of the sloping situation of the site, the construction of the foundations represented a special technical challenge. They are fixed by concrete piles sunk to a great depth in the bedrock. The concrete constructions of the buildings were created with a self-climbing shell. In proportion to their height, both buildings are extremely slender and therefore particularly susceptible to swaying. Since powerful typhoons are frequent in Hong Kong, dampers had to be installed to reduce to an acceptable degree the calculated extreme building movements at the top. The dampers are located at the peak of the building and consist of a damper tank system, whose structural models are derived from shipbuilding. Since this is a passive system of large quantities of water in a number of interconnected tanks, it functions independently of computer control or power supply. The system reduces the degree of sway by about half.

As a city of millions, Hong Kong today possesses by far the highest population density in the world in relation to its surface area. Because of the extreme shortage of space, it is practically impossible to build luxurious individual housing in the form of, for example, free-standing villas. Highcliff and The Summit are outstanding examples of the further development of the skyscraper as an exclusive residence. They offer the highest standards of individual comfort along with breathtaking views of the city from all of their floors.

The ground plans demonstrate the different layouts of the closely adjacent buildings

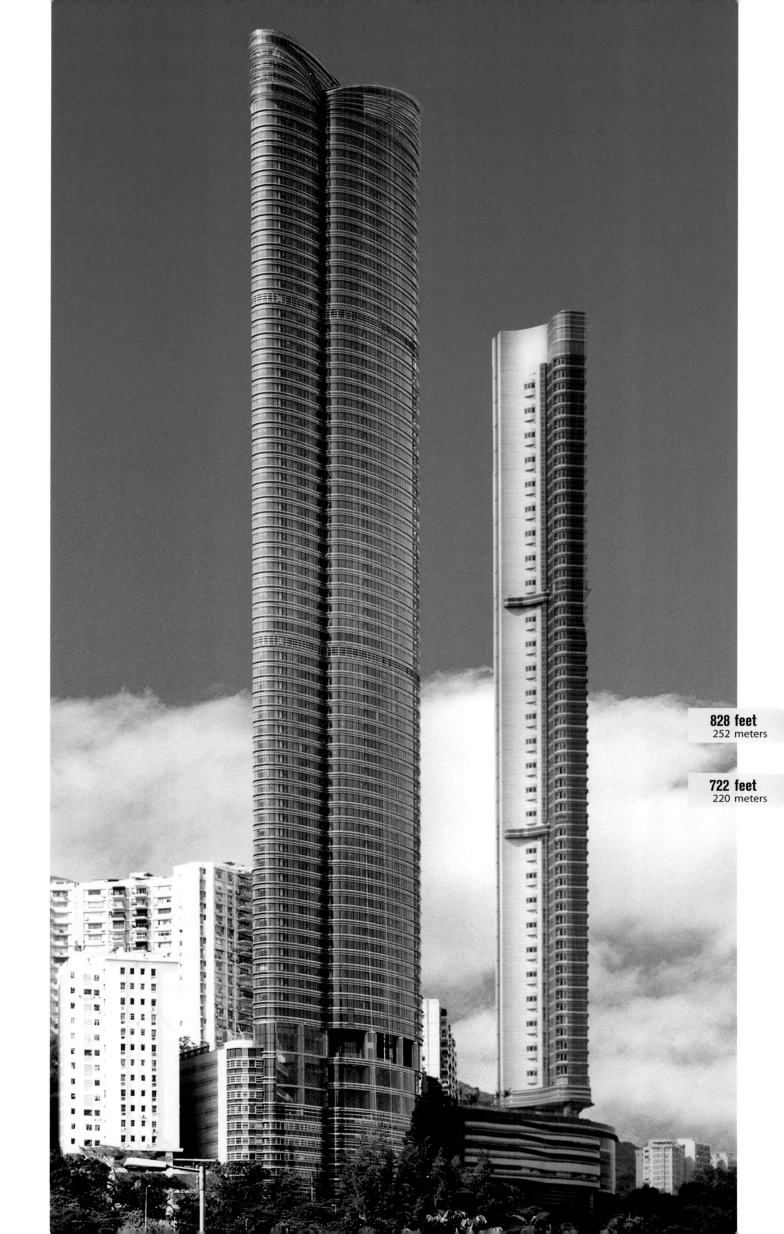

828 feet
252 meters

722 feet
220 meters

Swiss Re Headquarters London, UK

Norman Foster & Partners

1997–2004
590 feet / 180 meters

Drawing by Norman Foster showing the wind conditions near the building

For more than twenty years, since the NatWest Tower was built in 1980 at a height of 600 feet (183 meters), there had been no new high-rises built in the inner city of London. But at the turn of the millennium, the prevailing attitude of rejection suddenly changed, and a new boom in high-rise projects set in. One of the first buildings completed since then is the tower of the insurance and finance company Swiss Re, at 30 St. Mary Axe in the heart of the banking district. It stands on the site of the old Baltic Exchange building, which was demolished in 1992. The city planners wanted a high-rise building to be created on that site which would allow more public street space than its predecessor had. A 98-story Millennium Tower, 1,265 feet (386 meters) in height, designed for this site by Norman Foster in 1996, was not approved. The site was sold to Swiss Re, who then commissioned him to design a smaller high-rise.

Foster, who had already developed decisive new approaches in high-rise construction with the Hongkong and Shanghai Bank (p. 106) and the Commerzbank in Frankfurt (p. 120), also tried in this project to develop new technological, urban planning and ecological concepts. The most striking element of this building, certainly at first glance, is

its outer form, which has already led to a number of nicknames such as "the Gherkin." Foster explains the development of the pine cone-like shape as the result of aerodynamic experiments which showed this shape provides the lowest resistance to wind. This in turn diminishes demands on the load-bearing structure, as well as the danger of strong katabatic (downward) winds in the area around the building—a frequent problem of high-rises.

The office spaces are quite traditionally arranged around a central access core with elevators, side rooms and fire escapes. The load-bearing structure, a net-like steel construction, which lies directly behind the glass facade, allows support-free spaces right up to the core. The decisive new element in the inner structure is the inclusion of triangular light shafts behind the facade, which spiral upwards over the whole height of the building. On each floor, six of these openings are cut into the circular outline, and the darker tinting of the glass in these areas results in a striking pattern in the facade. These light and air shafts are interrupted every six stories by an intermediate floor, to minimize the development of drafts and noise. This produces open spaces over several stories, as recreation rooms, similar to the "sky gardens" of the Frankfurt Commerzbank. Below the top of the tower are three technological stories, which can be recognized from the outside as black rhombuses. At the very top, below the suspended glass dome, is a restaurant, a function room and a bar. These, however, are not open to the public.

The Swiss Re Tower is one of the first high-rise buildings in London in recent times to mark a widely visible urban planning breakthrough for the city center. While it sets no height records, its biomorphic form makes it esthetically significant. And with its highly complex inner structure and its concepts of natural ventilation and lighting, it represents a further development of a European type of high-rise building. Although the building, as demanded, allows more public space at street level, integration into its urban surroundings is supplied only by the stores on the ground floor.

Cross section through the building

In its form, the building at 30 St. Mary Axe fits remarkably well into the urban context

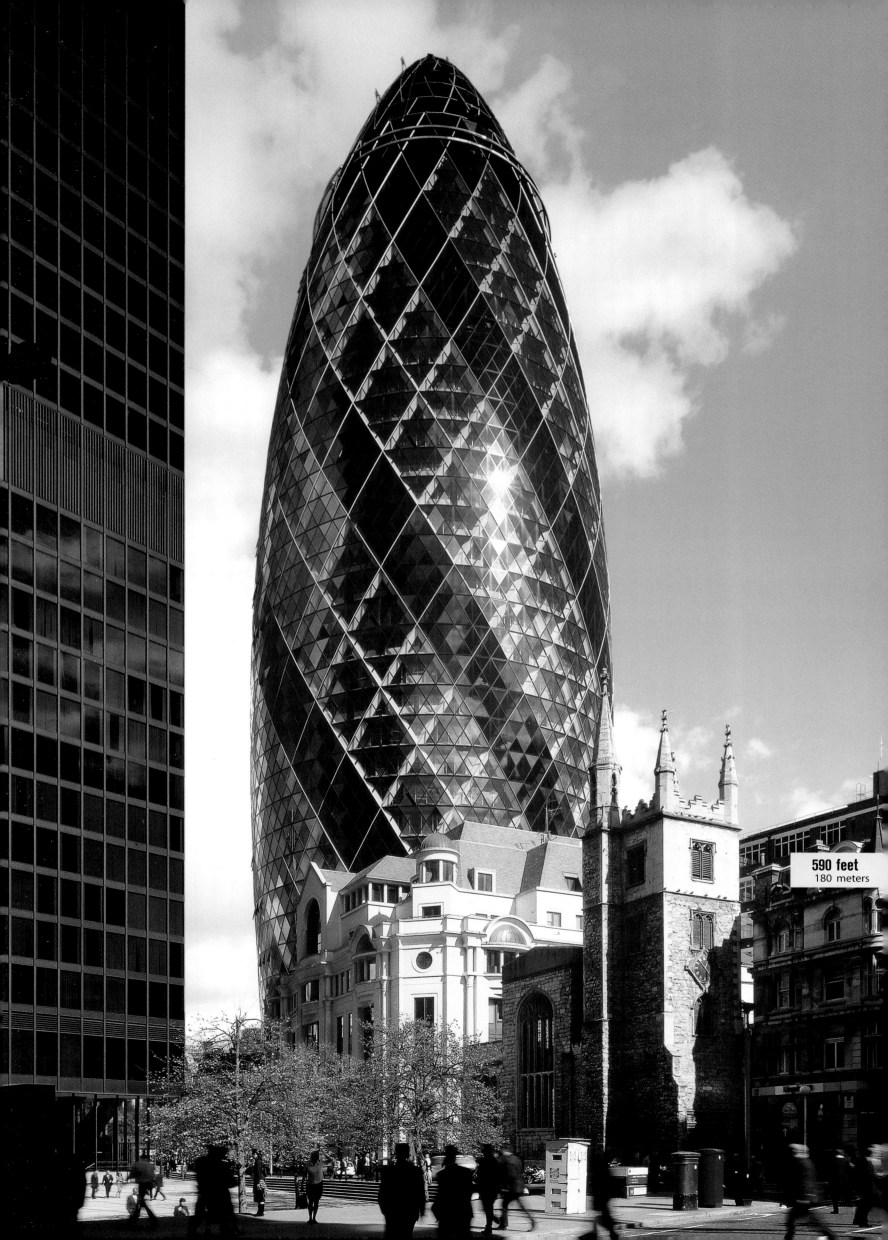

Taipei Financial Center (Taipei 101) Taipei, Taiwan

C.Y. Lee & Partners

1999–2004
1,667 feet / 508 meters

In a geographical region which is doubly endangered, not only by frequent earthquakes, but also by typhoons with wind speeds of up to 155 miles per hour (250 kmh), the building of a super-high-rise represents an extreme challenge. Nevertheless, this area possesses bedrock at a depth of 197 feet (60 meters), in which the foundations can be anchored. For the foundations of the Taipei Financial Center, 550 concrete piles were embedded in the bedrock. Upon this, a combined static system of eight steel megasupports and a rigid concrete core was placed. The outer megasupports measure 8–10 feet (2.5–3 meters) in diameter and extend through the entire height of the tower. Inside they are filled with heavy-duty concrete. The rigid core in the center of the tower contains the supply core with staircases and elevators, while the ring of megasupports and the core are, as in the other more recent super-high-rises, linked with each other in various sections by means of outrigger trusses. In order to restrict excessive swaying of the tower in high winds, a vibration damper consisting of a suspended steel ball weighing 660 tons was installed on the 92nd floor and is visible to observers on the inside. The intent is to keep the tower stable against all vibrations. But an earthquake during construction in 2002 caused two construction cranes to fall from the building, and five people lost their lives as a result.

Detail of the facade

Interior space with lighting from above

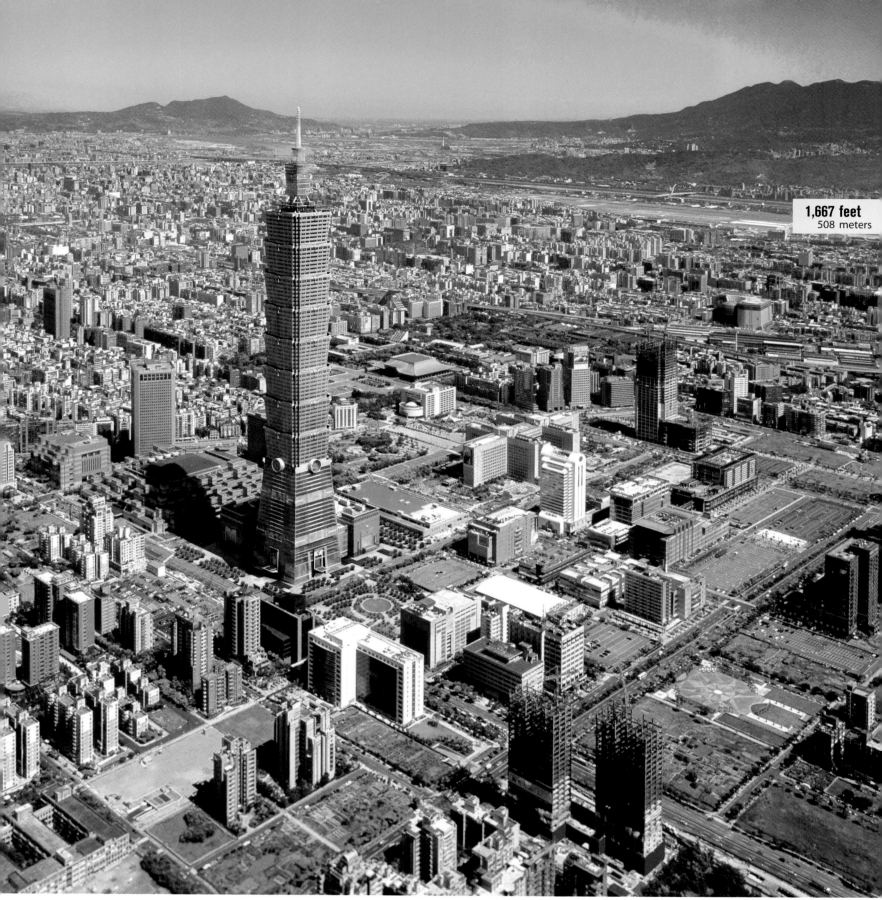

1,667 feet
508 meters

The Financial Center stands out clearly from its urban surroundings

4F

Floor plan

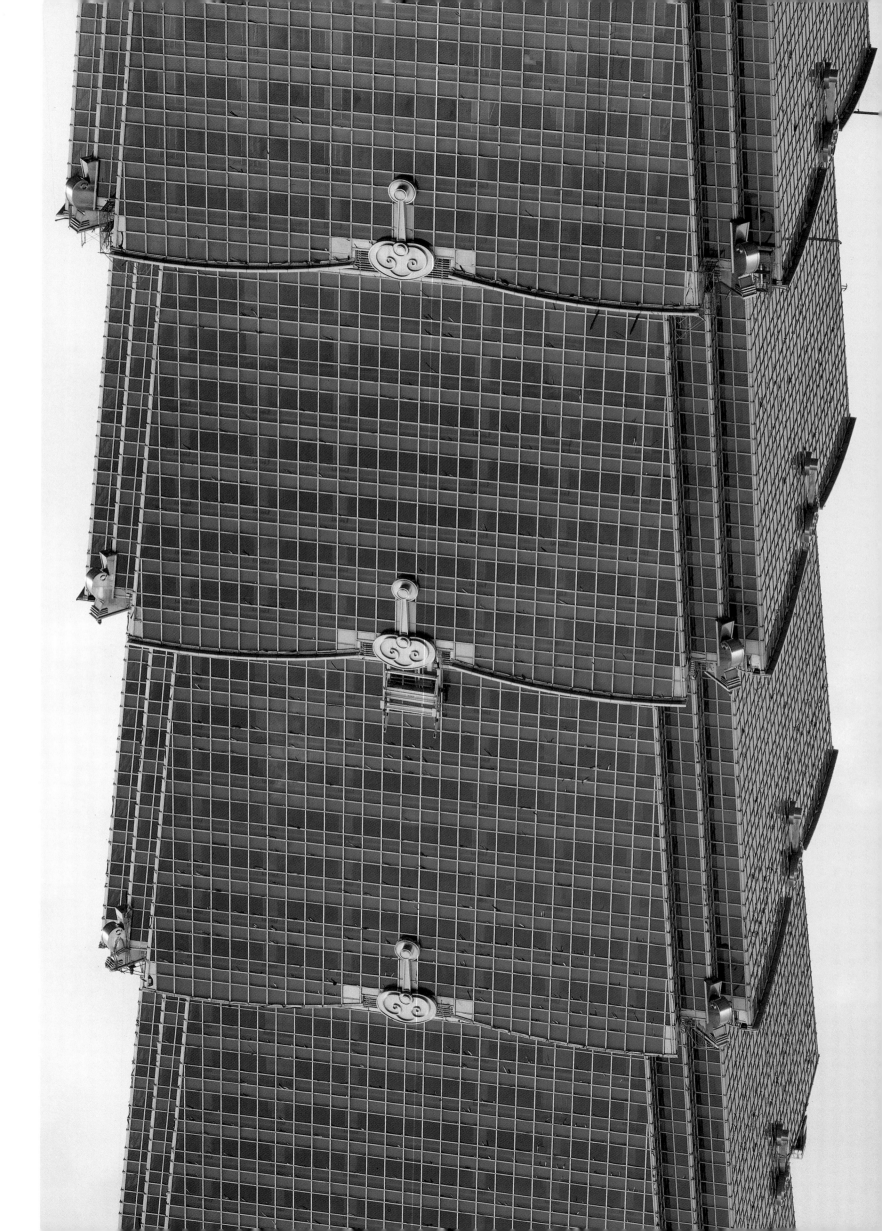

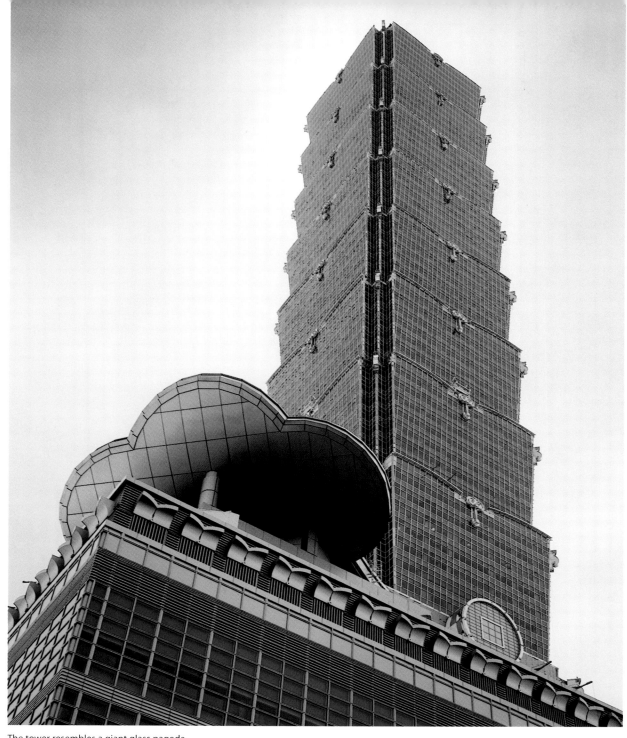

The tower resembles a giant glass pagoda

In its form, the Taipei Financial Center combines a suggestion of the shape of bamboo sprouts with that of the Chinese pagoda. Like the Jin Mao Tower (p. 126), the Taipei Financial Center includes multiple references in its structure to the lucky number eight. Thus, the upper shaft of the structure, which sits on a pyramidal base, is composed of eight funnel-shaped elements with eight floors each. At the upper end of each section, ornaments of stainless steel 26 feet tall (8 meters) are applied on all four sides, and on the corners are further ornaments symbolizing luck-bringing dragons. The tower does not taper upward in its totality, but on its topmost section stands a narrow peak crowned by a transmitter mast. On the 91st floor is an observation platform. The Taipei Financial Center contains sixty-three elevators, which are used by some 10,000 workers daily. Three elevators convey visitors to the restaurant to the 89th floor in 39 seconds, at a record speed of 3,281 feet per minute (1,000 meters per minute).

Taipei 101 was built in Hsinyi, the newly developed business quarter of Taipei, and symbolizes a departure in a new dimension of skyscrapers. The idea of making this tower project into the tallest skyscraper in the world came, once again, not from the designing architect, but from the former mayor of Taipei and current president of Taiwan, Chen Shui-bian. The Taipei Financial Center thus takes over the title of the tallest skyscraper in the world from Petronas Towers (p. 124) after only seven years, but with the construction of the almost completed Burj Dubai (p.148) it will be obligated to relinquish its title at the latest in 2008.

Torre Agbar Barcelona, Spain

Jean Nouvel

44

1999–2004
466 feet / 142 meters

The Torre Agbar in its urban context

Leading up to the 1992 Olympic Games, a strong push toward urban renewal began in Barcelona. This included the first two high-rise buildings on the coast, the Hotel Arts by Skidmore, Owings & Merrill and the Torre Mapfre by Ortiz Leon Arquitectos (505 feet / 154 meters). A new wave of high-rise projects, designed by internationally renowned architects, is presently being realized in the city center. On the Plaça de les Glories, in direct view of the famous Sagrada Familia church by Antoni Gaudí, the French architect Jean Nouvel is building the Torre Agbar.

The Torre Agbar was commissioned by the firm of Aguas de Barcelona. At 466 feet (142 meters) in height, the building will be the tallest new building in the city center, but will still not reach the height of the Gaudí church. The aim is to provide an architectural landmark that will represent both an enrichment of the city and a striking symbol for the firm. In 1989 Jean Nouvel had already designed a spectacular high-rise building in La Défense in Paris, the Tour Sans Fin—a glass, double-shelled cylinder that visually breaks up bit by bit up to the top at 1,378 feet (420 meters) in height. At only 141 feet (43 meters) in diameter it would have been the most slender high-rise in the world, but its realization fell victim to the real estate crisis of the 1990s. For the Torre Agbar, Nouvel reverted to his unrealized project, but designed a new, unusual form and structure.

The high-rise takes the form of a concrete shell, elliptical in cross-section, which is interrupted by irregularly inserted windows. Inside, the building contains an elliptical, off-center supply core with elevators and staircases. The shell and the core together form the static framework, and the office spaces between them are completely unsupported. The tower tapers upward in the form of a projectile. The exterior of the building is clad with colored aluminum surfaces, in front of which, at a distance of about 28 inches (70 centimeters), a glass facade is suspended forming a second skin. The glass facade is partly transparent and partly printed with a semitransparent design. In the strong sunlight of Barcelona, the double shell creates a living and dynamic play of colors and reflections. Since the load-bearing concrete shell is interrupted by irregularly cut windows, costly calculations were necessary to ensure stability, since the load-bearing capacity of each story had to be calculated separately. Toward the top of the building, the shell becomes gradually thinner in accordance with the decreasing load. In the building process, a new self-climbing casing was used for the concrete.

With the Torre Agbar, Jean Nouvel succeeded in linking the idea of the skyscraper with the architectural context of Barcelona while at the same time creating a new architectural landmark in the city. Even though its use of available space at 62.5 percent is not very high compared to other high-rises, in its spectacular structure and form it proves yet again that the symbolic value of high-rise buildings is often more important for the client than their economic value.

Various interior impressions

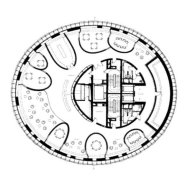

Typical floor plan

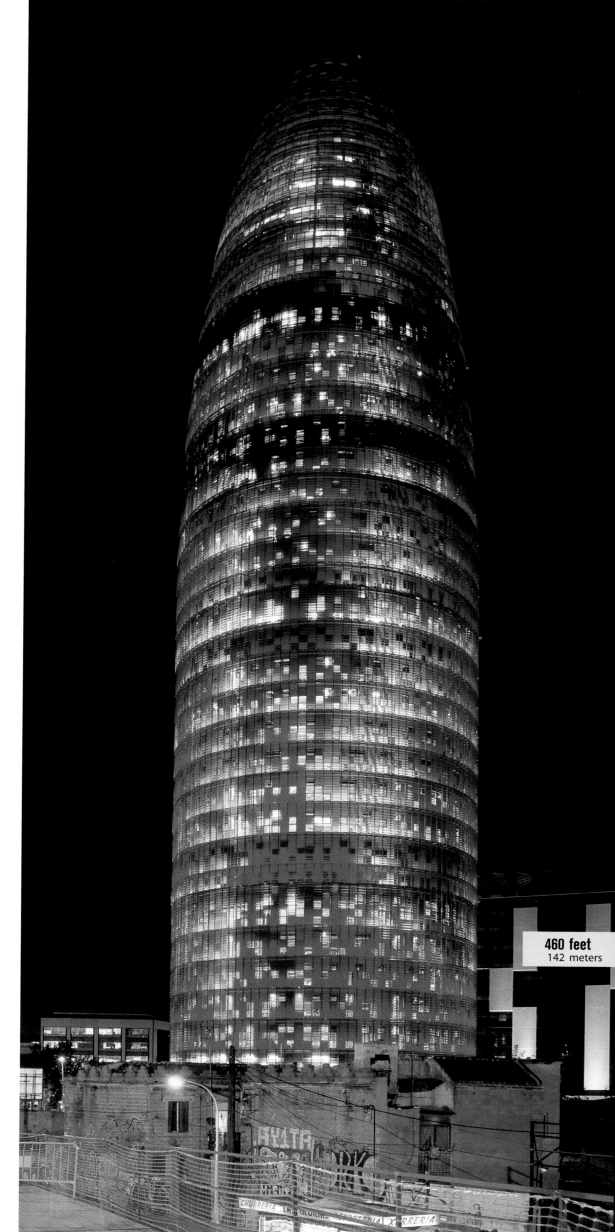

460 feet
142 meters

Night view

Turning Torso Malmö, Sweden

Santiago Calatrava

1999–2005
623 feet / 190 meters

Typical floor plan

Since 2000, the Swedish city of Malmö has been linked to Copenhagen in Denmark, directly opposite the city, by the bridge over the Øresund. This traffic link has further improved Malmö's economic position in this dynamic region. The Turning Torso, taking shape on a former industrial site right on the city's western port, is one of the most interesting high-rises of recent times.

The project originated from an idea of Johnny Örbäck, manager of the apartment and project development firm HSB. In 1999 he had seen Santiago Calatrava's sculpture *Twisting Torso* in a catalogue, and prompted the architect to transform this work of art on a large scale into an office and residential high-rise in Malmö. Like the sculpture, the building is composed of nine cubic elements, which turn gradually upward at 90 degrees around a circular axis in the center. The individual segments of the high-rise, unlike the sculpture, are however not square but polygonal in the ground plan.

The load-bearing structure of the building rests for the most part on a central concrete ring 35 feet (10.6 meters) in diameter. Its foundations are fixed 49 feet (15 meters) deep, directly into the bedrock. The thickness of the core narrows from 8 feet (2.4 meters) at the base to 3 inches (8 centimeters) at the top. As with the Johnson Wax Research Tower (p. 60), the ceilings of the stories are fixed directly to the core and not carried by supports at the outer edge. The prefabricated facade elements of white aluminum and glass are freely suspended. The steel supports applied to the exterior were not specified in the first draft. But when it was realized that strong winds could cause the tower to sway up to 35 inches (90 centimeters) at the top stories, an additional rigid element was designed. The exterior steel construction reduces the maximum amount of swaying to an imperceptible 11 inches (30 centimeters). In addition, this construction means that a weight of 3,500 tons can be transferred to separate foundations.

Cross section through the building

The Turning Torso is designed as an exclusive office and residential high-rise. The two lower sections offer 45,200 square feet (4,200 square meters) of office space, and the upper sections contain a total of 152 condominiums of between 538 to 1,830 square feet (50 to 170 square meters) in size. The static core contains the technical supply facilities, several elevators and a staircase. Apart from the high-quality interior decoration of the apartments, the building offers its residents additional benefits such as a personal reception room on the 49th floor, a sauna and a fitness room on the 43rd floor, and guest apartments.

As with other projects of Santiago Calatrava, part of the construction of the Turning Torso is visibly turned outward. Very much in the tradition of the engineering-led architecture of Luigi Nervi, Calatrava is also interested in both making construction more aesthetic, and in the dynamics of organic form. With the Turning Torso, Sweden has been given the tallest high-rise in the country and at the same time a skyscraper whose colorful form points to a new direction in the design of high-rise buildings.

623 feet
190 meters

A view of the Turning Torso showing the sculptural character of the building

Shanghai World Financial Center Shanghai, China

Kohn Pedersen Fox Associates

1997–2008
1,614 feet / 492 meter

Aerial view of the building

The design of the Shanghai World Financial Center was developed from a simple geometrical idea: a structure on a square base is gradually truncated to the point where two corners meet, so that at the very top only the line of the diagonals remain. At the top, a hole is cut into the concave cross section. This hole serves primarily to reduce wind pressure on the facade. In its minimalist geometry, the World Financial Center gives the impression of an oversized sculpture. The tower rises at its base from a semicircular service structure, which accommodates stores, an entrance lobby and various side rooms. However, no direct relationship with its urban environment can be discerned. The load-bearing system of the building will, as with practically all recent high-rise buildings, consist of a combined structure, formed by a core and megasupports behind the facade.

The Shanghai World Financial Center will be devoted to mixed uses. Above the office floors, a luxury hotel occupies the upper area, which will be the highest hotel in the world. Moreover, there are plans for a club floor for members of the board, several restaurants and an observation platform at the peak.

The cornerstone of the Shanghai World Financial Center was laid in August 1997, but as early as the following year the investors' group of some thirty-six international firms and banks put a stop to construction as a result of the financial crisis in Asia. In 2003 construction resumed, and on September 14, 2007, the building reached its final height at 101 stories. This makes it taller than the adjacent Jin Mao Tower (421 meters) and the Oriental Pearl Tower (468 meters), and is therefore the tallest building in China today.

In the immediate neighborhood of the Jin Mao Tower (p. 126), on Century Avenue in the financial district of Pudong, another super-skyscraper will have arisen by around 2008. At around 101 stories, and with a height of 1,614 feet (492 meters), the Shanghai World Financial Center will noticeably reach an even greater height than the Jin Mao Tower, thus becoming the tallest building in mainland China. Like most of the record projects of the early twenty-first century, the Shanghai World Financial Center was designed by a large American architectural firm. The office of Kohn Pedersen Fox in Manhattan was founded in 1976 and has become, after SOM, Cesar Pelli and Murphy/Jahn, one of the major internationally active firms specializing in high-rise building.

The form of the floor plans changes from the bottom to the top of the tower

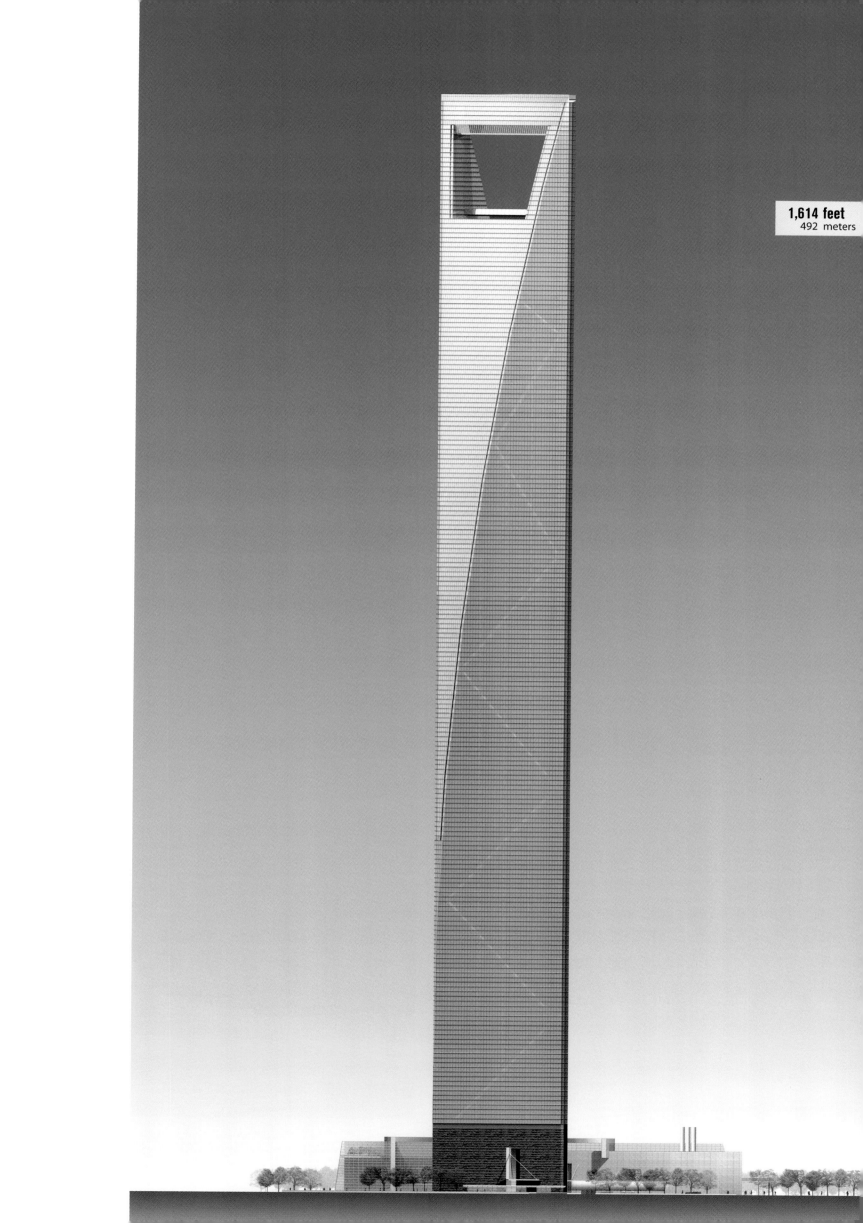

1,614 feet
492 meters

Central Chinese Television Headquarters (CCTV) Beijing, China

OMA Office for Metropolitan Architecture

2002–2008
768 feet / 234 meters

Model of the building

With an intended height of 768 feet (234 meters), the Central Chinese Television Headquarters commissioned by Chinese state television (CCTV) in Beijing, scheduled for completion in time for the 2008 Olympic Games, will not contribute to the height records in Asia. However, on account of its spatial concept and statics it will certainly rank among the high-rise buildings to attract the greatest attention worldwide at the beginning of the twenty-first century. The design comes from the Dutch architect Rem Koolhaas, who established his reputation in the 1980s with books such as *Delirious New York* and *S, M, L, XL*, and has been active in designing and building internationally since the 1990s. For some time he has occupied himself intensively with the necessity, as he sees it, for a new definition of the high-rise building. In 1996, with the unrealized design of Togok Towers for Samsung Electronics in Seoul, he put forth a precise approach toward overcoming the usual pattern of the purely hierarchical/vertical structure of monolithic high-rises.

In the spring of 2002, Koolhaas had to decide between an invitation to take part in new plans for Ground Zero in New York and the competition for the China Central Television Station. He decided in favor of the latter, won the competition, and received the commission for the largest building project of his career up to that date. The building program envisages bringing together production and administration, news station and broadcasting services in one building with about six million

View of the illuminated facade by night

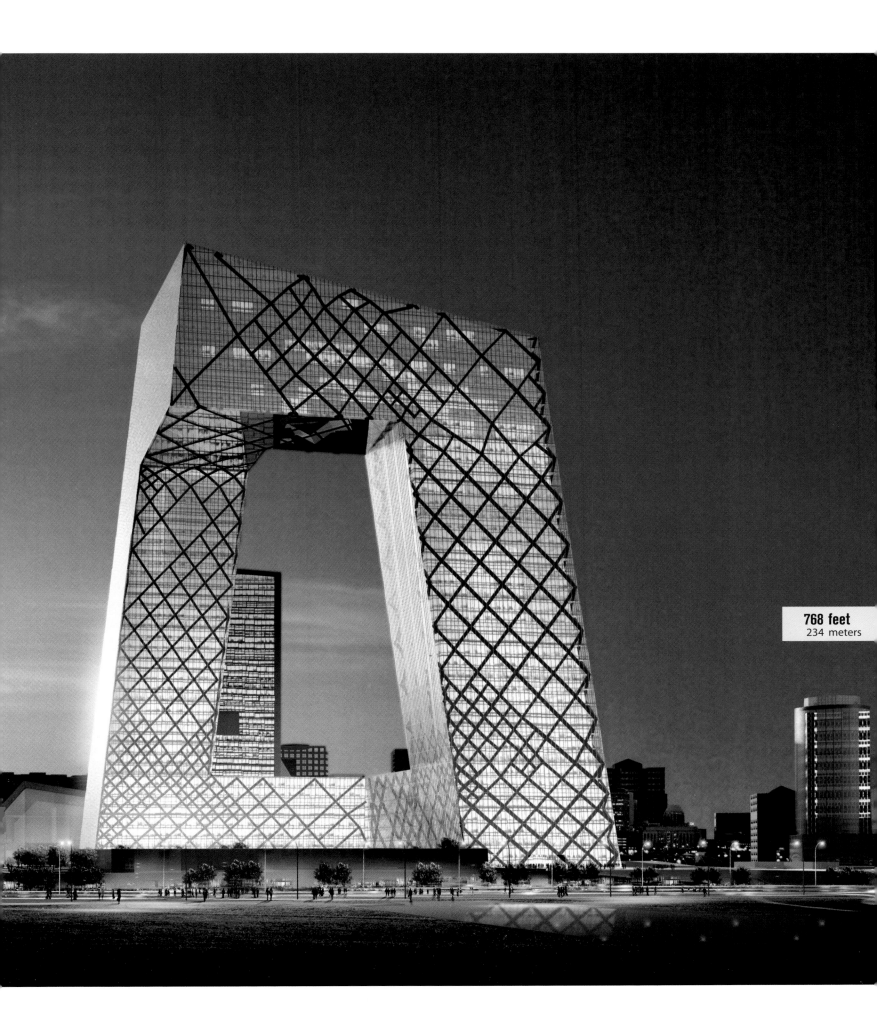

768 feet
234 meters

Axonometric view of the building

At night, the building becomes a projection surface

The CCTV Headquarters in its urban context

Model of the building

Detail view of the facade

Interior view

square feet (558,000 square meters) of usable space. For this project, Koolhaas has developed a sculptural form in which two towers, slightly slanted, rise from a common platform on a square surface. At the 37th floor, they merge with an L-shaped horizontal bridge structure. This results in a complex play of positive and negative forms, including a deliberately "empty" center. With these inclining towers and the vertical buildings linked at a great height, the structures seems to take on elements of Soviet Revolution architecture such as El Lissitzky's designs for a Lenin Tribune (1920–24) and that of a horizontal skyscraper (1924–25). Koolhaas's design is reminiscent at the same time of Peter Eisenman's unrealized design for the Max Reinhardt House in Berlin (1992–93).

The projection of a large part of a building at such heights presents extreme challenges to the static system. The supporting structure should be understood as a set of tubes, closed in themselves yet linked with each other. Koolhaas stresses the symbolic power of the new concept of high-rise form, which according to his wish clarifies the cooperation of employees in a looping total design more strongly than do the conventional, purely vertically oriented structures. The facade of the CCTV Headquarters is intended both to make the complex, supporting structure detectable from the outside while at the same time to enliven it in the darkness with brilliant images that reflect the identity of the television station. In this way, a part of his aborted design for the Center for Art and Media Technology in Karlsruhe (1989) would be executed after all. The construction of the two diagonally placed towers was completed in 2007 and the linking bridge structure will be finalized by the winter of 2007–08. The building is to be completed in time for the 2008 Olympics in Beijing.

Burj Dubai
Dubai, United Arab Emirates

SOM Skidmore, Owings & Merrill

2003–2009
1,900 feet / 586 meters

Computer-generated aerial view of the building

On Sheik Zayed Road, Dubai's skyscraper mile, a skyscraper of some 1,900 feet (586 meters) in height is to come into being by 2009, which will bring the record for the tallest high-rise in the world to the United Arab Emirates. The exact height of the Burj Dubai, the "Tower of Dubai", has not yet been announced, in order to keep the competition in the race for the much-sought-after record title open for as long as possible. But, at the end of 2007, with the shell of the building almost complete, it is clear that at about 586 meters it has

already broken all records. If further additions and transmitter masts are built at its top, the building could reach a height of more than 700 meters. The client is the project development firm Emaar Properties of Dubai. It took over the plans for a tower of more than 1,640 feet (500 meters) in height from the Australian investor Bruno Grollo. His Grollo Tower, planned for Melbourne, had been rejected in 1999 by the Australian authorities. After the takeover, however, the project was refurbished by means of a design competition, which was won by the designing architect Adrian D. Smith for SOM.

The ground plan for the Burj Dubai is Y-shaped with three arms of equal length, clearly following the model of Lake Point Tower of 1968 in Chicago (p. 84). Here too, this basic form is intended to enable an unobstructed view from all the apartments. Unlike Lake Point Tower, however, the Burj Dubai tapers gradually from ground level upward, and with a gentle turn around the central axis, so that the tower acquires a spiral shape up to the top. In its center, it will have a hexagonal concrete core as static support, which will also serve as a central supply tower. The multiple offsets in this structure are intended to reduce the pressure of wind on the facades. The interior supply elements, access and air conditioning for this gigantic structure will represent an extreme challenge, especially in view of the local desert climate.

For the American architectural firm SOM, the Burj Dubai commission is of great importance. SOM has designed four of the fifteen tallest buildings in the world, and with the Sears Tower (p. 96) it has already attained a world record. With the canceled project for 7 South Dearborn in Chicago of 1998, design partner Adrian D. Smith had already designed a new world record structure, which however was not executed. With this project, and also with the simultaneous new designs for the World Trade Center site in New York (p. 150), SOM is aiming for the sky.

The Burj Dubai is planned as a multifunctional building, which will accommodate apartments and hotels, but also cultural institutions, shopping arcades and in its base the largest shopping center in the world. The entire complex is to be surrounded by a park with a large lake. The client's wish is that the Burj Dubai should become a new milestone in the country's economic development and an architectural symbol that will be known worldwide. It is therefore logically linked to the already realized, and equally fabulous major projects Dubai Marina and Burj al Arab (p. 128).

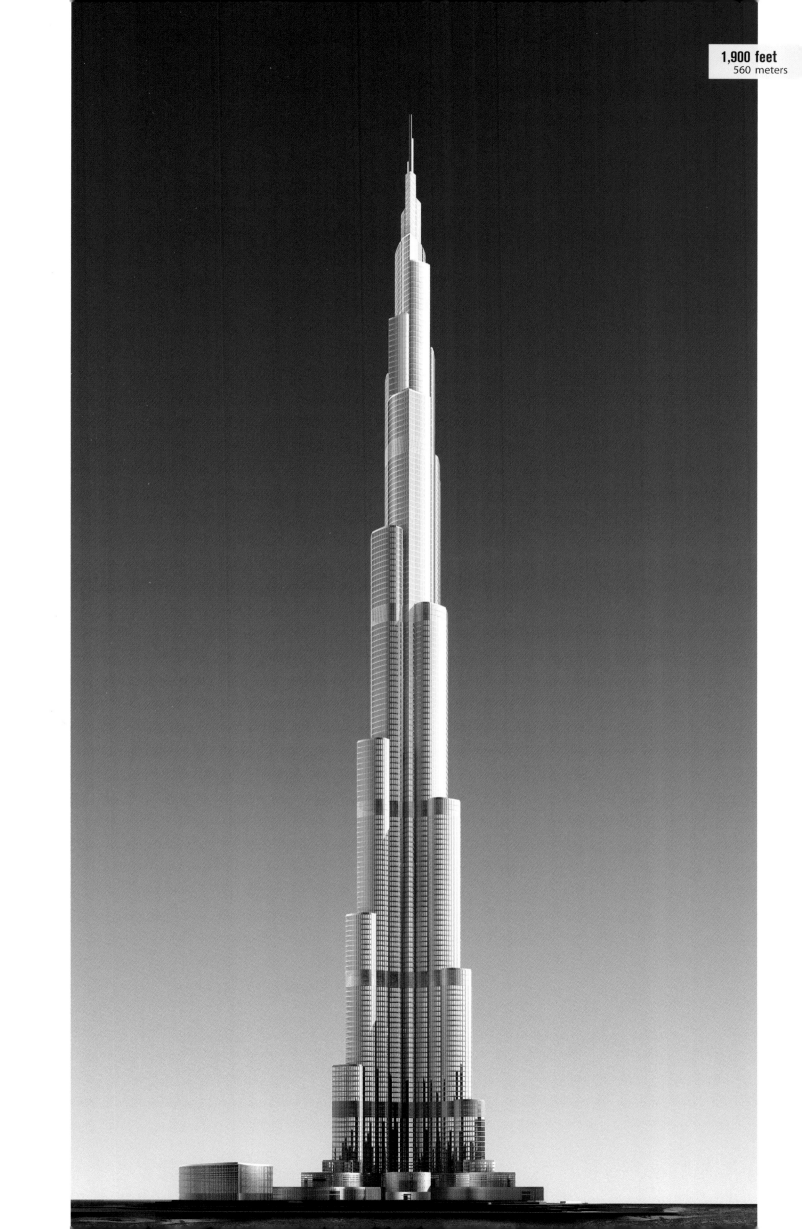

Freedom Tower <small>New York, USA</small>

David Childs of SOM Skidmore, Owings & Merrill, Daniel Libeskind

2004–2009
1,776 feet / 541 meters

Night view of a model from the south

The revised design by Daniel Libeskind

The attack on the Twin Towers of the World Trade Center on September 11, 2001, tore a painful hole in the cityscape of southern Manhattan and in the consciousness of people all over the world. The monumental void of Ground Zero that was created after the clearance work had been completed acted as a powerful vacuum, sucking in the most varied ideas from all sides. Soon after the disaster, the Lower Manhattan Development Corporation (LMDC) was founded to handle new plans for the area. In July 2002, together with the owners of the site, the Port Authority of New York and New Jersey (PANYNJ), the LMDC presented six preliminary planning proposals for public discussion. At a hearing, all six proposals were rejected as inadequate, but this discussion resulted in the definition of guidelines for a new master plan. The "footprints," the surfaces on which the towers of the World Trade Center had stood, would not be built upon in the future, but a memorial should be created and the newly designed building should provide a significant contribution to the skyline of Manhattan.

An international competition was launched in August 2002 and 406 entries were received. By December, the LMDC had chosen seven architectural offices and teams for further discussion: the studio of Daniel Libeskind; the THINK group, consisting of the architects Shigeru Ban, Frederic Schwartz, Rafael Viñoly and Ken Smith; the office of Foster and Partners; a team consisting of Richard Meier, Peter Eisenman, Charles Gwathmey and Steven Holl; the office of Peterson Littenberg; and the partnership United Architects. Rather than submitting merely urban planning designs, nearly all delivered plans that were already very thoroughly thought out, stimulating ideas for actual buildings.

In February 2003, after further public hearings and discussions, and with the significant participation of the national and international specialist press, Daniel Libeskind and the THINK group were asked to produce a further revision of their proposals. However, at the end of February when the LMDC announced Libeskind as the winner, the investor Larry Silverstein spoke up. He had taken a lease on the World Trade Center a few weeks before the disaster, and at that time had already entered into discussion with the architect David Childs of SOM to discuss the restructuring of the building complex.

From the investor's point of view, Libeskind's plans did not conform to economic considerations; they offered too little rentable space. But above all, Libeskind was unable to demonstrate any experience in high-rise construction. After an abortive attempt to let Libeskind and Childs work as a team, Silverstein declared David Childs to be the executive architect of the Freedom Tower. Libeskind's task was restricted to that of a consultant in the general planning. In November 2003, three further architects were named who would build office buildings on the basis of Libeskind's master plan: Fumihiko Maki, Jean Nouvel and Norman Foster. Libeskind was not given a building contract. In July 2003, the Port Authority commissioned Santiago Calatrava to restore the railway and underground stations on the site of Ground Zero.

Computer-generated view of the final design by SOM

Daniel Libeskind's design, with its graphic and very deliberately patriotic language of symbols, went straight to the heart of public expectations. His proposal left the foundations of the WTC open to a depth of 70 feet (21 meters) and created a new square, the "Park of Heroes." Beside this he placed the so-called Freedom Tower. This was planned as an office building only up to a certain height because it was expected that the top floors would not be rented out any more; the top third consisted of an open construction which would accommodate the "Gardens of the World." The planned height of 1,776 feet (541 meters) referred to the date of the American Declaration of Independence, and it was probably not mere chance that the building at that height should become the new world record holder in the endless race for the title

of tallest building in the world, albeit only if the framework above the office floors is included.

The Freedom Tower designed by David Childs retains, apart from the symbolism of its height, only a few remnants of Libeskind's master plan. It will above all be a commercial, rentable product of the architectural firm SOM, in accordance with the wishes of the investor. As with the double-tower of the Time Warner Center on Columbus Circle (2004), also designed by Childs, the Freedom Tower when completed cannot be expected to provide any decisive stimulus for Manhattan or the skyline of New York. The triumphal gesture with which the top of its tower repeats the raised arm of the Statue of Liberty is an illustrative, but not an architectural symbol.

Computer animated view
of the crystalline high-rise

Design sketch by Renzo Piano

London Bridge Tower London, UK

RPBW Renzo Piano Building Workshop

2005–2009
1,016 feet / 306 meters

In 2005, according to the design of the Italian architect Renzo Piano, the tallest skyscraper in London will come into being on the south bank of the Thames. This multifunctional high-rise stands on the busy traffic junction of London Bridge Station and is directly linked with the station at its base. This area used by many commuters, between railway station, underground station and St. Thomas Street, will also be completely restructured and extended with stores and new traffic zones. The sixty-six stories of the London Bridge Tower are subdivided into several functional layers. Apart from the basement level, two more sections higher up between the 34th and 36th and the 65th and 66th stories, are designated as public areas. As "piazzas in the sky" they are equipped with winter gardens, stores, restaurants and exhibition spaces. Offices are located between the 4th and 31st floors, between the 37th and 51st is a hotel, and toward the top, between the 52nd and 64th floors, are a total of 114 exclusive apartments.

In its construction, the building is based on a combined system of steel megasupports running immediately behind the glass facades and a rigid concrete core in the center, which contains supply shafts, staircases and elevators. The overall form, a slender glass pyramid, ensures that the building does not give off a too "block-like" impression in the cityscape, or overshadow the street space. The facade is not designed as an entirely closed skin, but is composed of several layered glass surfaces. Since it is constructed of especially white glass, it conveys the idea of a crystal structure which becomes ever more slender upward to the top. The interior of the London Bridge Tower will be equipped with a newly developed heating and air-conditioning system, which uses about thirty percent less energy than comparable buildings of this size. The apartments and hotel rooms benefit from heat reclaimed from the office floors that lie beneath them.

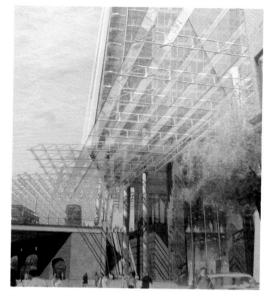

The tower will restructure one of the city's major traffic junctions

Renzo Piano's London Bridge Tower condenses the theoretical and practical approaches of the high-rise building of recent years into an elegant synthesis. Its prominent location near the center of London and directly above one of the important main stations of this city of millions makes it a new point of density, a junction and a local landmark. Accessibility for its some 7,000 workers is facilitated up to ninety percent by the adjacent public transportation options—no car parks are planned for individual traffic. With its multiple functions, it will contribute to the planned enhancement of the status of the district of Southwark. In addition, it is to be expected that the public gallery on the 65th floor, at 735 feet (224 meters) the highest observation platform in London, will become a great tourist attraction. On its completion in 2009, it will assume the position of a new landmark in the cityscape and at the same time replace Cesar Pelli's Canary Wharf Tower in Docklands (1991, 800 feet / 244 meters) as the tallest building in London. The London Bridge Tower is already influencing the debate on the functionality and necessity of skyscrapers in European cities that has been going on since the beginning of high-rise construction.

1,016 feet
306 meters

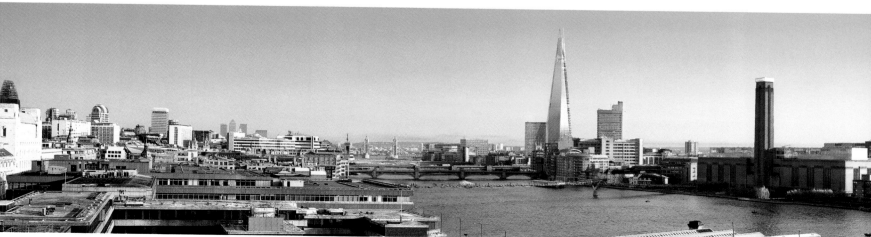

London Bridge Tower on the London skyline

Bank of America Tower at One Bryant Park New York, USA

Cook + Fox Architects

2004–2008
1,200 feet/366 meters

A computer rendering
of the tower in its
Midtown location

Even before September 11, 2001, the management of the Bank of America had decided on an imposing new building for their head office, and in 2002 they publicly announced their plans. In cooperation with the property developers Durst, the bank was able to acquire the site on the northwest corner of Bryant Park and 42nd Street. A central consideration for the bank in this project was the enhancement of the spatial quality of the workplaces, since good lighting and air quality are linked to higher staff performance. The architectural office of Cook + Fox was awarded the commission for the design which was extended to include the task of a comprehensive, lasting redesign of the whole high-rise structure. This skyscraper was to be New York's first "green" skyscraper according to the latest requirements, and would receive the highest honor bestowed by the independent US Green Buildings Council, the LEED (Leadership in Energy and Environmental Design) "Platinum" certification. This decision also rested upon a corresponding authorization on the part of the New York Buildings Department, which however had until then hardly been prepared for such projects. In order, therefore, to facilitate the approval process for the new permanent construction methods and planning techniques, a member of the New York Buildings Department was trained in the architects' office in the necessary planning processes. The project became a model for many subsequent building projects, as set out in Mayor Bloomberg's plan of 2007 for "A greener, greater New York" scheduled to run up to the year 2030.

The Bank of America Tower was built in the center of Manhattan at one of the busiest intersections in the city, and makes quite intentional use of the local public transport links available. A major subway hub exists just below street level at the building's location of Times Square and 6th Avenue

where about a dozen train lines are linked. The Bank of America decided against providing any parking space at all, so that all the 4,000 or so employees would have to make use of the local public transport. The essential aspects of permanence in this project include, apart from natural lighting of the workplaces, cooling and source ventilation from the ground up. The reduction of water use also plays a central role in the planning. The collection and recycling of rainwater and the use of waterless urinals reduces the use of drinking water by about half for each workplace. A built-in energy installation allows significantly better use of energy. More than one-third of the building materials used were recycled (even in the case of the steel girders), and as far as possible drawn from the surrounding area, in order to reduce transport as much as possible. Unlike most other skyscrapers in New York, this building houses its entire engineering services in the multistory basement. This frees the upper stories from the air-conditioning apparatus which would otherwise be located there, so

View from the corner of 42nd street and 6th Ave

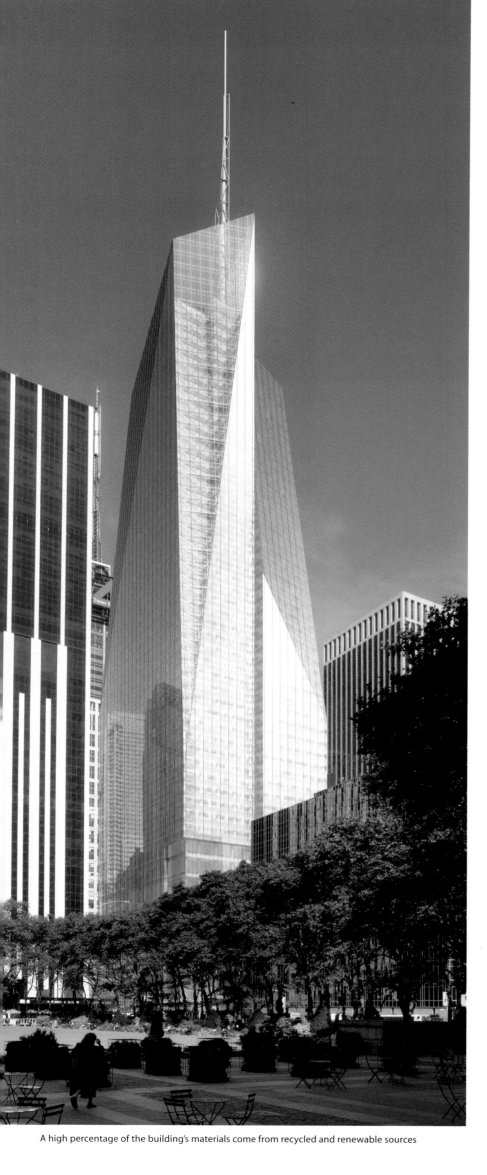

A high percentage of the building's materials come from recycled and renewable sources

that they can be used as rentable spaces. A wind turbine planned for the roof turned out to be impractical because of the highly unpredictable winds in New York.

The outward form of the Bank of America Tower, with its prismatic upward gradation, follows the model of the visions of Hugh Ferriss, developed in the 1920s (p. 10), and is at the same time inspired by natural crystal formations. The glass facade surrounding the building is formed as a single-layer skin, which at the top of the building extends beyond the actual structure, and makes the outside of the building, seem even taller. For security reasons, the public has no access to the upper stories of the Bank of America Tower, but there is a public plaza, a winter garden, and a pedestrian walkway at street level. The listed facade of the Henry Miller Theater, built on this site in 1918, was preserved, and behind it a whole new theater with 1,000 seats was built below street level. The Bank of America will use more than two-thirds of the area of this building for its own offices, while one-third will be rented out to other businesses.

Suggested Reading

Of the great number of publications on the topic of skyscrapers, only a selection representing the most important and comprehensive titles are listed here.

Ábalos, Iñiaki, and Juan Herreros, Joan Ockman, ed. *Tower and Office: From Modernist Theory to Contemporary Practice*. Cambridge, Mass., 2003.

Abel, Chris. *Sky High: Vertical Architecture*. London, 2003.

Bennett, David. *Skyscrapers: Form and Function*. New York, 1995.

Campi, Mario. *Skyscrapers: An Architectural Type of Modern Urbanism*. Basel, 2000.

Dupré, Judith. *Skyscrapers*. New York, 1996.

Eisele, Johann, and Ellen Kloft, eds. *High-rise Manual*. Basel, 2002.

Ferriss, Hugh. *The Metropolis of Tomorrow*. Reprint. New York, 1986.

Gillespie, Angus Kress. *Twin Towers: The Life of New Yorks City's World Trade Center*. New Brunswick, 1999.

Goldberger, Paul. *The Skyscraper*. New York, 1981.

Höweler, Eric. *Skyscraper: Design of the Recent Past and for the Near Future*. London, 2003.

Huxtable, Ada Louise. *The Tall Building Artistically Reconsidered: The Search for a Skyscraper Style*. New York, 1982.

Jencks, Charles. *Skyscrapers – Skyprickers – Skycities*. New York, 1980.

Krinsky, Carol Herselle. *Rockefeller Center*. New York, 1978.

Koolhaas, Rem. *Delirious New York: A Retroactive Manifesto for Manhattan*. New York, 1978, reprinted 1994.

Koolhaas, Rem. *Content*. Cologne, 2004.

Landau, Sarah Bradford, and Carl W. Condit. *Rise of the New York Skyscraper 1865–1913*. New Haven, 1996.

Magnago Lampugnani, Vittorio, and Lutz Hartwig. *Vertical: Elevators, Escalators, Paternosters: A Cultural History of Vertical Transport*. Berlin, 1994.

Mujica, Francisco. *The History of the Skyscraper*. New York, 1929.

Neumann, Dietrich. *Architecture of the Night: The Illuminated Building*. Munich, 2002.

Nash, Eric P. *Manhattan Skyscrapers*. New York, 1999.

Riley, Terence, and Guy Nordenson. *Tall Buildings*. New York, 2003.

Robinson, Cervin, and Rosemarie Haag Bletter. *Skyscraper Style: Art Deco New York*. New York, 1975.

Sabbagh, Karl. *Skyscraper: The Making of a Building*. New York, 1989.

Saliga, Pauline A., ed. *The Sky's the Limit: A Century of Chicago Skyscrapers*. New York, 1990.

Shepherd, Roger, ed. *Skyscraper: The Search for an American Style 1891–1941, Annotated Extracts from the first 50 Years of Architectural Record*. New York, 2003.

Tauranac, John. *The Empire State Building, The Making of a Landmark*. New York, 1995.

Tigerman, Stanley, ed. *Chicago Tribune Tower Competition & Late Entries*. New York, 1980.

Willis, Carol. *Form Follows Finance: Skyscrapers and Skylines in New York and Chicago*. New York, 1995.

Yeang, Ken. *The Green Skyscraper: The Basis for Designing Sustainable Intensive Buildings*. Munich, 1999.

Zaknic, Ivan, Matthew Smith and Dolores Rice. *100 of the World's Tallest Buildings*. London, 1998.

Zukowsky, John. *Chicago Architecture 1872–1922*. Munich, 1987.

Zukowsky, John, and Martha Thorne, eds. *Skyscrapers: The New Millennium*. Munich, 2000.

Important links on the topic:
www.emporis.com
www.skyscraperpage.com
www.skyscraper.org
www.die-wolkenkratzer.de

Index

Photographic Credits

Our special thanks to the architects who made illustrative material available for this publication.

Numbers refer to pages (t=top, b=bottom, r=right, l=left, c=center)

Kim Ahm, Copenhagen: 74–75
akg-images, Berlin: Keith Collie 40
AMO, Rotterdam: 26
Masao Arai: 18
Martin Jones / arcaid.co.uk, London: 80
Architekturphoto/delbeck + tedeskino, Düsseldorf: 62 b
Archiv Simmen / Drepper, Berlin: 6 l
The Art Institute of Chicago, J. W. Taylor Photographer: 31
artur, Cologne: Madjid Asgahri 70 t r, 71; Roland Halbe 92, 93 b l
W.S. Atkins & Partners: 129 b
BILDERBERG, Hamburg: Wolfgang Kunz 58–59; Wolfgang Volz 35
Barbara Burg + Oliver Schuh, Cologne: 140
Santiago Calatrava, SAMARK, Malmö / Stockholm: 141
Professor Campi, Departement Architektur, Lehrstuhl Architektur und Entwerfen, ETH Zurich Hönggerberg: 53 r, 54 t l, r, 57 l, 62 r, 64 r, 66 r, 78 t r, 86 b r, 88 b r, 97 b r, 100 b r, 108 b l
Thomsen-Ellis, *The Cathedrale of Commerce, Woolworth Building New York*, 1921: 38 b r
Cervera & Pioz, Madrid: 21 b l
Chicago Historical Society, Chicago: 6 r
Chicago Historical Society/Hedrich Blessing, Chicago: 84-87
Chicago Tribune Tower Competition, vol. 1, New York, 1981: 13 l, 42–43
China Jin Mao Group: 126 b r
Peter Cock: 60 l
Collection of The New-York Historical Society, New York: 38 t r, 44 t r
Cook + Fox Architects, New York/ dBox for Cook + Fox Architects 154–155
Cooper-Hewitt Museum, New York: 10 t
CORBIS, Düsseldorf: Bettmann 47, 50 t, 55, 59 b l; Paul Colangelo 94 b l; Angelo Hornack 38 l; Hulton-Deutsch Collection 57 r, 59 b r; Lake County Museum 33; Royalty-Free 79; Alan Schein Photography 68–69; SETBOUN 45; Richard Hamilton Smith 49; Vince Streano 48 l; Underwood & Underwood 39; Roger Wood 68 b l
Richard Davies, London: 21 t r
Digital Archive of American Architecture, Chestnut Hill, MA: 30 b, 41
Peter Eisenman Architects, New York: 24
Esto, Mamaroneck, NY: Alex Bartel 96; Jeff Goldberg 66 l; Tim Griffith 119; Wolfgang Hoyt 100 b l, 100 t r, 101; Peter Mauss 32, 46, 51, 56, 103, 109; Jock Pottle 150 t r; Ezra Stoller 61, 63, 64 l, 65, 67, 68 b r, 88t, 97 t l
George Fessy, Paris: 21 b r
Foster & Partners, London: 107 t l, 107 t r, 121, 122b, 132; Nigel Young 133
Josef Gartner GmbH, Gundelfingen / Do.: 105 t r, Daniele Domenicali 137, David Wang 134 b l, 136
gta-Institut, ETH Zurich: 11 t r
Roland Halbe, Stuttgart: 115 t r
T.R. Hamzah & Yeang International, Kuala Lumpur: 118
Herbert Hartmann, Munich: 8
Hedrich Blessing, Chicago: 126 t r, 127
Hentrich-Petschnigg & Partners KG, Photographer Manfred Hanisch, Düsseldorf: 76–77
Lewis W. Hine, courtesy of The Empire State Building Archive at the Avery Architectural and Fine Arts Library, Columbia University in the City of New York: 50 l, c, r
Historic American Building Surveys (HABS), Library of Congress: 30 t, 36 b l, b r, 37, 54 b l, b r
www.hotelattraction.com: 10 b
Bildagentur Huber, Garmisch-Partenkirchen: Giovanni 28–29; Hans Peter Huber 89, 114 r; Picture Finders 125

IFA Bilderteam, Munich: Picture Finders 93 t r; IT / tpl 94 t; Fritz Schmidt 128 t, Siebig 104; Travel Pixs 95
Helmut Jahn, Chicago: 115 b
Kohn Pedersen Fox, New York: 142; Superview 143
Balthazar Korab Ltd.: 7 r
Shang Wie Kouo, Singapore: 17 l
Kisho Kurakawa Architect & Associates, Tokyo: 90–91
laif, Cologne: Sebastian Hartz 34 t, 53 l; Heep 78 t l; Langrock / Zenit 120, 122 t,123; Martin Sasse 94 b r, 124 t, b
Ian Lambot, Hong Kong: 106 l, 106–107, 112
Dennis Lau & Ng Chun Man, Hong Kong: 130, 131
C.Y. Lee & Partners: 134 b r, 134–135, 135 b
Studio Daniel Libeskind, New York: 150 b r
LOOK, Munich: Franz Marc Frei 52, 108 t l; Jan Greune 78 b l; Christian Heeb 48 r; Holger Leue 129 l, r
Norman McGrath, New York: 98 b l
Nick Merrick © Hedrich Blessing: 99
Osamu Murai, Tokyo: 116 b r, 117 t, 117 b
Murphy/Jahn Architects, Chicago: 114 b l
Museum of the City of New York: 9 l, r, 13 r
Atelier Jean Nouvel, Artefactory, Paris: 139 b l
John Nye, Hong Kong: 111
Obayashi Corporation, Osaka: 21 t l
OMA Office for Metropolitan Architecture, Rotterdam: 25, 144–147
Richard Payne: 102 t r
Pei Cobb Freed & Partners, Architects, LLP, New York: 110 b l
Renzo Piano Building Workshop, Genoa: 19, 152; Hays Davidson & John Mclean152 l, 152–153; Frédéric Terreaux 153 t
Philippe Ruault, Nantes: 138, 139 r
Photo Scala, Florence / The Museum of Modern Art, New York © 2003: 11 b
Photo Scala, Florence / The Museum of Modern Art, New York © 2004: 68 t r
Harry Seidler & Associates; Max Dupain, Milsons Point, NSW: 82–83
Skidmore, Owings & Merrill LLP: 148–149
Skidmore, Owings and Merrill LLP / dBox: 151
Steinkamp / Ballogg Photography: 22
Stiftung Deutsche Kinemathek, Berlin: 5 r
Strüwing, Copenhagen: 73
Stubbins Associates, Cambridge, MA: 98 t r
Yoshi Takase: 17 r
Tange Associates, Tokyo: 116 b l
Paul Warchol Photography Inc., New York: 72, 110 t l, 113
Frank Lloyd Wright Foundation, Scottsdale, AZ: 14, 60 t
The Frank Lloyd Wright Archives, Scottsdale, AZ: 60 b r

For Maximilian

Acknowledgments

For all manner of help, suggestions, discussions, and critiques, I would like to thank Paul Kahlfeldt, Stefan Steidele, Regine Leibinger, and Frank Barkow, as well as Barry Bergdoll and William Ryall, Bertram Steingräber, and Ralph Heusner. Christian Dubrau carried out fundamental research work for me. I would never have reached the end of this project, however, without the intellectual structure learned from Hanno-Walter Kruft. I am very grateful to Regina Göckede and Ken Tadashi Oshima for their critical reading of the English translation of the introduction. Special thanks to Cristina Steingräber for her meticulous copyediting of the manuscript.

Revised edition 2008

Prestel Verlag
Königinstrasse 9
80539 Munich
Tel. +49 (89) 242 908 335
Fax +49 (89) 242 908 343
www.prestel.de

Prestel Publishing Ltd.
4, Bloomsbury Place
London WC1A 2QA
Tel. +44 (20) 7323-5004
Fax +44 (20) 7636-8004

Prestel Publishing
900 Broadway, Suite 603
New York, NY 10003
Tel. +1 (212) 995-2720
Fax +1 (212) 995-2733
www.prestel.com

Library of Congress Control Number is available

The Deutsche Bibliothek holds a record of this publication in the Deutsche Nationalbibliografie; detailed bibliographical data can be found under http://dnb.ddb.de

Prestel books are available worldwide. Please contact your nearest bookseller or one of the above addresses for information concerning your local distributor.

Translated from the German by Christine Shuttleworth, London

Editorial direction by Angeli Sachs, Sandra Leitte
Picture research by Katharina Kulke
Copyedited by Charles Heard, Munich

Cover design by LIQUID | www.liquidnet.de
Design and layout by Meike Sellier, Munich
Origination by Repro Ludwig, Zell am See
Printing and binding by TBB, Banská Bystrica

Printed in Slovakia on acid-free paper
ISBN 978-3-37913-3992-4